curb. service

curb.
service

scot sothern

SOFT SKULL PRESS

Library of Congress Cataloging-in-Publication Data

Sothern, Scot, 1949-
 Curb service : a memoir / Scot Sothern.
 pages cm
 Includes bibliographical references and index.
 ISBN 978-1-59376-520-0 (alk. paper)
1. Sothern, Scot, 1949- 2. Photographers—United States—Biography. 3. Prostitutes United States—Portraits. 4. Men—Sexual behavior—United States. 5. Prostitution—United States. I. Title.

 TR140.S638A3 2013
 770.92—dc23
 [B]

2013002747

ISBN 978-1-59376-520-0

Cover design by Michael Kellner
Interior design by Elyse Strongin, Neuwirth & Associates, Inc.

Soft Skull Press
New York, NY
www.softskull.com

Printed in the United States of America

For my father and for my son, I got lucky on both accounts. I love you Austin and I miss you Pop.

And for all the hard-luck whores, you deserve better.

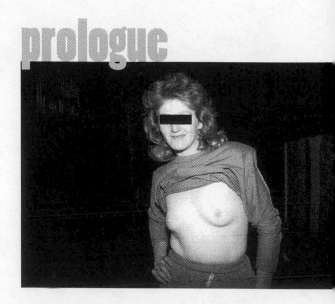

Going north on Western above Hollywood Boulevard just past the empty Pussycat Theater, I pick up a working girl in a T-shirt and sweatpants. I drive up the long curve onto Los Feliz Boulevard at the edge of Griffith Park. I take a left on a clean street of big houses with big yards and security lights. When I get to the end, I follow a one-lane dirt and gravel road and then park in a secluded spot. The dark feels warm and liquid. The sounds of humanity are distant. The working girl tells me she hopes I'm not a serial killer and I tell her no I just take pictures.

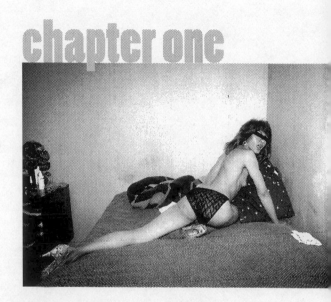
chapter one

macarthur park

1990

The Grand Slam special at Denny's looked just like the laminated photos on the menu: two eggs, two buttermilk pancakes, two strips of bacon, and two sausage links. Using the last bite, a triangle of hotcake, I painted a yokey sunset across the oval platter, a maple syrup lake, a sprig of parsley for trees.

At 2:00 a.m. the Hollywood clubs turned out the lights and disgorged a cadre of metal-headed rockers headed for downscale

eaterics. They, like me, had settled for home cooking served up by a cheerful Denny's waitress. From my backpack I retrieved a bottle of acetaminophen and downed five with a wash of ice water. I clinked my Zippo and lit a smoke. The guy on the neighboring stool at the counter spoke to me. "You got an extra one of those?"

He had a bushel of hair, a hungry rock-and-roll face, and the chapters of his young life tattooed up one arm and down the other. He eyeballed my box of Kool Kings on the counter.

I tapped out a smoke, which he took and lit with a Bic. "Thanks, dude."

"You're welcome."

He glanced at my cane, which I'd hooked over my right knee, then back to my eyes. "Bad leg?"

"Yeah, sort of."

"That's fucked-up, dude. Get better."

"Thanks, I'll see what I can do."

He rotated his back to the counter, put an Elvis snarl on his lips, picked up an unplugged electric guitar, and improvised a steel-heavy mating call. A chorus of lace-and-leather late-night cuties sashayed up the catwalk to the ladies' room, giving the metal-minstrel sly winks and sultry smiles. They checked me out as well, though not with the same intensity.

Outside, in the parking lot, I could smell wood smoke from the annual wildfires, warm September Santa Ana winds stoking the flames and sucking the moisture from the air. I took a red and blue tube of Blistex lip ointment from my shirt pocket, squeezed an oily white plop on a digit, and lubed my lips. It was a cheap addiction since elementary school; withdrawal was chapped lips. The moon was filtered, dim and yellow like a darkroom safelight. Inside my Camaro, I turned on the air and wheeled out of

Denny's onto Van Ness Avenue facing south at Sunset Boulevard. Westward past the KTLA television tower through miles of glitz, Sunset went all the way to the Pacific. Eastward it curled downtown to skid row.

I turned left over the Hollywood Freeway viaduct. Red taillights and white headlights rolling up and down the 101 flared into streamers across the windshield. I was steering with my right hand. Three days ago my left arm had gone to sleep, wrapped in a force field of vibrating pins, and had yet to awaken. I bit a chunk from the inside of my cheeks and watched the final traces of Hollywood go by like a chorus line.

On the sidewalk, a streetwalker in baggy pants and a camouflage jacket kept her back to the traffic while taking sneak peeks over her shoulder, attempting to catch the eye of some guy like me. Pulling into an empty parking lot, I turned the car around and tooted the horn. She walked to the car and climbed in. She was small with smooth skin the color of sandstone, a wavy nest of henna hair. She was a transvestite, probably pre-op, probably still had boy parts hanging around, waiting for the guillotine.

Her voice was wobbly. "I just got out of jail. I haven't had nothing to eat in a long time."

"There's a 7-Eleven a couple of blocks from here. I'll stop and we can get you something."

"I don't have no money."

"I'll take care of it."

"What do you want from me?"

I throttled back onto Sunset. "I like to take pictures."

"Oh . . . Okay."

She was angular and pretty, like Pocahontas, the cartoon, not the person.

"How'd you get in jail?"

She sat up straight, put her hands on the dash, and hissed through grinding teeth, "Cops er fuckin' assholes. Took me to jail for not doing nothing."

"Yeah, they can be that way."

At the 7-Eleven I parked and got out without my cane, as though I didn't need it. Despite my best efforts, my right foot dragged a step behind, and I walked stiff-legged with my arms out for balance. I'd always had a cocky bounce to my step. I could jump and click my boot heels, three times, and land gracefully with the tipping of an imaginary hat, all cute and sexy. Three times. Click, click, click.

Inside, Pocahontas got a Hostess apple pie with a sixteen-ounce cherry Slurpee. At the counter, while she drifted around, I added a pack of Kool Box to the merchandise. A clerk rang up the sale and made change from a twenty, and we lugged our supplies to the car.

"Pick a direction, which way do you want to go?"

She opened the apple pie with her teeth and threw the wrapper on the floor, took a bite, and pointed east. I picked up the trash, put it in the litter bag, then followed her point back onto Sunset, leaving behind a squeak of rubber.

"I know a place not far from here where we can take some pictures," I told her.

"You get high?"

"Sometimes."

"We get a rock an' go to my place. I can give you whatever you want, all night long."

"I don't know, maybe. How far is your place?"

"Real close. We can stop an' get a rock. Real close, not far."

As we stopped for a red light, at the five-way intersection where

Hollywood Boulevard becomes Sunset, she told me I should turn on this street here, indicating Virgil Street going south.

On the northeast corner, the seventy-year-old Vista Theater looked like the Alamo with a marquee and a ticket booth. Across the way the garish orange porn shop looked like the red-light section of Tijuana. Between them and a few blocks up was Carol's little courtyard bungalow. I'd moved in two weeks ago, and we had both made firm commitments to our lasting love. I had connected a Nintendo game-player to the television for the custodial weekends with my eight-year-old son, Dashiell, my other firm commitment and everlasting love. I could see the three of us pajama-clad and smiley-faced, watching Saturday morning cartoons. Sound of mind; healthy.

Carol would be sleeping now, warm, soft, and naked, between clean sheets. She would have the covers on my side turned down, waiting for me to undress, climb in, and snuggle up. Only two blocks away. True love. Salvation.

"You don't have to wait on red. You can go."

"Yeah, alright." I turned right and gunned it down Virgil, watching the street that went between the Vista Theater and the porn shop disappear in the rearview mirror.

Pocahontas slurped Slurpee and asked me a question. "You like apple wine?"

"I guess so. I don't know. How come?"

"Cause I jacked a bottle." She took a green bottle of applejack from her jacket and held it up like a gold metal.

"Good for you," I said. "None for me, thanks. My cocktail hour doesn't start for a while yet."

She poured half of the wine into her Slurpee and stirred it, round and round, with a red straw.

Virgil came to a halt at Wilshire, and I braked for a red light. Catty-corner, on the right, the old Bullocks-Wilshire building, silver and night-shaded with a green-copper tower, a deco rocket through time. Film noir tough guys in sleek, dirigible-sized cars. Feral shadows; cats, rats, and tommy guns. The light changed and Pocahontas directed me east.

A few blocks later, at Park View Street, we took another left and drove into MacArthur Park.

Pocahontas pointed and said, "Stop over there."

I pulled across three nose-in parking spots and stopped next to the curb. A hundred yards across, a grass slope and a small Greek theater reflected the dirty yellow light from the street lamps. Four sets of ten rows of green benches embedded in a concrete slab sat in front of a bright white clamshell stage. In the 1960s, flower children and groovy dudes like me dropped acid and sang, from the stage, about changing times. In the 1970s, this was the setting for Joseph Wambaugh's Choirboys and then, later, John Rechy's sexual outlaws. Now, crack cocaine was all the rage, and MacArthur Park was a zombie graveyard.

Between the car and the stage, a flock of terminal crackheads, guys and gals, stumbled, gray and spectral, in nowhere circles, seeking a higher plane and a cheap fix.

"You got some money? I can get us a rock here."

"Yeah. Okay." I dug out my wallet and gave her two fives. "I'll give you another ten after we take your picture."

She absorbed the cash. "Give it now, an' I can get enough for both a us."

"Ten will buy enough for both of us. You want the other ten, you gotta come back and let me take your picture."

"Okay. You stay here. Don't get outta the car. Nobody don't know you."

"Yeah, alright. Just do it and get back."

She climbed out and said, "You should lock the door behind me."

"Don't worry about it. I'm comfortable here."

Pocahontas walked off into the jungle while I sat in the car, with the motor running and the radio on, listening to oldies. I knew all the words to all the songs. Oldies and I were the same age.

In the beacon of my headlights, a friendly biped came over to welcome me to the neighborhood. He was dressed in purple-and-gray-checkered double-knit. He flattened his arms across the roof of the car, leaned down, and put his face next to the open driver-side window. His forehead was iced with coagulated blood. He grinned a sardonic ear-to-ear and mumbled a string of incoherent words with a question mark at the end. His breath triggered my gag reflex.

I gave him the change from my pants pocket and told him have a nice day.

He told me thank you or maybe he said fuck you and then he went away.

My neck was stuck in place, so I put my head in a wrestling hold and wrenched until my cervical spine popped, like pink plastic pop-beads, three times. The relief was temporary, but for the moment, it was like intravenous morphine. I lit a smoke and inhaled carcinogens, opened the door, and exhaled smog. I stood up on the floorboard, leaned my elbows on the top of the car, and watched the theater crowd.

In the acoustical bowl, shopping-cart bundles spilled recycled keepsakes to the stage floor. Numbed-out castaways flitted aimlessly about like slow-motion bumper cars, crashing noiselessly into empty space. Crack-pipe fireflies illuminated on intake, then died like shooting stars.

On the radio James Brown took the stage and screamed into the microphone, *It's a man's world but it wouldn't be nothing, nothing, without a woman or a girl.* I turned it up.

An LAPD patrol car going west on Sixth turned south on Park View and drove slowly to the center of the block. The lone cop behind the wheel pulled up even with the Camaro and braked to a stop.

"You don't need to be here," he said through the open window. "Let's move it along."

He was wrong, I did need to be here.

"Yeah, alright, I'm going."

He watched me as I got back in the car and sat with the motor running, ignoring him. After a long minute or so, Pocahontas came into my sights, trudging through the war zone back to the car. She opened the passenger-side door and plopped onto the bucket seat. The cop threw his spotlight around and hit me in the eyes.

I dropped into drive and went one way while he went the other. She got to her knees on the seat and turned around to watch him through the rear window. "What if he comes back?"

"Don't worry," I told her. "He's done with us."

"Cops er assholes."

"Yeah. They certainly can be."

"Took me to jail for not doing nothing." I braked at the two-way stop at Sixth Street. "Turn right up here," she told me. "Couple more blocks, hotel on the other side."

On the left side of the street, taking up half a block, an old bar-bell tenement was huddled next to a liquor store like a sick drunk.

"Is that it?"

"Uh-huh."

I U-turned at Bonnie Brae and idled back the way I had come.

I pulled to the curb and parked in a loading zone. Hieroglyphic graffiti had been sprayed-gunned across the stone façade like territorial piss. All along the sidewalk, a gypsy carnival of commerce in the grainy and lurid hues of pulp nonfiction. Nocturnal men and women, old and young, brown and black, hanging around, making deals and concessions, making the most of their lives. A boom box, cranked to capacity, megalomanic rhymes thump-thumping like an elevated heartbeat. Pocahontas said, "Don't leave nothing in your car. Lock it up an' stay close to me."

Grabbing my backpack and cane, I came out of the car like a guy having a good time. We walked through the swarm and into the hive. It was dim inside. The light fixtures flickered like smoky torches on the walls of a mummy's tomb. Tendrils of tall window drapes hung like Spanish moss. The bloated ceiling was held upward on shaky concrete pillars, fingers poking a fat stomach. The floor was strewn with litter.

Pocahontas stopped and for a long moment looked at my cane; then she took me by the hand. "Come on," she said. "Stay with me."

At the back of the lobby, next to an out-of-order elevator, a black cage door next to a caged-in window manned by a long, thin, bewhiskered guy. He sat below a blue L.A. Dodgers hat, watching a portable TV. He looked at us, recognized her, but leaned forward to check me out. "Where you goin'?"

"With her. Upstairs, I guess."

"What's in the bag?"

"Some stuff and some things."

"Yeah?"

"Yeah."

"Yeah, okay, fine." He pushed a buzzer and the door opened.

I followed Pocahontas over mildewed and threadbare carpeting, up three warped flights. I took the stairs slowly, holding

the rail, watching my feet, concentrating on my balance like a baby taking his first steps, or an old man taking his last. On the third floor we went to the third door.

"When we go in, don't say nothing. Okay? Jus' don't say nothing."

"To whom am I saying nothing to?"

She knuckled the door and said, "My mom. She's good, she takes good care of me. Jus' don't say nothing."

Her mother opened the door. She looked like Pocahontas, only older and sadder. Her eyes fell for a moment on her child, then she walked, slow and heavy, to a double bed on box springs. She sat on the mattress next to the recumbent body of a big red-headed guy with a face like a bag of potatoes. The room had four walls, a window with the steel silhouette of a fire escape, a door to a small bathroom with a whistling toilet. In the far corner, a mattress pad, home sweet home for Pocahontas.

They spoke Spanish, leaving me lonesome. The girls worked out the logistics and everyone looked at me, smiling like an idiot, leaning on the door frame.

"C'mon," Mom said to her roommate. They climbed up from the bed and walked out of the room into the hallway. As he passed by, the guy stopped, moved his face in a little too close and said, "Ten minutes. Scumbag."

"Yeah, sure thing," I said. "See you later." A jet stream of cigarettes, wine, and body odor trailed him like a gas leak. I closed and locked the door.

Pocahontas went quickly to a corner space where she picked up an aluminum-foil pipe and a pink disposable lighter. She moved to the bed, sat next to a fuzzy, yellow teddy bear, and loaded the pipe with crack cocaine. She wanted to get high as soon as possible, and I didn't mind. I could hang out for a little bit, take some pictures, and then go somewhere else.

She set fire to the rock and it crackled like static, smelled like cotton candy and hospital corridors. She spoke at chipmunk pitch, holding in illicit smoke. "You want some?"

"Not right now, thanks." I set down my backpack and walked over to the bed. "I'm going to take a pinch and save it for later."

She put a flaming kitchen match to the pipe and stoked up residue. I picked up the rock and thumbnailed a pebble onto a dollar bill from my wallet, folded it into a drug-stash origami, and returned it to my pants pocket. She blew out secondhand smoke, then sitting quietly, hugging herself, allowing the buzz to infiltrate her being, she leaned over close to me and whispered out loud, "You want me to suck your dick?"

"Uh, not really. Let's take your picture instead."

I took the camera and flash from my bag. She picked up the stuffed bear and gave it a hug. "This's Madonna Bear. She's my best friend. Can she be in the picture?"

"Yeah. That'd be great."

She stripped down to her panties; she had sinewy boy muscles and pointy, palm-sized breasts.

I turned on the flash and was setting the aperture and shutter speeds when, without warning, a bolt of ice struck an open nerve in my cervical spine and vibrated my fingers and toes. I clenched and my left leg kicked at the air, and I sat down on the bed, grinding my teeth.

"You okay?"

"I'm fine, just give me a second." I pulled myself back to my feet and shook it off like a tough guy; pretended nothing was wrong.

I picked up my Nikon, looked through the viewfinder, and told Pocahontas just stay there. "Hold Madonna Bear if you want to. You look great. Look at me."

She didn't look at me. She started looking around the bed instead. "Where'd the rock go? Wanna get high first."

"You already did."

"Just a little bit. I wanna do it again. I can't find the rock." She ran her hands over the bedspread like a blind person speed-reading, escalating toward hysteria.

I walked back to the bed and found the evil drug sleeping in a fold with the pipe, then set it, along with the pipe, next to a bag of Cheetos on the night table. "Here it is. Let's go ahead and take a quick picture."

She climbed back onto the bed, held her stuffed bear tight, and struck a pose while I focused and took a picture. She put the bear aside and went into a sexy cheesecake pose, throwing back her head and laughing at nothing. Her eyelashes were inked black and thick; her dark eyes were dilated and suggestive, like the glance of a veiled Bedouin girl. My Nikon click-clacked and the portable flash splashed white light on the neutral gray scene. "Thanks, that was great. You're really pretty and you're pretty sexy."

I put my gear away and Pocahontas got high again, hyperventilating three hard hits in a row. She dropped the pipe and stretched prone across the bed, hugging Madonna Bear. Cotton stuffing leaked out through a rip in the seams below Madonna's fluffy tail. "You sure you don't wanna do nothing to me?"

"No, thanks." I told her. "I'm trying to quit. I got the pictures and that's all I really wanted. I'm gonna go in a minute."

"Okay. I'll walk you down so's nobody will bother you."

"That's okay, thanks. Nobody's going to bother me."

"You got s'more money? You said you was gonna give me s'more money."

"Yeah, sure." I took out a ten and showed it to her. "Here, I'm putting this in your coat pocket along with your rock." From my backpack I took out a ladder of tin-foil wrapped condoms. "I'm also giving you some rubbers." I picked up her jacket and placed the booty in a zippered pocket. She placed the teddy bear behind her head for a pillow and closed her eyes. Her eyelids fluttered and her fingers vibrated. She hovered above the mattress. She said, "Fuckin' cops put me in the cage with the men, just 'cause they thought it was funny. Cops are assholes, I didn't do nothing."

I sat on the edge of the bed watching Pocahontas levitate. A warm wind flew in from the open window, along with the kinetic urban drone from sea level, three floors below. "I'm an asshole," I said.

Pocahontas opened her eyes, looked at me, and smiled like a happy person. "You been nice to me."

"Yeah, well. I'm glad you think so."

Somebody knocked on the door so I got up, unlocked it, and pulled it open. Momma Pocahontas stood in the doorway. She looked at her semi-naked child sprawled on the bed in narcotic stupor and then went over and sat on my indentation in the mattress. She lit a cigarette and dropped the spent match to the floor.

As we crossed paths, the redheaded guy said, "Don't come back, asshole."

Taking the stairs down, holding on to the banister with one hand and my cane with the other, carrying my weight with my arms, I stopped at the second-floor landing. A battered-looking woman in a tatty bathrobe was sitting on the floor looking at her feet. She was wearing a pair of fluffy, pink bunny-slippers, and when she wiggled her toes the bunnies twitched their whiskers.

I said, "Excuse me, I need to get by."

She was slow to respond, but eventually tore her eyes from her fuzzy feet and looked up at me. Teardrop tattoos wept from her eyes. She smiled and showed me a shiny silver incisor. "Bunnies," she said to me.

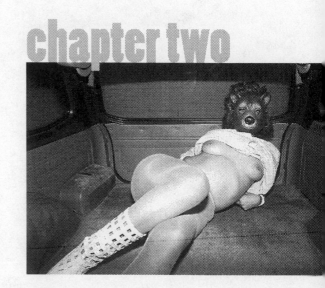

chapter two

hulky takes a ride

1986

A child-friendly, birthday-themed restaurant. A clamorous amalgamation of amplified kid ditties, video games, a hollow din, like bells from a blow to the head. Checkerboard picnic tables laden with pizza, soft drinks, and birthday cake. An exuberant multitude of sugar-fueled youngsters soaring through the balloons, crashing into their parents like paper airplanes. At table sixteen, I was the master of ceremonies.

My son's name is Dashiell. The occasion was his fifth birthday. His mother, my former spouse, Sylvia, made the arrangements and mailed out the invitations. My job, my duty, was to hand out video-game coins, make nice with the moms and dads, conduct the opening of gifts, cut the cake, and lead a rousing rendition of "Happy Birthday to You, You Belong in the Zoo."

Table set, I poured soft drinks into paper cups. Sylvia was somewhere else supervising and socializing. Dashiell was killing Ninja Turtles in the arcade. I wanted to join him. He was the only one here at my intellectual level, the only one I could talk to.

A woman with a toddler in her arms sat next to me on the picnic bench. I knew her older child's name, Jason; I oversaw playtime with him and Dashiell now and again, but mom's name and the tot's name had never taken root.

"This one," the woman told me, meaning the girl in her clutches, "is ready for her afternoon nap. Jason always slept through the night and went strong all day. But this one wakes in the night and needs her nap by two or three in the afternoon."

"Dashiell likes to stay up all night and sleep during the day," I told her. "He gets it from me. We're mushroom people."

She gave me a smile that wasn't really a smile, scooted down the bench, and turned her attentions to the papoose. At the table next to ours they were singing B-I-N-G-O, B-I-clap-clap-O. A giant mouse, wearing a red-and-black checkered bib, walked by and waved at me. Excusing myself, I fled on the tail of the mouse.

Dashiell was in the arcade, but he wasn't playing any games. He was wandering around watching others, talking to no one, alone in the crowd. His face was hidden behind a plastic Three Bears mask, though I could see through his disguise. Dashiell was frail and beautiful, blond and blue-eyed. Supermarket strangers

would assail us with gushes of "oh what a beautiful child," or occasionally, "oh what a beautiful girl." Dash and I were both offended, not because of the gender faux pas, but because of the rude assumption we wanted to talk to strangers.

I said, "Yo, Fuzzy Wuzzy, how's it goin'?"

He came to me, arms open, and I scooped him up and squeezed, then lifted his mask and kissed his cheek. When Dash was three months old, I left him in his mother's care and took a year-long photography gig in Saudi Arabia. A year after that I took an optical camera gig for seventeen months in New York City while he and his mother stayed mostly in La Jolla, a ritzy beach village just north of San Diego. I'd been an absentee father, and I was trying to make up for it. I was staying with a friend in Los Angeles and driving down to La Jolla every weekend and sometimes more.

When we were together, my son and I, we clung tightly with everything we had, and when we were apart, we mourned.

I asked him how come he wasn't hanging out with anyone, though I already knew the answer. Dash wasn't comfortable with the other kids any more than I was with their parents.

He answered me with a shrug, then grabbed my cheeks and stretched out the skin, like Plastic Man. It cracked him up, molding my face into cartoons.

"Hey, Little Bear," I said. "You wanna go open presents now?"

"I guess. Okay."

"Such enthusiasm. You wanna know what I got for you?"

"What?"

"One of these." I put my lips on his neck and blew farts as though rude noises and ticklish vibrations were the key to good parenting. All around us an abstract carousel of fun and games. Dashiell hid behind his mask, and I put on a happy face.

※

Dash made a wish and blew out five candles, while I watched and made a wish of my own. He opened presents, to overstated oohs and ahs, and we had cake and ice cream and sang "Happy Birthday." I documented the smiles with my trusty Nikon, and when the party wound down, I carried Dashiell's gifts out to Sylvia's car to load them in the trunk. Sylvia had a new car, which kind of pissed me off, a pseudo-chic Japanese Jeep that looked like a Happy Meal toy. She was making good money freelancing property appraisals. She was in her first year of law school and was Dashiell's primary caregiver. She got things done, which was good, because I didn't.

Sylvia was smart and pretty, and sometimes sexy. We had stayed married for five years and had survived that long because I was gone a lot. We had met when she was twenty and I was twenty-nine. I, a romantic rapscallion, who had been throwing rocks at convention since before Sylvia was born, had a world of stories: drugs, drink, mayhem, barn-burning, scams, and sex. I was thin, chiseled, and sexually creative. I was arty and had big plans for a career as a fine-art photographer. How could she not have fallen in love with me?

A year later, with Dashiell's delivery, Sylvia and I were tied together forever. Neither of us was prepared for parenthood, though Sylvia was adept at the logistics. I was still throwing rocks, and my big plans for success in the arts were still just big plans, which Sylvia has come to regard as empty posturing. Her opinion of me had been tested, and I wasn't who she wanted after all. Conversely, Sylvia was no longer the one I wanted. She had her own long list of problems, and I had broken the number one rule of good relationships: never get involved with

someone more fucked-up than you are. Now, five years later and eight months divorced, we got along at times and didn't at others.

When Sylvia came out to the parking lot, we both got angry the moment our eyes touched. She came at me in an accusatory tone that balled up my fists. "What are you doing?"

"I'm putting the stuff that needs to go to your house in your car."

"You mean you're putting all Dashiell's things in my car because you don't have a house."

"Yeah, that's what I meant to say. Where's his overnight stuff?"

"I didn't bring it. He needs to come home and take a bath and eat dinner before he goes with you."

"Goddamnit, I thought he was going to go with me from here. We gotta drive all the way back up to L.A. in Saturday night traffic. I just want to get going, and for some crazy reason, I don't really want to hang out with you."

"You know what? Maybe Dashiell should just stay home. He is going to be exhausted from the party anyway. He doesn't really need to go to Santa Monica with you. You can't really take care of him anyway."

"Don't start."

"You already started it. You're such a jerk. Dash is coming home with me to eat and clean up. I can't trust that you'll get him cleaned and fed. You don't even have a bed for your son, Scot. Where's Dash going to sleep? On the floor again?"

"He's not sleeping on the floor anymore. Gus lets me use his bed and sleeps where I usually sleep, on the couch in the living room. Dash sleeps with me. He likes sleeping with me. Far as that goes, he liked sleeping on the floor, in his sleeping bag. Let's talk about something else."

"Okay, Scot, did you bring me money? You owe me."

A hundred and forty-five dollars was tucked into my wallet, but I wasn't feeling charitable. "I paid for the party. I thought that's all you needed for now. I haven't had much work. I'll be better off next month."

"What's so special about you that you don't have to work? What have you been doing, other than sitting around drinking beer and watching television with Gus?"

"I've been writing, taking pictures."

"How's that working out for you, Scot? Are your hobbies a good source of income?"

"I give up. You win. Remind me later, and I'll shoot myself in the head."

We could have continued like this for hours. We could digress to the point of name-calling. We had been at it for years. Out the double doors and into the parking lot, an employee in a Mother Goose costume walked out holding Dashiell's hand. Dash was sobbing. His face was red. A mucous slug crawled from his nose to his lip. When he saw me, he ran to my arms. I swooped him up and squeezed him close.

"I thought you left without me!" His little body shivered in my arms. I kissed his face and wiped away tears and snot with my hand.

"I'm so sorry, sweetie. I'd never leave you. I thought your mom told you we were out here."

Sylvia shot a poison dart at me. "That's what you do," she snarled. "You make it look like my fault. You try to turn him against me. You're such an asshole."

Mother Goose stood there watching. She probably saw dysfunctional parents all the time. I told her sorry and thank you, and she went back inside.

I walked a circle with Dashiell in my arms. "You gotta go home with your mom and eat dinner and take a bath before we go up to Gus's."

"I want to stay with you."

"You're going to. I'm gonna pick you up in a couple of hours."

"Come home with me while I eat dinner."

"No, I'll pick you up in a while. Your mom and I aren't doing so well today." I kissed his neck. "I got some shit I've gotta do anyway. Then we'll go to Santa Monica."

"You have to do some shit."

"Yeah, I gotta do some shit, and then I'll pick you up."

"Take Hulky with you. Hulky wants to do shit with you."

Hulky was a large, pillow-sized facsimile of wrestler Hulk Hogan. He went everywhere with Dashiell. Leaving Hulky behind could result in trauma. Dashiell was entrusting his most valuable possession to my care.

"Yeah, okay. Hulky can come with me to do my shit. Then we'll pick you up in a little while."

I gave Dashiell a couple of loud kisses, told him good-bye, happy birthday, and I love you, then returned him to his mother's care.

※

Sitting in my car, in the parking lot, I watched happy-birthday boys and girls with balloons and party favors holding hands with moms and dads, skipping merrily through the candy landscape. Sylvia was right about me. My life had been in shambles from early on, and try as I might, I hadn't changed. I was an artistic bohemian, with genius boiling away, just below the surface. What I needed was management and a muse, and unfortunately, no one was applying for either job.

Retrieving a joint from the ashtray, I lit the fuse and, with the first blow, felt better than I had the moment before. A white Camaro was parked opposite my junky Toyota wagon. Much of my life was spent behind the wheel of the decade-old Toyota wagon, which had been Sylvia's and came to me by default. It had no style and the tape player didn't work. The driver's seat had sprung springs and the seat-back was stuck too far forward. I could see myself behind the wheel of the Camaro, sleepy-eyed and hip like Robert Mitchum in *Thunder Road*. I needed a joyride.

On the floor behind me, nudged halfway under the front seat, I kept an old army-surplus backpack with my basic camera outfit, a Nikon FE2 with two lenses and a flash. I rewound the color film of the birthday festivities and replaced it with a roll of Tri-X. Black-and-white and grainy to match my mood.

After putting the camera and backpack on the floor, on the passenger side, I put Dashiell's Hulk Hogan doll in the passenger seat and buckled him in. Hulky was wearing Dash's bear mask. After a while the sun went down, and Hulk Hogan and I went for a ride.

Metropolitan San Diego had long been a military base. Downtown was a place where swabbies stationed at Coronado Island and jarheads from Oceanside could drink themselves shit-faced, pick up a whore or a queer, and get a red-white-and-blue tattoo.

San Diego is also a Southern California tourist mecca. In the mid-1980s concerned city denizens instigated an assault on poverty and open degradation. They tore down the strip joints, the tattoo parlors, the sleazy arcades. They pushed the nutcases, drug addicts, and assorted disenfranchised all the way to the Pacific.

A new, antiseptic mall had been erected in the downtown square. The effort to sweep the streets clean of human detritus was ongoing. While mall shoppers could be seen puttering along the multihued parking structure, there remained a moribund tribe of downtrodden on the north side of the final block of Broadway.

I drove my rattrap toward the ocean breeze. The sun was down and the lights were up. Music was in the air, heavy-metal poets lamenting their adolescent past.

On a corner, next to an arcade, a couple of young women decked in whore regalia, miniskirts and high-heeled boots, were working the curb with bright, encouraging smiles. Cruising by, I got a buzz in my pants. Not wanting to give in easily to impulse buying, I headed around the block to think it over, and the more I thought about it, the harder my dick got. Decision made, I raced around the final corner. My stomach gurgled and my digits began to tremor.

One of the hookers was gone from the corner, and the other was waiting for me. Opening the passenger-side door, I transferred my camera gear from the front to the floor in the back, unbuckled Hulk Hogan and sat him on the backseat. The girl sat on her haunches and looked at me through the open door. She was pleasantly plump with large breasts. Her face was unlined, a little puffy and pretty. She was young and clean with laughing eyes, twinkling with a trace of hysteria.

"Hi," she said. "You looking for a party?"

"Yeah, I guess so. Hop in, we can discuss it."

She chewed a wad of bubble gum, her jaw working overtime banging her teeth together, smacking her pretty pink lips. She climbed in and closed the door behind her. I pulled from the curb and continued toward the ocean.

She opened negotiations. "I can do you all the way for a hundred dollars. I'd like to do you for nothin' just because I like doing it, but I get a hundred dollars."

"I don't have a hundred dollars. How's twenty?"

"Twenty-five, but only for a hand job." She bounced on the seat and had yet to buckle up. On her knees, she turned to the back and checked out Hulky. "What's that?"

"That's Hulk Hogan."

"How come he's wearing a mask?"

"He's in disguise. He doesn't want anybody to see him hanging out with me."

"You're funny."

"Yeah, I know. I wanted to be a comedian but everyone just laughed at me. Do you have a place where we can go? I'm gonna run out of road up here."

"Turn right."

I turned right, and traffic thinned. We drove by Union Station, San Diego's circa-1915 mission-style train depot. A gigantic sand castle on the beach. I imagined old San Diego, rip-roaring with saloons, soiled doves, and idiots like me looking for trouble.

The hooker bopped about like a puppy. Just to hear myself talk, I asked for her name. She twirled around on the seat with Hulky in her lap, taking off his bear mask and tossing it into the back. She blew large pink bubbles that popped like corks, then clung to her mouth like dead skin. Her name was WeeGee, she told me, and that was because she knew things that were going to happen before they happened. She told me to make another right turn.

I said there had been a famous photographer who called himself WeeGee for the same reason. Spelled it W-E-E-G-E-E instead of O-U-I-J-A.

"That's impossible," she informed me with a degree of indignation. "Couldn't be anybody else with my name, 'cause I made it up."

"My mistake. Where do I go now?"

"Two blocks, two blocks." She turned on the radio. "Does the radio work?"

"Sort of. The speakers are fuzzy. You gotta keep it low."

She turned it up anyway, a pop station, Billy Idol's new take on an old song, "Mony Mony." The speakers rattled the interior of the car, so I reached over and turned it down.

"That was a stupid song anyway," she told me, then started punching buttons. She found another old song with a new voice, "I Think We're Alone Now" by Tiffany, and gave the volume a twist. She danced in her seat. "This is better," she yelled over the full-bore buzz. "I love this song. What kind of music do you like? What's your name? Turn right again."

Again, I lowered the volume. "We're driving back to Broadway. My name is Flummoxed, because I never know what's gonna happen next. I like all kinds of music when it's played on a decent system. Are you aware that we are heading back to where we started?"

"Yeah, Broadway, make another right on Broadway." She held Hulky and boogied him, down and funky, on her lap. "I wanna buzz the street cause I'm lookin' for somebody. Then we can go to a place I know. What's your name really?"

"Scot. Who is it we're looking for, and what happens when we find them?"

"I just wanna see 'em, that's all." She turned the music back up and bounced on the seat like she needed to pee. "Get in the other lane. Over there, over there." She pointed to a couple of guys and a girl. The girl I had seen earlier, on the curb, in my first pass.

The guys were white with shaved heads and obtuse, testosterone-flushed mugs. They wore tattoos and muscles.

Following WeeGee's directions, squeezing through traffic to the edge of the curb, I posed a question she couldn't hear above her own excitement. "Why am I doing this?"

"Don't stop!" she yelled. "Get close but don't stop!" She snapped her gum, and without warning, she stood up on the seat, putting her upper half out the open passenger-side window, and loosed a scream that had pedestrians a block away turning to look. She had Hulky by one leg, swinging him around in circles like a drive-by pillow fight. She screamed a second time and then a third.

I goosed the gas, for what little pickup the Toyota could muster, grabbed WeeGee by the hem of her short skirt, and yanked her back inside. "Get back in here with Hulky," I yelled. At the nearest corner, I turned right, went a quarter block, and pulled to the curb.

She plopped down onto the seat. "Here, give me that." I nabbed Hulky and put him on top of my camera gear in the back. "You can't be taking chances with Hulk Hogan. He's a very important person."

"That was so awesome," she whooped. "Buggy didn't know what was goin' on. You should a seen his face. His eyes were all big." She was twitching with excitement. I was a little buzzed myself. Suddenly she screamed again and opened the door. Her friend jumped into the backseat and told me to goose the gas. "Go," she said. "Go, go, *go*. Get out of here quick!"

No one was in the rearview mirror, but I pulled away from the curb anyway, cruising, again past Union Station. The new passenger in the backseat was plain and broad and acne-scarred. She wore thick makeup, and she was the same bundle of energy as WeeGee. They communicated in noisy unison. WeeGee cranked

the radio again; another current top forty, Los Lobos's "La Bamba." Both girls were go-go dancing. I turned it down. The new girl leaned up between the seats and cranked the music back up. I reached over and turned it off.

"What'd you do that for?" this stranger in my car asked. "That was a good song. What's wrong with you? You don't like music?"

"I like it fine, but I can't think when there's too much simultaneous shit going on."

"I knew you were going to say that," WeeGee said. "I told you I'm a psychic, didn't I? And I knew you were going to say that."

"I wish I could do that," her friend said. "'Cause I would have known that you was gonna drive by with this pillow thing." She had Hulky in her arms. "What is this thing?"

Reaching back with my free hand, I took Hulky and set him in my lap, where he hindered my steering abilities but was safe from further abuse.

The gals danced without music and squealed like little kids on a playground. I drove out of the hub to a less populated area, pulled into an empty parking structure, backed up into a spot, against a steel and concrete wall, cut the engine, and stretched my frame. Closed my eyes. Took a deep hit of oxygen and shook the muddle from my head. I said, "Much fun as I'm having here, I need to get back to the subject at hand. I'd be glad to take you back and drop you wherever you want. Or, if my money's still good, I remember something about a twenty-five-dollar hand job."

WeeGee's friend said, "You ever make it with two girls at once? For five hundred dollars, you can have twice the fun." She leaned forward and massaged my shoulders. Her hands felt good.

"Five hundred, huh? Seems a bit steep."

"We get five hundred all the time, isn't that right, WeeGee?"

WeeGee was not as convincing as her friend. She blew a

rubbery bubble, pink as a pornographic bull's-eye, popped it with the chewed nail of her right index, and said, "Uh, yeah. We do that all the time. Sometimes a thousand dollars."

"Wow, that's a lot and I'm sure you're worth it, but it's over my budget and besides, there is only so much the three of us can do in the car." Taking a twenty and a five from my wallet, I dangled it. "I'll stick with the twenty-five-dollar hand job. How's that, Weezie? Are we still on?"

"WeeGee," she said, taking my money. "Like one of those things that you ask questions to. Those eight-ball things." She rubbed my inner thigh, prepping me for the procedure.

From the backseat, WeeGee's friend said, "You go ahead and do it, I'll just hang back here. Can we turn the radio back on?"

I put the radio back on at a sensible volume. Kim Wilde singing a disco version of "You Keep Me Hanging On." WeeGee pulled her shirt up over her breasts. The mood seemed ill-suited for sex, but I relocated Hulk Hogan to the backseat then unbuttoned my pants anyway. Somewhere, back on Broadway, the magnetic thrill of illicit sex that first pulled me to the curb had lost its force. But I was there and it was the moment and a release would be a healing thing.

WeeGee climbed to her knees and leaned her body into mine, plugging the space between the seats. She pushed her breasts into my face and took my sex in hand. She got busy and I tried to relax and enjoy it. The other girl was dancing about in the backseat, singing along with the music. Ahead of us cars drove by. Seeking escape I closed my eyes but then the passenger-side door opened.

"Don't worry," WeeGee's friend said quickly, "it's just me. I'm gonna go ahead and go now." I couldn't see her; my vision was

eclipsed by a close-up of WeeGee's nubile breasts. Her naked skin was nice on my face, but she lacked finesse in the art of male masturbation. I was trying to picture Sylvia, bound and gagged, and wishing I had my twenty-five dollars back, when WeeGee's friend shut the door behind her and I had a sudden epiphany. I jerked away from WeeGee, opened my door, and jumped out running. WeeGee's friend was a couple of yards away with my camera backpack over her shoulder and Hulk Hogan in her arms. She did not attempt to run. She handed me my belongings. I said thanks and walked back to the car, my deflated penis leading the way.

Back in the car, prim and proper under the yellow dome light, WeeGee was defensive. "I didn't have anything to do with that. I didn't know she was going to take that stuff. I don't even really know her."

"That's alright, I don't care."

"Really, I mean it. That's why I'm even still here, cause you paid me and you didn't finish yet."

I buttoned and buckled, pants and belt. "Really, I don't care if you knew or not, it doesn't matter. Besides, you had to know about it because you know about everything before it happens. Anyhow, you don't need to finish my hand job. I got a better idea."

"What kind of idea? I'm too high-class to do funny shit, mister."

"I wanna take your picture."

"I knew you were going to say that."

"I figured you did, but I said it anyway." Turning in the seat, I leaned to the back and pulled the backseat down flat, creating a station-wagon stage. "I want you to get back there and let me take a couple of pictures." I got my Nikon and Vivitar 283 flash, slipped it on the hot-shoe, and turned it on. It screamed like a mosquito.

"You gotta give me more money," she said. "I already gave you a hand job and it's not my fault if you didn't come, so if you want to take pictures of me you gotta give me another twenty dollars."

"Yeah, okay." I reached for my wallet, took out a ten, and handed it to her. "Here's ten bucks; I'm keeping the other ten because it's only half my fault that I didn't come."

"Okay, but you can't show my face. Someday I'm gonna marry a really important rich guy. You can take my picture for ten dollars, but you can't show my face. Because if you do, then someday you could blackmail me."

I picked up the bear mask and gave it to WeeGee. "Here, wear this." I turned on the dome light and checked out the composition through my 35mm to 105mm zoom lens. It wasn't wide enough, so I traded it for the 28mm wide-angle from my bag. She put on the mask and climbed into the back. She pulled up her top to again expose her breasts. I suggested a comfortable pose and took three pictures.

She told me I was only supposed to take one picture for ten dollars, and I told her yeah sure, coaxed her into another pose, and made three more exposures. When we finished, I parked my camera, lens down, between my legs, and drove WeeGee back to a corner, on Broadway, where her friend and the two guys had congregated. Her friend refused to meet my eyes. The two guys scowled and the taller of the two bugged his eyes. "See you round," WeeGee told me as she climbed out of the car and joined her clique.

"Okay," I told her. "Have a nice day."

I drove back to the train station and parked across the street. Taking Hulk Hogan from the back, I buckled him up, in the front, then I smoked some reefer and took on a buzz. Picking up my camera, I looked through the lens and put frames around compositions but didn't make any exposures.

*

I'm a second-generation photographer. My father owned and operated a successful portrait and wedding studio in Springfield, Missouri. He photographed a lot of brides and babies and made a nice living. From the time I was old enough to stand on a chair and drop exposed paper into developer trays, my father groomed me to carry on this fine tradition. But it didn't work out. Life in the Ozarks was too restrictive. It made me nervous. I was a mass of tics and anxiety.

I was seventeen in 1967. College was not an option as I had proved myself an idiot in high school. I wanted to travel, grow my hair long, take massive doses of drugs, and get laid a lot. I wanted to be someone other than myself, and I wanted all those I left behind to stagnate in that fucking hick town while I became a legend. Neal Cassady was my ideal; Richard Fariña and J. P. Donleavy were the world's greatest writers. I figured I could go crazy for a few years and then write about it. If that didn't work out I could always come back home and take over Sothern's Studio. So I hit the road and headed west looking to become all my crackpot heroes, irreversibly beatnik.

Things didn't really work out the way I'd hoped, and I never really made it back home to run Sothern's Studio. I did, however, survive the previous twenty years with a camera in my hands, eye to viewfinder, jumping from one freelance gig to the next, with long gaps of unemployment. It's not that I lacked talent as a photographer; I had a shitload of talent. But business, and the concept of money, were a complete bafflement. Plus, I had a hair-trigger self-thwart mechanism that sprang into action whenever success nudged my way.

Now, as I watched a train pulling into the station across the street, an idea formed: I could photograph street prostitutes and

put together an exhibit and a book. A few bucks and a healthy cult following would serve as my goal and motivation. Human nature goes screw-neck at schadenfreude, and dirty pictures are always topical. I could make fine-art, silver-halide social commentary; maybe I could write little stories to go with the pictures: Iceberg Slim meets E. J. Bellocq. I could be exactly who I wanted to be, and money and recognition would fall from the sky. It was all just another marijuana fantasy, but then a prostitute walking the curb grabbed my gaze, and our eyes said hello. She put her head into the open passenger-side window and said, "What're you doin' here all alone? You lookin' for a date?" Her timing was perfect and my fate was cast.

"Hey, good-lookin'," I said. "You wanna be a model?"

She was a few years older than my previous pickup, and she was black. Her skin was smooth. She had a nice face and a hairdo like Motown soul. Her eyes were sleepy. She wore a tight leopard-skin top and a short white miniskirt.

She climbed into the car and we haggled then settled on thirty dollars for a tasteful photo shoot. We didn't talk much. I found a private alleyway with a chain-link fence backdrop. We got out of the car, and I took ten medium-wide-angle photos of her in cheesy pinup poses and various states of undress. The flash-head popped and opened up the shadows. She was sexy and playful and I got an erection.

Back in the car, we again negotiated, settling on a twenty-dollar hand job. She went about the task like she was pulling weeds. It was not what I had hoped for. I took her hand away and made a request: "Kiss me."

"I don't kiss nobody except my boyfriend."

"I'll give you another ten bucks."

"Give me it first."

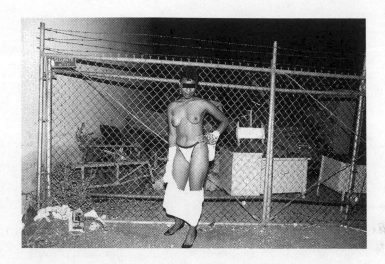

She kissed me with juicy open-mouth passion, and I closed my eyes and masturbated to completion. For a few elongated seconds, my inner voice howled with pleasure, and then, just as quickly, a cold flop-sweat of depression broke out. I took the hooker back to her corner and put my camera into my backpack.

A recurring dream for most of my life: I'm back in Springfield and I've inherited Sothern's Studio; I'm attempting to remove an exposed roll of 120 Kodak VPS color negative film from a Hasselblad camera and I keep dropping the film, watching it unravel. My pop, who was a newsreel photographer from Southern California, in the army during World War II, had big dreams of success as a Hollywood portrait photographer. He trained at Paramount Studios, along with his buddy Russ Meyer, who later became the king of soft-core porn. Somehow, though, my father fucked up after the war and ended up in Springfield, where he became a big fish in a small, stagnant pond and pined for the life he didn't make for himself and his family. And with that, he always felt that I should accept my limitations as he had his; otherwise, I was doomed for a life of broken dreams. Once, in high school, I told him I wanted to be a writer when I grew up. He

gave me a heartfelt pat on the shoulder and told me I wasn't smart enough to be a writer; I should stick with small-town photography, babies and weddings, high school graduation portraits. Sometimes, in the intervening years, it seemed he was right.

※

Pulling into Sylvia's drive, I parked and sat with the radio singing softly in the background. Reviewing current events, pondering the immediate future, I'd spent ninety-five dollars for twenty frames of exposed film and a kiss. Fifty dollars remained and I had nothing coming in; I would need to mooch money from my friend Gus. Dashiell, my birthday boy, and I were going to Santa Monica for five days and nights, where I would stay sober; not smoke pot; keep my secondhand cigarette smoke aimed at open windows; play games in the park; fix scrambled eggs, peanut butter and jelly sandwiches, and macaroni and cheese; read bedtime stories; make silly faces; tell absurdist jokes; feed and bathe and tuck in my son; and each night lay my head down next to his. Yet, with all the peace, love, and joy of five days with my son, I was already looking forward, with anticipation, to the close of our precious time together, when I would return Dash to his mother and I could load my Nikon, take twenty or thirty bucks, and pick up a prostitute, make some art.

I went into Sylvia's without knocking. Her boyfriend, Joe, was there. I liked Joe. Joe was affable. He fixed cars for a living. A sports event of some kind was on television. Joe was watching it from the corner of his eye. He had a roll of paper towels in his hand, wiping up a drippy red and white mess from the couch. It looked like strawberry yogurt.

"Hey, Joe," I said, "where ya goin' with that paper towel in your hand?"

Joe always seemed happy to see me. I amused him. "Hey, Scot. How's it goin'? You been watching the game?"

"I don't really watch sports," I explained. "Seems like everyone in San Diego assumes the world pays attention to sports stuff. I find it kind of bizarre. I walked into a 7-Eleven the other day, and the guy behind the counter asked me, 'What's the score?' like I would automatically know what he was talking about."

"Oh yeah? What'd you say?"

"I don't know. I guess I said, give me a pack of Kool Box. I just thought the assumption was goofy, you know. People thinking we're in the same tribe and speak the language."

"Yeah . . . He was talking about the game. What day was that?"

"I don't know. Doesn't really matter."

"You don't follow football?"

"I don't follow sports."

"It was probably the Chargers."

"Yeah, I think it was."

"Chargers lost."

"Bummer."

I motioned to the mess he was haphazardly sopping up. "Accident?"

Joe grinned. "Sylvia threw a tub of yogurt at me."

"Oh yeah?" I laughed. "One time she threw a half a cantaloupe at me, got me in the side of my head."

Sylvia came into the living room from the kitchen, and without a trace of malice, she said, "Hi, I'm glad you're here." Her mood had shifted into good, and I had cooled down a bit myself.

"I'm glad you're glad," I said, also without malice. "Where's Dash?"

"He's in the tub. You can get him out and dry him and dress him in his pj's and make sure he brushes his teeth. I don't think

he brushes his teeth when he stays with you. It's getting kind of late anyway; why don't you stay here tonight and sleep on the couch? Dashiell's just going to go to sleep in your car anyway. You guys can go up in the morning. I've got a movie, *Matewan*. A John Sayles film, supposed to be good."

She wanted me to hang around for a while. She didn't want to be married to me and she didn't want to sleep with me, but we still shared commonalities, and she preferred my conversation to Joe's.

"No, thanks. I've already got my mind set to go tonight, and it's too late to reverse the gears."

"You want a cup of coffee? I just made a pot. I thought you'd want a cup."

"Thanks. I'm going in to say hi to Dashiell. Will you fix me a cup, please?"

Sylvia went to the kitchen. Joe sat with the wet, wadded paper towel and watched the big game.

Dashiell sat in the lukewarm tub playing, bringing to life an army of plastic action figures. He was far from the real world, captivated within his own imagination, and in that respect, as well as others, he confirmed my worst fears: he was me. He was a third-generation dreamer. When he saw me, he smiled and so did I. I folded to my knees, hugged his little wet body, and kissed his clean skin. His fingers and toes were pink and cockled, like an old man's face. I said, "How's it goin', Boo Boo?"

"Where's Hulky?"

"He's out in the car waiting for you. I'm gonna get you out of the tub in a minute. I gotta take a dump first."

I sat on the crapper without taking off my pants, as though I had forgotten. I pushed out a loud fart, then feigned a look of surprise. "Oh, no! I forgot to take off my pants!"

Dashiell probably didn't really find it funny, but he laughed anyway. He was a sweet boy. He indulged me.

※

Back in the car, on the 5 Freeway, I had a headache from not eating and my bladder was ballooned with recycled coffee. Dash sat, buckled up, with Hulky in his arms. While neither his mother nor I had ever, would ever, raise a hand to Dashiell, he seemed somehow braced for blows. Anything less than a smile on his face made me feel guilty, anxious, and inept. I reached over with my right hand and gave him a love pat. He took my hand into both of his and curled into nap position.

"I'm gonna need that hand to drive, Bonehead."

"It's mine," he said, and didn't let go.

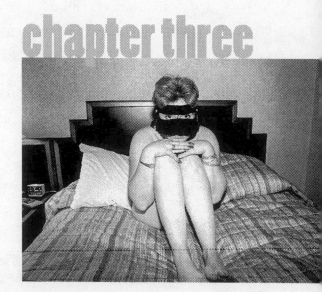

chapter three

room service

1986

I got a call from a media production company. Apparently they got hold of my résumé, and apparently, they didn't run a background check. It was an easy gig. They flew me to a resort hotel and paid me $250 a day to photograph a five-day corporate conference. They had seminars and motivational speakers. Luau Night, Back-to-the-Fifties Night, Awards Night. Shooting long rolls of Ektachrome with my Nikkor zoom and Vivitar flash, all

I had to do was focus and pull the trigger. Kapow kapow. I flirted with the gals, clowned with the guys, and mostly kept to the sidelines, burning film, documenting the dorks at work and play.

On the morning before Awards Night, I gave the edited slides to the AV guys, who loaded eight carousel trays and added music: the theme song from *Rocky*. That night, in the formal dining hall, after drinks, dinner, and the awards ceremony, we dimmed the lights and projected the film-positive highlights on a jumbo screen. The audience reaction was good. Primed with drink, they whooped, laughed, and pointed at themselves like carny rubes at a nudie show. When the lights came back up, I feigned humility and fended high fives. The party was just starting, but my job here was done.

I'd been doing these jobs for a while; a couple of months earlier I'd taken a gig at a resort hotel in the Missouri Ozarks, close to my childhood home. I'd asked my father to drive up and see the big show, sat him at a table up front. Afterward he said, "I enjoyed that, but you know, Scotty boy, it's just a real shame you quit the portrait work." In my twenties, as a portrait photographer, I had been competitive with my pop. I wanted him to tell me I was better at it than he was, but that was never going to happen. It was time for me to let it go. It no longer mattered what I thought of his work or what he thought of mine. We both loved photography and we both loved each other. We sat up late that night talking shop—Arnold Newman, who I loved; Yousuf Karsh, who Pop loved; Edward Steichen, who we both loved.

Our relationship was mostly good, though there were times when it had been tested. In the late 1970s, after a few sketchy years making portraits in Florida and Los Angeles, I was looking for a place to hide and came home to Springfield. I was twenty-nine and busted. This was my final attempt to live the proper

life and move into the family business. My father owned the downtown building that housed the studio and a restaurant next door. Upstairs thirteen rooms with a kitchen and bathroom—an old empty hotel that had been closed for twenty years. I moved in.

We were close, my pop and I, but the timing was bad. I was still drinking and drugging and I wasn't yet finished with the sexual revolution. Plus, I'd decided I was not just a photographer anymore but an artist—making a living was somehow embarrassing; I was ill at ease at Chamber of Commerce luncheons. For my father's part, he wasn't ready to share the money he was making and didn't feel I could contribute enough to make up the difference. He was also on wife number four, a hillbilly idiot who didn't like me any more than I liked her. Frictions arose and I was back in Los Angeles nine months later. For a few years afterward I felt like we were a couple who had broken up. Now the air was clear and we were good.

※

Before leaving Awards Night after the slideshow, I stopped at the open bar and got two double shots of scotch, which I took up to my room. I left the drinks on the table, then went back down to the other open bar and got two more doubles, which I took back upstairs to my room, then went back out for a bucket of ice. I drank an icy drink and smoked some pot. I took a shower and put on the hotel bathrobe. I retrieved a piece of paper with a phone number from my wallet and made an outside call.

"Friday's Child Escort. This is Gloria. How may I help you?"

"I need to be escorted."

"Could I have the number you're calling from? Have you booked an escort with us before? Could I have your name please?"

I supplied the information, and she told me an escort cost fifty dollars for the first half hour and fifty dollars for each half-hour after that. They didn't take checks but they did take credit cards.

"Alright, sure. What's the time frame?"

"Someone will call you in the next fifteen minutes."

"Okay, thanks."

I had time to kill so I sat and looked at the walls. Earlier in the week, upon my arrival, I'd met the corporate coordinator and her husband, the activities director. They were the team that hired me and told me what to do. Her name was Janet. She was in her late twenties, five two, plump, wacky in a suburban-world way, very cute and very sexy. She tingled my wiener. She liked to flirt and so did I. Her husband's name was Larry. He was thirty or so, tall, tan, energetic like a cheerleader, and 100 percent homosexual. He liked to flirt as well, though he was more covert. He played, with a great lack of thespian skill, the part of a heterosexual male. Larry and Janet held hands a lot. They exchanged feel-good looks, and their love was firmly on display. But there was no way they were doing each other, and I got the feeling they both wanted to do me.

※

On day two we had activities galore, which I recorded with an eye toward the amusing. We began with a breakfast buffet. Next, a motivational performance and talk by an Olympic medal winner and his pommel horse. He gyroscoped over and around the horse, like a chimpanzee, while explaining the path to championship. I photographed the action on the stage, then made my way through the tables, grabbing audience reaction shots. At the back of the dining hall Janet studied a clipboard while watching the show. I

leaned on the wall next to her and checked my camera and flash sittings. She smiled at me. I pointed my nose at the guy in a spin on the stage. "Can you do that?"

"Not anymore, I can't. I did gymnastics in high school. I could still do some of it. How about you? You're built like a gymnast."

"It's just a disguise. The only part of me that's limber is my face."

"Well, you look in pretty good shape to me."

"Thanks, so do you. I'd rather watch you do gymnastics than that guy. I could get motivated watching that."

She blushed but didn't hide it. "Maybe when I was in school I would have been something to watch, but not now. Not until I trim down."

"Au contraire, you don't need trimming. You'd look great up there, twirling and jiggling around, maybe in a leopard leotard."

"Jiggling around? Should I say thank you or eff you?"

"I'll take either one."

"I'm not sure, Scot, but I think maybe you're a little over the line for no better than you know me."

"Oh? Well, sorry. You're fun to talk to. I get carried away. You're the boss. I mean no disrespect."

"Yes," she said. "I am the boss and it's time for us both to get back to work."

That afternoon, at an athletic field, the rah-rah minions, men and women in casual clothing, all looked like the same person. They played some sort of running and tagging game with a gigantic air-filled ball and a red flag and a green flag. I twisted my zoom lens from the periphery and froze the fun and frolics in the viewfinder. On the sidelines, whistle on a lanyard around his neck, white T and gym shorts, tennis shoes and crew socks pulled up nearly to his knees, was Janet's husband, activities director Larry.

"You getting a lot of good pictures?"

"Yeah, I think so." I took two quick shots of some doink in a baseball cap waving a yellow flag.

"I'm a bit of a photographer myself, though just an amateur. Nothing like what you do. I don't think I have that kind of talent."

"Just between you and me, what I do is not all that hard."

"Would be for me. Seems like a pretty good job; you probably travel a lot. And you're on your own, you know. I mean, I just think you probably have an interesting life."

"Not really, Larry, my life's not all that interesting." I raised my camera and took a picture of two doinkettes in a victory dance, waving a green flag. "I mean, look at what I'm doing now."

Larry laughed. "That's kind of what I was saying. You find this job boring, yet for me, it's the most exciting thing I do."

"Yeah, well. I'll tell ya, Larry, the most exciting thing I do, I do at home alone."

"I don't get much time home alone. You know, Janet and I spend a lot of our time together. We're like best friends. We're happy and everything, you know. I mean, now and then, I need a little room."

"You mean like time alone with someone else, for covert activities?"

"That, yeah, sort of, you know, just something different once in a while. I can't believe I'm telling you all this."

"Well, I try to be a good listener, and I got a trustworthy face. I mean, hey, Larry, tell me your darkest secrets, I'm here for you."

"Uh, thanks, uh . . ." He looked into my eyes, then blushed and looked down at his feet. "Sure, maybe, ah, Scot. You're just joking. Anyhow, I kind of need to get back to work. I guess."

"Yeah, me too."

Larry took the whistle, which was nestled between his pecs, and blew it, then walked out onto the field, telling me so long. I took his picture and told him see you later.

❈

In Room 678 the phone rang.

"Did you call for an escort?"

"Yes I did. Would you be she?"

"My name is Rhonda. What is it, exactly, you want?"

"I need about an hour's worth of physical affection."

"I can give you a massage, but that's all I can agree to over the phone."

"No problem."

"It costs seventy-five dollars for thirty minutes, in advance."

"Yikes. Either the price keeps going up or that includes your tip."

"If you want to tip, that's up to you. But it's seventy-five dollars in advance before the tip."

"Yeah, alright. How long till you get here?"

"Maybe twenty minutes, maybe sooner."

I said au revoir and iced another drink, my last, until my hireling had come and gone, as a drink too-many would put me in the No Climax Zone, which would be a waste of seventy-five bucks plus tip. I sat and waited, killing time with career retrospection.

When I was young, photography was just what my father did to make a living, and when I learned to make images, as he taught me, I learned how to make likenesses, portraits that flattered and had little to do with the subject. But alas, as I got older I found that a real portrait revealed a real person, and I didn't know how to go about making a living if I was making paying customers

look like assholes. Nowadays, I was spending money on whores, making pictures that no one really wanted to see. So to feed myself and my habits, I sucked in my snobbishness and squandered my talents shooting corporate slide shows.

※

My third night on the job, Thursday, after an AV show of new product line entries, and after dinner was served, I walked around the banquet room snapping pictures of the round-table groups. The drunks made goofy faces and the shy looked down at their plates.

Janet and Larry sat together at a table, next to the dance floor, with another couple. Janet and Larry were laughing and smiling. I took the empty seat between them. Janet introduced me to the other couple: Bob, a company man, and Pam, a company woman. Bob worked at East Coast HQ. Pam called Southern California home. They both wore wedding rings. Their manner suggested a fling.

Pam wore too much makeup and giggled in the middle of her sentences. She spoke to me. "I hope you"—giggle-giggle—"don't think we're always this crazy." She crossed her eyes to demonstrate just how crazy they were.

"Crazy is kind of a relative thing," I said. "I just automatically assume everyone's insane pretty much all the time."

"That's us alright." Giggle-giggle. "That's why we have these big wingdings. So we can let it all out for a few"—giggle-giggle—"days, and forget about all the crap. You know what I mean, some people just don't know how to have a good time. But not us. We're here to be as crazy as we want, gosh dammit." Giggle-giggle.

Pam seemed a bit crazy. No wonder she was fucking the dork, Bob. Her head was exploding.

The table went quiet for a bit while we collected our thoughts, and I think we were all thinking about sex. I moved my right leg to rub innocently against Janet's left leg. She reciprocated in kind. On my left Larry moved his right leg to accidentally-on-purpose brush against mine. I didn't really reciprocate, but I didn't move away. Across from me, Pam's left hand was underneath the table, and the corners of Bob's mouth were gathering drool.

Janet said, "You know what, Scot? I think what you really think is that we're just a bunch of dorks."

"No, no, not at all."

"Yeah, right. If we were all back in school, we wouldn't be in the cool crowd you would hang out with."

"If we were all back in school I'd drop out."

Larry laughed as though he wasn't sure if he should be laughing or not. "You know who you remind me of?"

Larry had my attention now, and I could feel Janet breathing on the back of my neck. "Who do I remind you of? Mick Jagger, Lee Marvin?"

"Tom Waits. Do you listen to Tom Waits? I'll bet you do."

Janet gave me a turn-around nudge. "We love Tom Waits."

All too often, people who hardly knew me told me I reminded them of Tom Waits and assumed I was a fan. I had, therefore, yet to give Tom Waits a listen. "Thanks, I'll bet Tom Waits has more fun than I do."

Larry jumped back in. "I think you have fun, maybe not like a rock star, but you're an artist like he is; he's a music artist and you're a visual artist. It's art, what you do, you know. You have to have a creative eye."

To date, Larry had never seen any picture I'd ever made. "Let's not get carried away, Larry. You might want to see some of the pictures I've been making before you call me an artist."

"I can just tell," Larry said. "I wanted to be an artist when I was in school. I used to draw pretty good. I used to imagine I was a starving artist."

"Cool, good for you. I've had that fantasy myself."

Now, Janet put her hand on my upper arm and turned me around to her. She said, "I don't care if it's art or not; you'd better be taking good pictures here, or you'll be facing up to me, and you have no idea what that can mean."

"That's hardly incentive, but if I require censure, I'll take it like a man."

Larry took my arm and twirled me to him. "I've seen these shows, like what you're doing. How do you choose the best pictures for the show?"

"I throw all the slides in a box and pull 'em out like lotto balls." I was the center of attention; it seemed they were competing for me, and I wondered if this might be a game between them.

Bob and Pam were bored with all-about-Scot-the-photographer so they hit the dance floor, the Bee Gees, "Jive Talkin'."

"Well, I should get back at it," I told Janet. "I'll see you later. If there is anything you need, you know, for the show, just let me know. Room six seventy-eight."

I stood and gave Larry a friendly pat on the back. "You too, Larry. Six seventy-eight."

"Will do," he said and gave me a little wave.

I walked out to the dance floor and found Bob and Pam. I took pictures that could easily be used for blackmail.

※

The phone rang.

"This is Rhonda. I'm downstairs."

"Great, come on up."

"Are you alone?"

"Yeah, sure. Why?"

"I just needed to know for sure. My boyfriend is with me. He's going to stay in the car, and he'll be calling to make sure I'm alright."

"I don't see a problem."

"I'm on my way up."

I loaded Tri-X into my camera, slapped on the 28mm lens, slipped the flash into the hotshoe, took $150 from my wallet, and divided it up in my bathrobe pockets. I treated my dry lips with a dab of Blistex, which gave me a nice little mentholated sting. I gave my nostrils two squirts each of Dristan nasal spray. I'd had a cold the month before, and not being able to sleep with blocked sinuses, I'd overdone the number of sniffs per day, and now I was hooked. Every couple of hours, my nasal passages closed until I took another hit. I carried it with me like a monkey on my back.

Now I was ready for an illegal tryst and the question here might be, why was I ordering in when I could be frolicking naked with Janet for free? The unfortunate answer: I blew all the promise of a naughty one-nighter last night; Janet had slipped from my hook and fishtailed away.

⁜

It was Back-to-the-Fifties Night. Hotdogs and hamburgers and baked beans and macaroni and cheese. A good third of the group were dressed the part with poodle skirts or cuffed Levis, ponytails and greaser fins, duck-butts. Up on stage the band wasn't playing oldies. The band wasn't even there, though Janet was.

Her aura was flat. She was talking—no, she was yelling at an underling as well as a couple of hangdog guys hauling a Wurlitzer on stage. I climbed the stile to the stage and overheard "Did you

book Sha Na Na or not, because they're not here. At least I don't see them; I don't hear any live music. I don't hear any rock and roll. I seem to remember writing a check. Maybe you could explain where that check went, because I don't recall ordering a jukebox. I paid for a band, Sha Na Na." The guy was defeated, yet he made a last-ditch effort to redeem himself. Unless I heard wrong he said, "Fuck you," then turned and walked away. Janet's face was crimson.

I should have walked away instead of lighting up my smile and opening my mouth. "Communication breakdown?"

"What?"

"Problems?"

"You might say that."

I circled and winked. "I get the feeling you could use a little tender care."

Janet walked up into my face and took a deep breath. "I like you fine, Scot. And I hope you are doing a good job here, though I really have no idea. Maybe your picture show will be just one more disaster. Because I've got to tell you I haven't seen you do anything other than flirt. I take my job seriously, and I wish you would do the same. I've tried to be friendly, but you seem to think my friendliness is an open invitation into my pants. I am stressed out right now, but that's beside the point. And if I need someone to make me feel better, I have a husband." She raised her left hand to give me a gander of her wedding ring. "So if you will excuse me, I don't have time for this. I have a job to salvage."

I said, "Gee, I'm sorry. You're right and I'm wrong. I didn't mean to offend . . ." I was talking to myself. Janet had taken her leave.

<center>※</center>

Earlier today and during the awards ceremony, we passed and cir-cled without so much as a nod. Even Larry had become weary

of me and wouldn't meet my gaze. And so here I was; Janet and Larry were history. Rhonda, the hopefully happy hooker, however, was tap-tapping at my door.

I opened the door and ushered her in. She said, "I'm Rhonda."

"I'm Scot."

She was a sizable woman, a couple of inches taller than me, avocado shaped with a nice face and pretty eyes. She was dressed in jeans and a blue sweatshirt with a ZZ Top logo. Her scent was Ivory soap, and her voice was soft with a tinge of back-home. "I need to collect the money from you before anything else."

I gave her five twenty-dollar bills. "Twenty-five of that is for you and nobody else."

"Thank you. I need to use the phone."

I sat on the bed and copped bits of her phone conversation. I heard her say one hundred dollars, which meant she wasn't keeping her twenty-five but turning it over to Pimp, Inc. Pissed me off.

Rhonda cradled the phone and sat next to me, close and with a soft hand on my thigh. "What can I do for you, Scot?"

"A straight fuck is fine with me, but first I'd like to take a couple of pictures."

"No, no way. I can't do that. What's going on, anyway? What do you need pictures for?"

"I don't really expect you to trust me, but the pictures are for me. It's not like you're going to show up in a magazine. It's just something I like to do. I'm a frustrated artist. I can pay a little extra."

"You can't photograph my face."

"I have a mask you can wear."

"A mask?"

I had spent most of 1983 in Saudi Arabia and brought home a handful of women's burkas. I carried one of these with my photo

gear expressly for this moment. "Yeah, it's a mask the women wear in Saudi Arabia. Hold on a sec, and I'll show you." I dug the mask from my backpack.

"This is kinda weird. I'm not feeling too good about this. Maybe I should just go."

"No, no, no, don't do that. Seriously, a straight fuck and a couple of pictures and that's it. Here's an extra twenty bucks."

"I guess so, but I don't have any tits."

"You mean they've been removed or you were born without nipples or they're just small?"

She smiled for the first time, pulled her sweatshirt over her head to show me the situation. She said, "They're tiny."

"They look great to me, seriously, my mouth is watering."

"Yeah right, and I'm a *Playboy* centerfold. You want me to take off my jeans?"

"Yeah, sure, take off your jeans, Miss October. And here, the mask. If you want I can help you tie it in the back."

Her pants came off to expose another layer of cloth, black panty hose. "I don't really feel all that good about being all the way naked. I don't look all that good for pictures."

"You look great, believe me, you're stimulating. But, no problem, keep the panty hose."

She held up the Bedouin mask. "Can I put this on at the mirror? Can you help?"

"Sure."

Across from the beds, two twins; a long desk with a chair; bureau drawers to the left and right; a large mirror centered up top; television on the left and table lamp to the right. Rhonda stood at the mirror while I tied the ties at the back of the mask. She played with her hair. She said, "No offense, but you don't look like you belong in this hotel any more than I do. You're different."

"Yeah, well, I'll take that as a compliment. Fact is, I cultivate that difference."

"Where you from?"

"Los Angeles."

"S'oky if I ask what you're doing here?"

"I got a gig taking some pictures. You mind if I ask what you're doing here?"

"What do you mean?"

"You're no run-of-the-mill druggie. I figure maybe you got a story, you know. You can tell me it's not any of my business if you want. And don't get me wrong, I'm not making judgments, I'm making conversation."

"I don't mind. My boyfriend, er, me and my boyfriend need to make some money. He, ah, we, there's just some stuff we need to get."

"Yeah, I can relate."

"Do I look alright?"

"You look terrific, you look hot. Let's go ahead and take a couple of pictures. Do me a favor and climb up here." The desk top.

I gave her a hand up, gathered up my camera, twisted off the zoom lens, and replaced it with the 28mm. I attempted an eye-grabbing composition. She folded her arms to cover her breasts. "I don't know what to do. You need to tell me what I'm supposed to do."

"You don't need to do a thing except look at me. Yeah, that's good, just like that. You look really sexy. I mean it." I took a picture but the shutter speed didn't sound right, so I adjusted the exposure and took another picture. "You really look great. How about if you give me a little wiggle and a peak at your tits. Just a couple more. Beautiful, beautiful."

She started a dance, kind of a slow-motion Marilyn Monroe; wiggle and mug. It was nice. I took more pictures, telling her that's

great, you're really hot, I'm falling in love, and hard as a hammer. After eight pictures, I set the camera on the bed and took her hand, helping her down. "You want me to keep dancing?"

"Yeah, sure."

"You want to slow dance with me?"

"Seriously?"

"Uh-huh."

"Okay."

I reached around her hips, slipped my hands under her panty hose, and pulled her close. Her skin was soft and cool.

She said, "You know how sometimes no matter how hard you try, nothing ever feels good?"

"Yeah, sure, I guess. I think so. I don't know. Maybe."

She put her arms around my neck, her head on my shoulder. The silence was overwhelming. We stayed, swaying, and slowly rubbing body parts, for a couple of long minutes. She said, "You're a pretty nice guy."

"I think so," I said. "Are your nipples sensitive?"

"I don't know, I mean yeah, sure."

I leaned down and put my mouth over a brown nipple and massaged it with my tongue. My penis parted the curtains of my bathrobe.

She said, "Who's your friend?"

"I don't really assign names to my body parts. Though when I was a teenager I named my dick Chunky, after a candy bar. They had a commercial on TV: 'Big, big, big, big, Chunky / Open wide for Chunky.'"

Rhonda laughed. She took my penis in hand and handled it with care. I closed my eyes and wondered if she were momentarily transported to a nice place, and figured probably not. Either way it felt pretty good to me.

After a while, Rhonda said, "We're kinda running out of time. My boyfriend is gonna be calling pretty soon, and I'll have to go. So if you want to have sex we should go ahead and do it."

"If it's alright with you, I'd like to take a couple more quick pictures."

"Okay, but we gotta hurry. What do you want me to do?"

"How about if you climb up on the bed and jump up and down."

"Really?"

"Yeah, really."

"I'm going to keep the mask on, but I don't need to wear my panty hose anymore if you want me to take them off."

"Yeah, sure, that'd be great."

She peeled off her panty hose and climbed on the bed and jumped up and down like a little kid. I took four pictures.

"Okay," I said. "That's great, I'm all done."

She sat and settled in the center of the bed, holding her knees. I kneeled on the floor, up next to the bed, took a couple of close-up pictures, and told her she was very pretty.

"I'm wearing a mask."

"Yeah, well, I have X-ray vision and your eyes, your eyes are . . . I can't think of the word I want, but it's better than beautiful."

She smiled and the Bedouin mask looked happy. She said we should hurry up, do the deed. I agreed and climbed onto the bed. She rolled onto her back and opened her legs. She said, "Big, big, big, big Chunky."

Taking a rubber from my backpack and rolling it into place, I crawled between her legs on my knees. "Open wide for Chunky." The phone rang. "Shit."

"That's Len, my boyfriend. He's going to make sure I get more money because we've gone past the time limit."

I got to the phone on the third ring. Rhonda said, "He's going

to want to talk to me."

I grabbed up the phone.

"You need to talk to your son."

"Uh . . . Sylvia?"

"I'm giving the phone to Dashiell."

"I'm at work, Sylvia. I can't really talk—"

"Daddy."

"Uh, hi, sweetie. What's going on?"

I could hear Sylvia in the background: "Tell your dad what you did."

"I flushed my bathrobe down the toilet and flooded the bathroom."

Rhonda was gathering her clothes from the chair where she had draped them. "I gotta go before Len comes up."

I missed what Dash had said. "Hold on a second, Bud. I got someone here. I'll be right back. Hold the phone, okay?"

"Hold on," I told Rhonda. "I still want to do what we were going to do. It's my son. I've gotta talk to him for a little bit, but I won't be long. Don't go yet." I picked my bathrobe up from the floor and took out my last twenty and gave it to Rhonda.

"Yeah, but Len's gonna be coming up. You don't really want that. Believe me."

"It's fine. I'll deal with that when I have to."

"That might be a mistake."

"Just hold on a few more minutes. I just have to talk to my son. He's only four and he kinda needs me to talk to him a little bit." Now back to the phone, "Hey, sweetie, I'm sorry. How come you flushed your bathrobe? What's the deal?"

"I'm five years old, not four."

In the background: "Your father doesn't know how old you are?"

"He knows." Dash defends me to his mother. "He was telling

someone."

In the background: "He has somebody there, in his room?"

"Uh-huh."

"Tell your mother it's none of her business if I have someone here with me."

"Really?"

"Well, no, not really. It's after nine o'clock. How come you're not in bed?"

"I couldn't sleep. That's why I flushed my bathrobe."

"I'm missing the logic there. Are you okay? Is your mom mad at you?"

"Uh-huh." He was starting to cry. I could close my eyes and see the tears on his cheeks.

Somebody knocked on the door. I said, "Shit," and so did Rhonda.

She said, "That's Len."

I said, "I'll get it."

She said, "I don't think you should. I think I should."

I knew she was right, but for some reason I didn't listen. I said, "Please, just let me take care of it."

I said, "Dashiell, sweetie. I'm gonna hang up, but I'll call you back in five minutes."

"Okay."

I put down the receiver, and at the same second, or possibly the second before, I realized I was hanging up on my son, who at that very moment needed me, who, at that very moment, was crying. I said, "Fuck," then I said it again only louder.

Rhonda picked up her clothes and went to the bathroom leaving the door partway open.

My penis had petered out; the rubber held fast but drooped like a sausage casing. I picked up my bathrobe and put it on. I walked

to the door and opened it, ready to face a pissed-off pimp. Janet stood there holding a bottle of red wine and two glasses. I said, "Uh-oh."

Janet said, "I've come to apologize." The wine was half drained. Her purple lips and wobbly equilibrium told me this wasn't her first bottle. She was drunk and horny.

I said, "Uh . . . I accept your apology."

"Well then, I guess you want to invite me in."

"Huh? Oh. Ah. Uhh."

"Are you alright?"

I was saved from answering, but not for the better. Someone was stomping down the hallway like Godzilla. I leaned out the door and took a look. I had no doubt that it was Len. The bad guy. He was about my size, but looked a hundred times meaner. His hair was long, orange, and greasy. His face was white as a marshmallow with freckles, red hot, like dashboard cigarette lighters. His eyes were light blue and signaled madness and doom. He passed us without a glance, but then, at the next door, he stopped and read the number, then walked back to us, shoved me aside, and yelled into the room, "Rhonda, you have about ten seconds to get out here."

And from the bathroom: "I'm coming, Len. Two secs more."

Now he turned to me. "You owe me some money."

Janet said, "What the hell?"

The telephone started ringing. I said, "Excuse me, I gotta get this call."

Janet was quick to tell me, "You're not leaving me out here with this guy."

Len grabbed the lapel of my bathrobe and leered at Janet, up, down, and back up. He licked his lips. He said, "You a workin' girl? You maybe need protection services?" He jabbed his chin up close

to Janet's face. Janet stumbled back and would have fallen had I not grabbed her upper arm. Len still had my lapel. We were all connected, but not in a nice way. The phone continued to ring.

Len leaned back into the doorframe. "Rhonda, I'm waiting, and I shouldn't be."

Janet addressed me directly, "What in hell is going on here? Just who the hell are you?"

"Who? Me?"

"You owe me some money, sport."

Rhonda came out the door. She handed me the mask. She said, "He doesn't owe us anything, Len. We're all straight."

With the flat palm of Len's free hand he smacked the back of her head. "We better be all straight, you fuckin' mutt."

The phone stopped ringing. I said, "Hey, hey, you don't need to be doing that."

He smiled at me. I wanted to hit him but didn't stand a chance. He let go of me, took a hold of Rhonda, and pulled her up the hall to the elevator. Rhonda gave me a pretty smile and a two-finger wave good-bye. Janet and I were alone. I said, "Hey, how's it goin'? You wanna come in, have a couple drinks, unwind?"

She turned and walked down the hall and vanished behind the stairway door. I put on the Bedouin mask and went inside. I looked at my reflection in the mirror. I walked in circles and said, "Fuck, fuck, fuck, fuck."

I dialed Dash. Sylvia picked up before the second ring. "I'm really sorry, Sylvia. Things here got out of control. Let me talk to Dashiell."

"He's in bed."

"Shit, goddamnit. I'm really sorry—"

Sylvia hung up.

Into the bathroom, I took a leak and flushed the condom. Removing my mask, I threw cold water on my face. I mixed a drink, smoked some reefer, and turned on the TV. For the half hour, I went through the channels without landing anywhere for more than a couple of minutes. Someone knocked at my door. I pulled it open.

It was Larry. He had a bottle of wine and two glasses. "Hey, Larry," I said. "I'm glad to see you. Come on in."

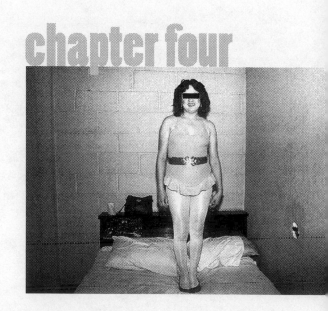

chapter four

borderline

1987

Every Sunday night, I drove Dashiell down to La Jolla and sur-
rendered him to his mother. Hugs and kisses for Dash. Overdue
child support, acrimony, and fuck-you-too for Sylvia. It wasn't
easy, saying good-bye to Dashiell; he clung to me, teary-eyed, as
though I was going to leave and never come back. Sylvia blamed
me. I'd been an absent parent for three years, then left for good
when she and I broke up. She said it was separation anxiety

because he couldn't trust me. I said it was because he didn't want me to leave him with her because she was a bitch.

South from La Jolla's ocean-view opulence, through San Diego's well-scrubbed middle; thousands upon thousands of white Republicans in running shorts and baseball caps, lower and lower, to Alamo stucco and down, down, to border town Tijuana, Mexico.

In my wallet: four hundred dollars and three fat joints. In my backpack: my Nikon FE2 with the 28mm lens; my Vivitar flash and four extra AA batteries; three rolls of Kodak Tri-X; a small ibuprofen bottle with four Vicodin mixed in; four packs of Kool Kings; a tube of Blistex; a squirt bottle of Dristan; six condoms.

In San Ysidro, a San Diego suburb hinged to the Mexican border, I parked in a large numbered parking lot and paid with enough quarters, dropped into a slot, for two days. I sat in the car and smoked half a joint, put $160 in my pants pockets and the rest in my socks. I locked up the car and went walking.

San Ysidro, at least the part going into Tijuana, was a kinetic mass of cultural mutts. Adverts on every surface: dog racing, jai alai, bull fights, dance clubs, Mexican car insurance. I stopped at a McDonald's and fueled up with burgers and fries.

Two or three years back, an angry man with an Uzi, a shotgun, and an automatic pistol walked into a San Ysidro McDonald's and murdered twenty-two people. With little time to contemplate the enormity of his spree, the guy died when the San Diego Swat Team took telescopic aim and put him down. Could this be the same McDonald's? I imagined everyone in the place dead on the floor.

At the border crossing, long, impatient lines going north, and all clear going south. Mexican border police waved the Americans

onto their foreign soil while the border police on our side gave everyone shit, as though they deserved it. When an American crosses a foreign border, he or she feels superior to the natives; it's an inbred response. Collectively we believe we are not just better, smarter, more sophisticated, but also somehow more human; our pain sensors more sensitive, our cognition less abstract.

A corkscrew foot bridge crossed over to the other side, poverty and piss stink, bruised Detroit clunkers and yellow cabs bouncing through potholes, maneuvering around pedestrians. I donated my coinage to a leather-faced old women on bended knees and tatterdemalion kids hawking papier-mâché piñatas. I wasn't here to improve anyone's living conditions, but still charity was soul cleansing and a pocketful of change was better than a rude gesture.

My first trip to Mexico was in 1968, when I was eighteen years old and still had youth as an excuse. America was coming apart at the seams, and while my political rhetoric called for Molotov cocktails and Bob Dylan, my contributions to the revolution amounted to not getting a haircut, not getting a job, shoplifting, drug use, and the constant pursuit of all things sexual. I'd ditched Missouri and was bumming room and board from a friend in Santa Monica—not much different from the way I was living now, nearly twenty years later, bumming from another friend in Santa Monica.

On the first trip, my friend Kelly and I, bored with loitering and panhandling on the Sunset Strip, had decided to thumb to Yuma, Arizona, where we could bum off another friend, Steve, and cross the border to San Luis, Mexico.

I had met Steve a couple of times before, in Los Angeles, and for me, it had been love at first sight. Not gay love; there was no lust involved. It was all about idol worship. I wanted to be Steve. Steve was dark and tall and thin with broad shoulders, long black hair, and a beautiful chiseled face with the straightest and whitest teeth I'd ever seen. He smiled a lot. When he saw me applying Blistex he bummed a little white squirt for his own lips and I told him, hey yeah man, that's cool. He rolled perfect joints with a twist at each end, which he would bite off with an audible pop. He wore a Mexican serape, tight jeans, and stovepipe boots. Steve was a desperado who smuggled kilos of pot into the U.S. of A. He was the ultimate new American hero.

Our first day in Yuma, Kelly and I met Steve's best friend, also named Steve, who had just been released from prison, where he had done nine months on a burglary and assault rap. Now he was partnering up with Steve as a marijuana sales and service rep. Steve the jailbird was big and ugly and scary.

Steve and Steve represented a great misconception of the times; they flashed peace signs and raised power-to-the-people fists. Steve the idol drove a funky 1949 Ford woody station wagon with a bumper sticker advising love it or lose it! Steve the jailbird had a great droopy mustache and wore tie-dyed shirts and a fringed suede jacket. But a year from now, he would be back in lockdown. Steve the idol would be a junky living on a mattress on the floor in some guy's garage. His white teeth turned gray. This was the swinging 1960s, full of criminal intent and moral vacuity under a banner of peace and love. I was caught up in the romance when Steve the idol suggested we go to Mexico and smuggle a couple of kilos of pot back across the border.

That night, we crossed into San Luis, Mexico, in Steve the idol's woody. Steve and Steve in the front, Kelly and me in the

back. We went from two-lane blacktop to dirt and ruts and back through time down a main street of saloons and Mexican cowboys and poverty beyond any I'd seen in my inexperienced youth.

❊

Nearly two decades later in Tijuana, I engaged my radar and walked through a gauntlet of black velvet paintings—matadors on tiptoe butchering bulls, naked Mexican maids with pink DayGlo nipples, Elvis the pelvis, and surf's up. Three-walled stalls selling sandals, boots and jackets, ceramic kitsch. Five minutes of walking brought me to a red-light neighborhood of ramshackle discos and bagnios, garish in primary colors and flickering lamps. Whores, pimps, pushers, corruption, and vice. The busy weekend foot traffic was mostly gone, but business was still open and at bargain prices. Beautiful sad-eyed women hawked souls and holes from dark doorways.

In a small nondescript bar, I creaked a barstool and ordered a shot of tequila and a beer. Other than the bartender, the place was empty. He pushed a buzzer, and from a swinging door at the end of the narrow bar, a working girl came out. She sat next to me and we grinned at each other.

She scooted in close, rubbing her body against mine, and asked me, in Spanish, would I buy her a drink? I motioned to the bartender, who brought her a beer. We clinked containers and toasted circumstance. The low-grade tequila kicked and clawed all the way down. I gritted my teeth and held on to the bar.

The girl was young and cute and kind of shapeless. She wore a belted leotard with a ruffled flounce at the hips, and shining white tights. On her cheeks, she wore round, red circles of rouge like a toy soldier. I inquired as to the price of an orgasm, which she told me was a steal at fifteen dollars.

In a back room, I negotiated a photo session, which she allowed but only fully clothed. I took three pictures, two of her standing next to the bed and one standing on the bed, her arms aerodynamically flat to her sides. We had no-frills, animatronic safe sex. I tipped her an extra five and said adios.

※

In San Luis, Mexico, with my friend Kelly and the two Steves, going to a prostitute still came with bragging rights; it was a cool thing to do. Steve the idol and Steve the jailbird, however, had a marijuana smuggling enterprise to attend to, so they dropped Kelly and me off at a swinging-door saloon. Inside, a Mexican rock band covered the Blue Cheer rendition of "Summertime Blues." I bounced when I walked. I was an outlaw on the lam in Mexico. I wished all the losers back home could see me now. Looking down at myself, from the rafters, I looked just like Steve the idol.

Going with the first woman who approached me, I gave her my last six bucks. In her little room, down a long hallway at the back of the bar, she lubricated herself with some kind of goop, wiping the residue on the bed sheet. She climbed on a cot, onto her back, and lifted her skirt. She wore a garter belt hooked to black stockings with nothing in between. Only once before had I seen this view of a garter belt and stockings: in a black-and-white pornographic film in the back room of a motorcycle shop, where I hung out in high school. A woman had sex with a German shepherd dog. I tried not to think of that now.

Somewhat at a loss, I undressed, then stood there gawking, like a kid from the Ozarks, until the hooker took charge. She rolled a condom onto my tumescent penis with the stoic professionalism of a nurse threading in a catheter, then pulled me

onto the bed and positioned me between her legs. She turned her head away, chewed gum with her mouth open, and grunted in rhythm with her only other moving part; her sex, automatically, up and down, in and out. Afterward, I wished I had my six dollars back. Going in, full of hope, I had been fulfilling a fantasy. Coming out, I wanted to hide somewhere and cry. Back in the bar a guy at a table grinned at me. "Hey amigo, hippie boy," he said. "Was she better than a big dog?" I forced a laugh that made me feel even more like a moron than I already felt. At the bar I bummed five bucks from Kelly and attempted to drink my ego back in place.

※

In Tijuana, 1987, after a few shots of tequila, after my liaison with the girl in the belted leotard and ruffled flounce, I was feeling happy and reckless. I walked half a block to a brightly lit nightclub whose outside walls displayed glossy photos of the naked girls inside. I pulled aside an orange leatherette curtain and went in. An elevated stage down the center of the room, one long wall with the bar, and a dancing girl in the spotlight. Around the stage a half-dozen U.S. Marine inductees drinking, carousing, luring the dancing girl up close with dollar bills. "Keep Your Hands to Yourself" by the Georgia Satellites played loud, through bad speakers. I took a seat and ordered, from a bar girl, two tequila shots and a Budweiser. My deviate radar was turned on, and it was clear to me the dancing girl was a guy, though nobody else seemed to notice. She had a mound of curly hair, high cheekbones, and a sad smile. She was up on high-heel pumps and wore a see-through baby-doll over smooth skin, perky tits, and bikini panties.

I drained the first tequila shot and nursed the beer. The second shot went down without pain. It unclenched the arthritis in my

neck and shoulders. It felt wrong and it felt good. I motioned to the bar girl for two more, then walked back to the hombres' bathroom. A door into permanent stink, a long communal pisser across the back wall. A Mexican guy taking a leak. We peed and he laughed and said something friendly in Spanish. I laughed along. "Yeah, sure," I told him. "There's a place in France where the women wear no pants." I buttoned my jeans and took the second half of a joint from my wallet. I fired it with my Zippo and shared it with my amigo.

Back in the main room I took a shot of tequila and sat at the stage. The dancing girl was still dancing; the music had changed to T. Rex and she had peeled down to a G-string. I really couldn't see much room for hiding a penis but then maybe it wasn't all that big or difficult to maneuver. She humped her pubis only inches from the wagging tongue of a young military recruit who was having a very good time. He seemed to believe the dancing figure was a real girl, and I saw no good reason to ruin his fun. Another tequila shot arrived, courtesy of my bathroom buddy now sitting at the bar. I gave him a salute and sucked it down.

When the dancing girl came my way I took out a ten-spot and tucked it safely into the top of her G-string. She sat on her spiked heels, leaned in whisper-close, and kissed my nose. She told me twenty dollars more would buy "fuck suck good-time."

The drink, the pot, the boisterous atmosphere, my flickering aura; I was morphing into Mister Hyde. Soon I would be howling. I saw it approaching and let it come. I took another shot of jet fuel and it burned all the way down.

The dancing girl picked her clothes up from the floor, a bikini top, tight silver slacks, a thin fluffy robe. I helped her down from the stage and she got dressed and took me by the hand, leading me back outside. The jarheads whooped and laughed and wished

me good luck. A taxi was waiting at the curb. The cabby got out and opened the door for us; she got in and I followed. The driver hopped back in and pulled from the curb. There was no meter. "Hold on a minute. I need to know where we're going and what it's going to cost me."

He said something, something, amigo, which wasn't good enough for me, so I opened my door, ready to bail. He said no, no, no, no, and the dancing girl said no, no, no, no, and I told him in a universal language I needed a set price or I was getting out. The dancing girl and the driver huddled, then the driver told me five dollars. Okay, fine. I closed the door.

With sign language and occasional Spanglish, the dancing girl told me twenty dollars was due and payable. I explained I was a cash-upon-receipt kind of guy, and she shrugged and put her head on my shoulder, a hand between my legs. A few minutes later we pulled up in front of a little court of facing rooms with a well-worn path down the middle. The taxi driver turned around and told me twenty bucks. Yeah, sure thing, hombre. I gave him a five. I climbed out to the sidewalk and the dancing girl came with me. The driver was also out of the cab, telling me I still owed him fifteen bucks. I was drunk enough to take a poke at the guy if he fucked with me, and he must have seen it in my eyes because he gave up the fight. I glanced up the street and realized the bar we had come from was two doors down; the cab was only three of four spaces up from where we had started; he had driven me around the block. The irony wasn't funny enough for twenty bucks, but he had earned the five from sheer audacity.

We walked into the courtyard. To the left a guy at a window counter told me seven bucks for the room, which was a rip-off, so I counted out six and put it in his palm, holding back a single in mild protest. There are no signs of warning at the U.S. border

reading EVERYTHING BEYOND THIS POINT IS A RIP-OFF, ENTER AT YOUR OWN RISK, but I had budgeted for it. Besides, it was only money; if I didn't throw it away here, I'd lose it somewhere else. Once inside the room, the dancing girl started dancing. In the distance a clarinet wept.

I gave her twenty dollars and she started a striptease. I took out my camera and let her know we were here for a photo session, not sex. My flash and focus set, I got her up on the bed and took aim. Totally naked she looked like a real girl. She kept her upper thighs together and when she turned, to give me a shot at her butt, she made a quick little adjustment with her hands. Abracadabra.

We communicated with pantomime and gestured words. I took pictures and, after a few shots, told her I wanted to see her dick for a couple of exposures. She responded with indignation, which I deserved; if she wanted to be a girl and the rest of the world saw her as a girl, it wasn't my place to be outing her.

She kept explaining, she had a pussy si, si, she had a dick no, no.

I said I was sorry, I had made a mistake. Anyone could see she was all girl.

Smiling again she let me know that for another twenty she would get me off in whatever method I chose.

"Thanks just the same," I countered, "but I got off just a little while ago." I was happy enough with the pictures, and I said thank you for being such a pretty model.

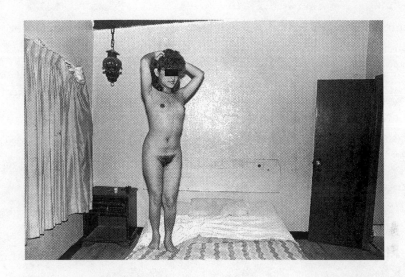

My bouts of hard drinking began in my early adolescence and reached a peak in my late twenties. After I married Sylvia, and Dashiell was born, I stopped drinking to excess. Now that I was divorced and on my own again, I was back at old habits. Alcohol consumption did not make me feel good; it didn't make me witty and relaxed. It changed me, the way a full moon makes a werewolf howl, into a wildly irrational asshole. It made me stupid and sick. Yet, here I was, a premeditated drunk, losing my grip, glass by glass.

My next stop on my Tijuana sojourn was The Chicago Club was in a weathered, barn-like building, painted globular orange with a marquee of red and blue neon dancing girls. Inside, a cement dance floor, wobbly tables and booths, green, yellow, red: posters and more posters, walls of cryptic art. A long bar. Bar girls. Small groups of couples sitting around, a dancing girl in a leotard. I walked to the bar and ordered two tequila shots and a beer. Music played, accordion, trumpet, violin, laughter, long polka lyrics, lazy inebriated musical notes floated about.

A young woman with a pleasant face, a big smile, and luscious

zaftig curves appeared next to me. She said her name was Lupe and I was very handsome. Would I buy her a drink?

"Hi, Lupe. I'm Scot." I patted the strip of plastic tape over the cracked vinyl seat cushion next to mine. "Please join me. Señor Bartender, a drink for the lady and another shot for me." I dug my camera outfit from my backpack and looped the strap around my neck. Lupe spoke English well with an accent that was easy enough to follow. She wondered aloud, Photo-graphy?

"Yeah, photography. How'd you like to be a model?"

She told me maybe and maybe not.

The bartender brought our drinks, which I paid for, leaving the small bills on the table. Lupe lunged forward in a nice way and, putting her arms around me, kissed my neck, cuddled in close, and proposed marriage: "Scot marry Lupe. Lupe marry Scot."

"Yeah, that's what I need, another wife."

She agreed, si, si, that's exactly what I needed, another wife. "Lupe wife, Scot handsome husband."

"I don't know, maybe we should get to know each other a little better first."

Lupe said why wait? She was already crazy for me, in looove.

"I love you too, baby. Let's raise a glass to love, marriage, and a baby carriage." I took a shot. I was fully inebriated, hopelessly, reeling in place. I took Lupe's hand and gave it a gallant smooch. "Let me take your picture. Look at me and tell me you love me." I raised the camera, but Lupe pushed it back down and took my hand and, placing on her left tit, told me, "Scot love big boobies."

"I like all kinds but at this moment I like yours the best."

Lupe opened her shirt, pulled down her bra, and presented her breasts for my appraisal. Scot did indeed love her boobies. She took my head in her hands and pulled my face between her round, brown *pechugas*. I stayed there for a while, submerged in

boobs; it was dark and quiet. Calming. I rose, slowly, to the surface and went for my camera. Lupe leaned back, grinning and laughing, offering her chest for a close-up. I took a picture.

I said, "You're great, sweetheart. Go ahead and put 'em away; let me buy you another drink."

The world was fuzzy and I was comfortable. I was drunk, shouting above the music even when it wasn't playing. I figured I could sit here with Lupe as long as I kept buying the drinks.

Lupe scraped her bar stool closer to mine and scooted her butt closer yet. She slung an arm around me and kissed my stubbled cheek. Again she proposed marriage, suggested we tie the knot and move to America, where I lived, and by the way, where did I live?

"Hard to say right now. Santa Monica, La Jolla, Interstate Five."

She told me she didn't really live in Tijuana but far, far away.

"Like once upon a time, far, far away?"

Si, si, she told me, Mexico City.

In Mexico City she had a ten-year-old boy and a seven-year-old girl. She told me their names, but they didn't stick. Rummaging through her handbag produced snapshots, black-and-white but

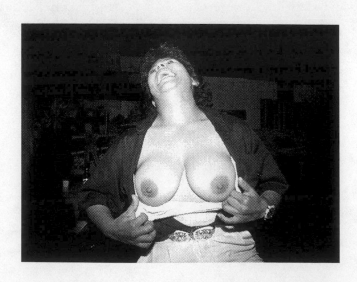

more befitting of a sepia tone. The boy wore a white T-shirt, denim jeans, and simple huaraches. He was standing on dirt in front of a tumbledown barber shop, stiff, over-aware of the camera. His eyes burned with anger or maybe it was despair. The picture was worn and wrinkled and added lines to the boy's face, like a depression-era Walker Evans. The girl was dark with Aztec cheekbones, long black hair, bottomless eyes, and a disappointed smile. Though only seven, she was dressed in ruffles and lace with bare legs and midriff. She was sensual in a way that embarrassed me, especially in the presence of her mother. "These are nice," I said and handed the pictures back. "Nice kids. You must miss them."

Oh, si, si, she did miss them, but if we got married she could bring the whole family to America.

"Yeah, well. I'm not collecting medals for supporting the child I already have."

She took my left hand, pulled on my ring finger, scrutinized it, inquired, niño . . . wife?

"At the moment I'm not married, no ah, esposa, is that right, esposa means wife? I've got a little boy, a niño, Dash, but I don't really want to go into that right now."

Lupe went back into the folds of her bag and brought out a pencil and a scrap of paper. She wrote down an address on Revolution Boulevard, pointed the direction and repeated a couple of times, "Revolution Boulevard, Revolution Boulevard."

"You want me to come see you? Where you live?"

Si, si, she wanted me to come stay the night with her. Get happily ever after.

"Maybe."

She told me to wait, "Scot, here, right here," and with that, she gave me a big sloppy kiss and departed to the ladies' room.

I put my head on the bar for a couple of minutes or maybe an hour. The universe engulfed me in a rising tide. Somewhere above me a mariachi band played and some guy sang "Blue Moon" in Spanish. Azul Luna.

※

After my first sexual experience with a Mexican prostitute, in San Luis with my friend Kelly and the two Steves, after being searched of body and car by the customs police, we crossed back into the United States. We went to an all-night restaurant and waited. I queried as to what we were waiting for and Steve the idol explained: while in San Luis, after depositing Kelly and me at the saloon, Steve and Steve had gone to meet their connection. They had purchased two kilos of Mexican brown for thirty dollars. Next, they had gone to a popular dance club frequented by underage teenage Americans who could legally drink in the border-town bars. Steve the idol, with his good looks, charm, and radiant smile, had met a girl who had crossed over from Yuma with a group of friends. The girl, most likely drunk, gave Steve the idol her phone number, which he would never use, and her address, which he would. She had crossed the border, she told Steve, in her parents' new Cadillac. Steve bid her adieu and then, with Steve the jailbird, located the Caddy parked close by, covertly popped the hood, and stashed the marijuana inside. Now if the group of girls were searched at the border they would get busted and Steve and Steve would be out thirty bucks. If they crossed without being searched, all we had to do was wait until they were back home in bed and then open the Caddy's hood and retrieve the dope. And now, that's what we were waiting for.

I regained consciousness with my head on the Chicago Club bar, sat up, and looked around. There were fewer people in the place. The bartender brought me a shot and a beer, telling me, on the house. Gracias, Señor. I rubbed my face for a while, then hit the tequila. Lupe hadn't returned, and I had a feeling she was no longer in the building. I got up and stretched and walked into the ladies' room and looked around. A young girl with a curly mass of hair and a bumblebee leotard followed me in, took me by the arm, and led me back out. She said Lupe was gone and she was here to take her place.

In the hombres' room I took a leak and smoked part of a joint, which filled me with a new energy and put the blood back in my legs. Back in the main room a live nude girl danced a slow hoochie-coochie. A young Mexican guy had staggered out to the dance floor and gone to his knees in worship. His friends in a booth on the sidelines whooped and whistled and encouraged him onward. I brought out my camera and turned on my flash and started taking pictures. The kneeling Mexican made crazy faces. The nude girl made sexy faces.

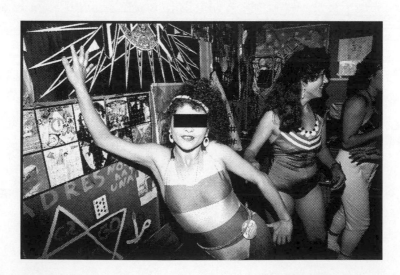

At the end of the set, I followed the dancer into the dressing room where a few girls, including the bumblebee, were hanging out, taking turns at the makeup mirror. I started taking pictures, posing the girls, laughing, flirting, hugging and kissing, making friends. I was whirling, happily vertiginous. No one was asking for money; we were taking fun pictures. A little goofy-looking guy from out of nowhere posed with one of the girls, then asked would I let him take a picture of me. I gave him my camera, and with a girl on my right and another on my left, we all said cheese.

A big guy came into the room to appraise the ruckus. He had twenty years on everyone but me. He was the straw boss. He told me no more pictures, told everyone else whatever he told them, in his native tongue. The party broke up and the boss demanded, with outsized gestures, I leave the premises. When I objected, he walked to a nearby closet and came back out with a baseball bat, to which I replied, "Adios, amigos and señoritas."

Outside I walked a block, then sat on the curb. I fired a smoke and drank from a bottle of mescal I'd lifted on the way out. I blinked in and out of consciousness. Somewhere a rooster crowed. I knew I had to get back on my feet. If I stayed here, sodden with drink, I would get robbed or thrown in the hoosegow. I got up and started walking. I stumbled by a teenager leaning on a post. "Acid, speed, marijuana, mushroom."

I hit the brakes. "How much for a dose of mushroom?"

I gave him a twenty and he gave me a baggie with a couple of good-sized 'shrooms. I took Lupe's address from my pocket and asked him to point me toward Revolution Boulevard. I pocketed the mushrooms and went back to walking, following the pusher's point. Again the rooster crowed through the otherwise silent night, and then again and again, echoing, from no discernible direction.

I'd never lived on a farm, but still, somehow, the rooster reminded me of home. My youth. Cock-a-doodle-do. Cock-a-doodle-do. Cock-a-doodle-do. I drank. And drank. And drank. I got a cigarette, lit it, and blew smoke rings. I took side streets where not a happy soul stirred. Here and there glimmering shadows evaluated my ineptitude. I stumbled forward and whistled "I'm Popeye the Sailor Man." I blinked but my eyes didn't open back up. I was in a little fishing boat puking over the edge into the wake of a speedboat. I jumped awake still walking; the rooster crowed. I checked behind me and saw the teenage pusher who was either following me or just happened to be coming this way. I tilted back my head and drank from the bottle of mescal, daring the pusher and the whole fucking world: Come and get me. I came to a man who was perched, haunches on heels, on an overturned trash barrel. He crowed like a rooster. He was the rooster. I stopped and watched as he crowed again and again. He looked up at me and said a paragraph that made no sense, then went back to crowing.

I put the flame of my Zippo into my face attempting to light a roach and slammed into a phone pole. I saw stars, a psychedelic light show. Down the block, the pusher was still coming my way. My eyes were kaleidoscopes. The pusher was joined by a hundred other pushers. They all held hands.

※

I was throwing up in a porcelain bowl. Somewhere. Jail?

Someone kissed me, and I swirled and swirled and swirled and rolled onto the floor.

Leaves were blowing, and a kid I knew in my childhood pelted my head with dirt clods.

The curtains were on fire, and I yanked them from the rod and stomped them out.

Someone was whistling, every little breeze seems to whisper Louise.

I was spinning into fragments and yelling: And you and you and you and you.

❋

A truck's air-horn honked, long and loud, from somewhere down below. I opened my eyes, and sunlight kicked me in the head and cranked up the tinnitus. My bowels were boiling. I was in a hotel room, in a bed. A chest of drawers, a sliding-door closet, a window without curtains above a small, pockmarked desk on which sat a wad of burnt cloth. Out the window, utility lines, a neon marquee blinking boots . . . boots . . . boots. On the walls a low-rent paint job. Attempting to reel in my senses, I held my head in my hands, searching through lost memory. Where was I?

A closed door going to a bathroom. I could hear the shower running. A night table on which sat a reading light and a framed picture of a couple of kids. Lupe's kids? Yeah, Lupe's kids.

A shot of anxiety broke through my nausea. I checked my pants pockets and found a single quarter and a baggie with a couple of psychotropic mushrooms. I checked my socks, stuffed in my boots on the floor, and found $250 safe and sound. On the floor, next to the bed, my backpack. In my backpack, everything that belonged in my backpack. From my backpack, I fumbled around and found medicine. I took out two Vicodin and four ibuprofen and staggered across the room to three bottles of Arrowhead water. I washed down the drugs and drank a bottle empty; I snorted six hits of Dristan, lit a smoke, and sat on the bed. I looked at my watch. Noon.

When Lupe came out of the bathroom, she wore a white towel turban, a red towel sarong. She leaned on the door frame and

considered me with neither a smile nor a frown.

"Hi, Lupe. How's it going?"

She told me I had arrived, loud and crazy, sometime in the night. She said I had set the window curtains aflame attempting to light a candle and a reefer. I had climbed out to the fire escape and heaved an empty bottle of mescal into the center of the street as a police car was cruising by. She said that as the sun was coming up, there had been cops in the building knocking on doors, but they had somehow passed hers by.

I apologized, telling her I was so very sorry; maybe I should leave now, and let me give her fifty bucks for all her trouble. Now she was frowning, angry, but almost teary-eyed. I had insulted her by offering her money. She was a bar girl, not a *puta*. No, she didn't want me to leave. She told me to take a shower. "Thanks," I said gratefully and gave her a kiss on the cheek. She smelled of soap and rain forest.

In the bathroom I sat on the crapper and voided my sick bowels of yesterday's folly. I was mortified by the sounds I made and the thick stink that would surely find its way to the other room. The water pressure was weak and the hot water soon went to cold, but I stayed. I soaped and rinsed and shampooed my hair. I took Lupe's toothbrush from the sink along with a green worm of Crest toothpaste, climbed back in the shower and scoured my teeth, brushed my tongue. I sat on the tile floor, closed my eyes, and let the cool water rain down on me. My stomach was pretty fucked and would be for the remainder of the day, but the meds were kicking in and my headache was slowly leaking down the drain. I don't know what I thought about.

When I finally came out of the bathroom, I wasn't wearing anything. Lupe was in bed, naked beneath a thin sheet. She motioned me to join her. I climbed in and we kissed for a while,

gently exploring. I took a dip downward thinking I might give her a few laps but she headed me off and pushed me away. Good Catholic girls were not to be pleasured orally. Besides, this was all for me, though I had no idea why I deserved it. I reached for my backpack and took out a condom. As I tore away the foil wrapping and went to put it on, Lupe told me no, she didn't want me to wear a rubber. But rules were rules.

I put on the rubber and positioned myself between her legs. She held my penis, and gently squeezing, guided it into place. With the first stroke, I knew she had rolled off the condom and I suppose I could have stopped but I didn't. She worked out a rhythm and did elevator kegels up and down my shaft. My brain melted. For a moment or two my body didn't ache and my stomach didn't gurgle and then I was spent.

I smoked a cigarette in bed, then got up and dressed. I was irritated by Lupe's condom snatch but saw no point in making it an issue. I asked her if I could take some pictures. Yes, I could, but not before she got dressed. She was not the same person who had laughed and paraded her tits in front of my flash last night. She was shy and serious. I waited for her to get dressed, then took a couple of shots, realizing too late I had overexposed and possibly double-exposed the final frame on the roll. I let it go.

Lupe took me to a funky little restaurant where we had fried eggs with beans, rice, corn tortillas, and a mug of coffee. She told me a story about taking her kids to a sidewalk puppet show where one of the hand puppets, from the curtain's edge of the portable stage, had kissed her daughter on the nose. She talked about her sister, Marie, who was still in Mexico City, where she took care of her baby and Lupe's two kids. Marie always made people laugh when she made funny faces, so I made funny faces at Lupe and she laughed.

Lupe gave me a pencil and paper, asked me to write down my phone number and address. I tried to explain how I didn't really have an address and how I was pretty much a freeloader and not exactly eligible for long-term relationships. She told me she was probably pregnant from our tumble less than an hour earlier and therefore we should get married. I used condoms as a shield against terminal disease; the thought of a pregnancy had never entered my head. I said I was really sorry and I guess I hadn't been communicating all that well, and besides, I was impervious to blackmail but here, take this, it's a hundred and fifty dollars, you get pregnant, buy yourself an abortion. She took the money then called me something vile in Spanish and slugged me, fast and hard below my left eye. When my vision returned she was gone. I drank two more cups of coffee.

I took a cab to the Greyhound bus station and bought a round-trip ticket down the coast to Puerto Nuevo, a seaside village. Before getting on the bus I went to a little market and bought a large bottle of soda water. I smoked some pot and ate the magical mushrooms. On the bus, in a window seat, I watched an unfair and unforgiving world go by. Here, on the borderline, was the squalor, the downtrodden, the weak, the uneducated, the stereotypical third world that I exploited with my pictures. This wasn't really what Mexico was, where Mexico is.

It was, however, where I was, what I was.

<p style="text-align:center">※</p>

Nineteen years earlier, in Yuma, Arizona, at four in the morning, Steve the idol parked the woody away from the street lamps in a neighborhood of tract homes. The Cadillac, with two kilos of marijuana under the hood, was back home, though it was parked in the garage and the garage door was closed and locked. The Steves

decided the best approach would be to break into the garage. Steve the idol threaded the handle of a claw hammer through a belt loop. Steve the jailbird did the same with a tire iron. I asked if the implements were for breaking the lock, and Steve the idol laughed. "The lock is easy, man. Don't need nothin' for the lock. This (the hammer, the tire iron) is in case anybody wakes up." Steve the jailbird added to that, "I'm not goin' back to fuckin' jail, man. I'll kill somebody before I go back to fuckin' jail."

And so I sat in the car and thought about a guy I knew back home in Missouri. He had sat in the car as two friends (who I also knew) broke into an auto body shop where they robbed the till of less than a hundred dollars and then shot and killed the sleeping night watchman. The guy who sat in the car was tried, just as the other two were tried, for murder, and he got twenty years. I didn't want to spend twenty years in jail for sitting in a car. Twenty years from now I wanted to be rich, maybe even famous. I vowed to cultivate a better class of friends, to spend my time more wisely.

Steve and Steve were back, in ten minutes, with the jackpot, which we took to Steve the jailbird's apartment and broke into ounces and smoked joints until long past sunup. Two days later Kelly and I hitchhiked back to Santa Monica, and I began looking for new idols.

※

I departed the bus to the shores of Puerto Nuevo, high on psilocybin. The sky was sunny but cool; a wet sea breeze washed the stale bus smells from my face. Puerto Nuevo was famous for lobster dinners: all the little critter tails you could eat, along with beans and rice, for around nine dollars. On a walkway of red

hexagonal tiles, I passed by the bright, vibrating colors of shack-like stalls filled with clothing, piñatas, and sombreros, to a row of restaurants with giant lobsters painted on dirty-white adobe walls. Signs and prices in English and dollars. Linoleum floors and tabletops. Mariachi bands strolling about.

I chose an eatery for later, then took a hike to the beach, where I sat in the sand at the edge of the Pacific and watched the curve of the earth as it rolled forward in time. I was stiff and tight and willed the sun to melt the ice in my shoulders and neck. I inhaled cigarettes and dosed with painkillers. The 'shrooms were fully dissolved into my brain, and I laughed out loud to myself because I had no one else to laugh with.

Boots off, I walked to the water and became fascinated with the waves washing over my feet, the sand moving beneath me, lowering me into the earth. Back on solid sand, on my back, I closed my eyes, looking for peace. I dreamt Richard Avedon discovered my whore photographs and arranged a big exhibit in New York.

I was far, far away when I heard children. Five barefoot kids in rags walked out of a cloud and into my line of vision. They varied in age from around three to eleven. The oldest pushed a tattered junkyard baby-carriage that wobbled across the sandy ground on squeaky, bent wheels. She stopped the procession a few yards from me and produced, from the interior of the carriage, five mud-caked soda bottles and handed one to each child. As she did so, she talked to the group in a soft but authoritative manner. A boy of around four held his bottle close and spoke to it like it was his rag-doll friend, savvy to the secrets of an imaginary world. He touched his bottle/doll to a cheek, then raised it with both hands above his head and exploded it on a concrete chunk, at the upper edge of the sandy beach.

The group leader arranged the children tallest to shortest. As they passed they maintained stride and kept all eyes to the front. The four-year-old boy broke stride and turned his head to look at me. I watched a fly crawl across his forehead and down to the dry snot on his upper lip. Diffused light glowed from his face, like a Kodachrome transparency. I smiled at him. He raised a short, skinny brown arm and showed me his middle finger.

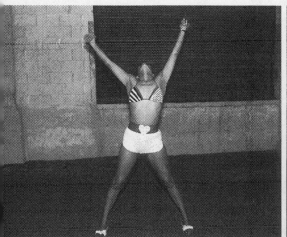

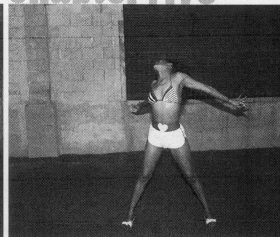

working stiff

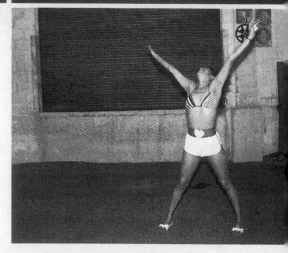

1987

I was born premature, a runt. I was cross-eyed with double vision. In my youth I couldn't play sports; I couldn't kick, throw, catch, dodge or put a cue-ball in a side pocket. Numbers swarmed on the page, and I was in seventh grade before I figured out I didn't see the way everyone else did. A surgery corrected my eyes cosmetically but my ability to see two sides of everything remained intact. I always thought it made me a better photographer, and so, ultimately, it all evened out.

When I was a budding apprentice photographer under my father's tutelage, he instructed me to read the landscape left to right like a book, frame it with a stopping point and circle back; notice how the light falls and coats the landscape, changes your views of mood and likeness. You don't need a camera to take a thousand pictures a day, he told me. You just take all the elements of an arresting visual, compose them in your head, and blink your eyes for the shutter.

At a traffic light on Wilshire Boulevard, an old guy with a single war-torn crutch took two light changes to make it to the other side. An impatient asshole in a new Pontiac Trans Am revved his engine and crept forward a couple of inches, as if the old guy with the crutch was stealing away his valuable time. I composed a sad picture of the homeless guy and an ugly picture of the asshole. I

put-putted my crappy Toyota wagon onto the freeway and followed the weary traffic, on my way to work.

I'd taken a full-time job with a multimedia company that produced, among a range of things, motivational audiovisual shows and flashy shindigs for corporate conferences and conventions. I was the optical cameraman and darkroom guy. The people were easy to work with and they encouraged my liberal eccentricities. For the first time in a while, I got two paychecks a month. It was a good gig and I hated it. Real jobs made me feel like a loser and a sellout, and even though I had no great causes to betray or acolytes to impress, it was embarrassing, though not as embarrassing as driving the Toyota.

I commuted five, sometimes seven days a week, south, an hour each way, to Long Beach. I was permanently crashing with Gus in Santa Monica and driving every Friday and Sunday night down to San Diego and back to pick up and then drop off Dashiell—a total of around ten hours' drive time per weekend. The Toyota coughed and convulsed and burned oil the whole way. I coughed and convulsed and burned nicotine and cannabis on top of caffeine and alcohol. I spent a lot of time daydreaming.

I seldom sat down to eat, and when I did, I stuffed myself with polyunsaturated fat and grease and sugar. I lifted weights occasionally and looked healthy and robust, but it was only a façade. My shoulders were pinched and there were bumblebees in my fingertips. The tingling never gave me a break, each day a little worse than the day before. I twisted and rolled my head to unravel the rheumatic knots in my neck. It made me look neurotic so I tried to do it covertly, which made me look even more neurotic.

My job came with medical insurance, but I took the money instead. I'd been seeing doctors since the 1960s and had yet to get a prognosis with a name or a treatment. I lived with endless

discomfort, and it seemed as if no one believed me. As if all my ills were conjured from my undisciplined psyche. I knew better. Maybe I was nuts, but I wasn't a hypochondriac; my body was damaged and so I ate the pain and self-medicated, and mostly kept it to myself.

Thirty minutes and three freeway exchanges later, I could smell Long Beach: oil rigs mixed with a salty ocean breeze. In the ashtray, a roach, among the cigarette remains, seduced me. I got high and made faces at myself in the rearview mirror and whistled "Turkey in the Straw."

Once upon a time, when I was some other guy, I took a job as an itinerant portrait photographer with a company that made high-school-style yearbooks for churches. I took family group photo-graphs in a portable studio setup of churchgoing Americans. I played a fool for the men and children and told all the girls, old and young, they were beautiful. The sage who hired me advised: "If you quit this job before a year is up, you're a fucking quitter, and if you stay with this job for more than two years, you're a fucking idiot." I took it to heart. This was my eighth week on the new job and so I had twenty-two months to go. I needed to prove myself a stable father and it didn't seem a lot to be asking of myself—a few basic responsibilities. For now, though, I was working on getting to sleep at night, getting out of bed each day, feeding and clothing myself. Walking upright.

I took the Pacific Coast Highway exit and drove slowly, cruising the intersection of Whore Avenue and Crackhead Boulevard, looking for trouble. Everything—buildings, cars, people—all exhibited decay, like a science fiction dystopia. Liquor stores, hourly-rate motels, graffiti, drug dealers, and doom.

Downtown, toward the ocean, Long Beach was gentrified: beautiful old buildings patched and polished, coffee shops,

restaurants, bars, boutiques, art galleries, and office space. Yuppies and displaced derelicts from here to the Pacific. It was nice, though I pined for the carny atmosphere of yesteryear. The Pike and Rainbow Pier amusement park. Brand new in 1902, the Pike of the 1960s and 1970s harbored rusty yet beautifully garish old Tilt-A-Whirls, Wonder Wheels, tattoo parlors and biker bars, bums and whores. Eight years ago they had torn it all down and rebuilt a sanitized pier with shops and seafood, the *Queen Mary*, and the *Spruce Goose* dome.

My father grew up in Long Beach but moved to the Midwest after World War II. We took family vacations to Long Beach in my youth, and I knew then Southern California was where I wanted to be. I plotted escape from my hometown in the Ozarks and counted the days from age nine forward. Now I'd been here, off and on, for twenty years. If home was where the heart is, it was never where I had come from; it was always where I'd gone to.

I parked the Toyota in my assigned slot and keyed off the ignition, but the engine continued to rattle and chug like an old man with lung cancer.

It was noon. As long as I put in the hours and met my deadlines, management granted me the freedom of making my own schedule. I was the lowest-paid employee on staff, but I didn't mind; I wasn't looking for advancement. I was on salary and my overtime was compensated with time off. Currently we were in the middle of a midsized production that kept me busy six to ten hours a day.

Into an old brick building made new, I revolved through the doors into the lobby. One of the two elevators opened and out came the lunch crowd, mostly nine-to-five management types. I smiled and helloed a couple of account executives and they dittoed me. In the elevator I pushed number eight.

The production company took up the whole of the eighth and uppermost floor. The receptionist was at lunch and the office secretary was manning the front desk. Her name was Gladdy. On my first day at work, when I was introduced to Gladdy, she had told me, "We're all a little nuts around here, but you'll get used to it." I had inwardly smirked, thinking myself more complex than they could ever be. Later that day, I saw Gladdy skipping about her cubical singing a medley of Weird Al Yankovic songs. Two hours after that, I came out of the darkroom to find Gladdy at her desk with her head in her hands softly crying, dripping tears onto her keyboard. I'd been wrong to assume that my craziness trumped everyone else's. I owed Gladdy a silent apology.

In the restroom I drained my bladder, washed my hands, and slapped cold water on my face. I combed my hair and smiled at my reflection. When I was young I hated the way I looked, but over time, I had cultivated my face, my voice, and my swagger. The personality traits that didn't register in the mirror, like a vampire without a reflection, were best kept in the shadows.

Back in the main office, through the cubicles, I stopped and knocked on a closed office door while pumping up my arms and chest with isometrics. A voice, distant, invited me inside. There, a console of video editing apparatus, walls of bulletin boards with storyboards and production schedules. At a desk sat a woman named Vicky Chow. Vicky was my favorite. She was a few years younger than I, and she ran the video department. She was ambitious, artistic, educated, liberal, and if my reading was correct, she was attracted to me. Just as I was to her. I liked her enough that I got a little stupid when she was around.

"Hey, how's it going?"

"How's it going? I don't really know, Scot. I've already used half of today trying to convince myself that I know what I'm doing.

Actually, I'm trying to convince myself that it matters if I know what I'm doing." Vicky picked up a pencil, tapped herself on the forehead with it, then set it back down and smiled at me. "How are you? I like your boots."

"Thanks, they make me taller."

"You wear boots because they make you taller?"

"Yeah, also 'cause I ride a horse to work."

"Really?"

"Yup, his name is Skeeter. On weekends we do the rodeo circuit. I wear six-guns and ride backward while people throw coins in the air and I shoot 'em."

"You shoot the people?"

"Yeah, well, just the ones who deserve it."

I was available for a meaningful relationship, but Vicky had a boyfriend, a jazz musician, a saxophone player, which is the epitome of cool and difficult to compete with. I didn't wish Vicky heartbreak, but I hoped she would lose the guy while I was still available.

"How's Dashiell?"

A couple of weeks back, on a weekend day, I'd brought Dash into work and set him up with a television and a couple of videos while I shot and developed film. Vicky had been here and had brought along her little wiener dog, Sophie. Vicky, Sophie, and Dash had visited for a while.

"He's okay. I see him every weekend and I call him once or twice during the week."

"He's really beautiful."

"Well, yeah, thanks. Do me a favor and don't ever tell him that. He hears it a lot and finds it pretty irritating. I've had the same problem all my life so I know what it's like."

"People telling you you're beautiful?"

"Yeah, it's my curse. I should probably, uh, go do work. I just stopped by to say hi."

"Tell Dash that Vicky and Sophie said hi."

A small desk lamp, with a bright light, reflected upward from a spot on a clean white sheet of typing paper, filling the shadows, illuminating Vicky Chow's warm complexion and pretty face. I blinked my eyes and took a picture.

Past the cubicles, past the offices and into a kitchenette, I started a fresh pot of coffee. The kitchenette was the dividing point of the top floor. With the exception of Vicky, everyone from the elevator to the kitchen was in sales and management. All the workers from the kitchen to the back wall were artists and creative types. You had to walk through the Republicans to get to the Democrats.

President Ronald Regan and first lady Nancy Reagan were urging America to *Just Say No* to drugs. *The Accused* with Jodie Foster was in theaters. *People* magazine featured John F. Kennedy Jr. as the sexiest man alive. Vice president George Bush was running for president against Massachusetts governor Michael Dukakis. AIDS was a slouch-hatted killer still running loose, shamefaced and unchallenged. U2 was on tour in the U.S., and I had the song "Sunday Bloody Sunday" stuck in my head.

While coffee gurgled into the carafe, I amused myself with Curly Howard imitations. I put a dollar into the coffee-fund jar, then changed my mind and took it back. I filled my mug and added milk, then went to the production office and sat with the production manager, who gave me a stack of flat art along with piles of product transparencies and a passel of pasteup art for multiple exposure and effects slides, all of which needed to be shot for three-screen pans and duplicated, six each. A couple of times a year we received photography books of images for sale by the

picture agencies. Rather than purchase the rights to these images, it was part of my job to copy them from the books. It was unethical and illegal, but as a good employee, I swallowed my protest.

I passed through the art department and gave a polite nod to each of the two freelance regular artists and a computer guy. They were friendly and somewhat doinkish in ironed and creased blue jeans and occasional fanny packs. They were discussing right-wing conspiracies.

All the way back in a corner was a small hallway to a full-length window to a fire-escape landing. Two ten-by-ten rooms, all mine. In the darkroom black walls. A wall-to-wall sink with photo trays, a treasure-chest dental-film processor for the miles of Kodalith film, for text slides, and for multiple exposures. A cheesy little black-and-white enlarger with crappy lenses. (For my personal work in off-hours, like pictures of prostitutes, I brought my own lenses from my store of supplies.) A roller transport E6 film processor that took up 80 percent of the room and required a lot of maintenance and still occasionally ate the film. I set the temperature and ran a color test strip. In the other room, also black walls. A long light table and a couple of roller chairs. A Marron-Carrel optical camera with a vertical rail that went up through the ceiling tiles and long, bent arms that aimed hot lights onto the film bed. Lights under frosted glass for shooting transparencies. A couple of lenses and a black control panel on my right, toggles and buttons and timers.

As much as I hated the concept of corporate worker bees and the American Way, I enjoyed the hell out of the work. It was technical and creative, it was visual, and I was good at it. In the dark, saddled to an optical camera, I was confident and comfortable, and this was the place my talents kicked in. I had no idea that in ten years' time, a computer program called Photoshop

would render my talents obsolete. My only marketable skill was endangered, and I couldn't see past the viewfinder.

I spent thirty minutes organizing, then unscrewed the frame to the hallway window and stepped out to the fire escape. I climbed the ladder to the roof, where I smoked a joint, watched the Pacific Ocean, and thought about Vicky Chow.

Now that I had a real job, I wanted a real woman. A smart, educated, and generous woman with a good job. Someone au courant and funny, with a dark deep humor. An attractive, sexy woman who liked kids but had none of her own. I needed intimacy and a good fuck from someone I would want to continue fucking. I closed my eyes and gave Vicky a big kiss and she responded in kind. We held hands and flew out over the blue Pacific. Schools of porpoise waved at us with their snoots. A tugboat went by and seagulls flew in heart formations.

Back to the camera room with a strong, steamy coffee, I tuned the radio to the latest musical wave. Saddled to the camera, I factored and calculated and shot film backwards and forwards. In another brain, I thought about freeways and traffic and bad weather. I thought about self-image and money, style, and comfort. I decided it was time to buy a new car.

People with full-time jobs bought nice cars. I had money coming in but far too little and too late for the debts I had acquired in the course of a year's unemployment. I had no car insurance, my driver's license wasn't valid, and I owed the California courts about a thousand dollars on warrants and unpaid fines. Two of my three credit cards had been shut down. I took the maximum dependents on my paychecks and hadn't filed taxes in two years. I was supposed to be paying Sylvia $350 a month for child support, and I was well behind. But if I rationalized, a new car seemed like a good idea.

The Toyota hadn't seen a hundred thousand miles for a hundred thousand miles. I had to pump the brake just to slow down and often had to incorporate the parking brake to come to a complete stop. It was a stick shift, which was a pain in L.A. traffic. I had to check the oil twice daily and add oil at least once daily. The tires were bald. The radio was fucked. The seat cushions were disintegrating patches of foam. The Toyota had not an ounce of style, and this was Southern California.

I shot and processed film for six hours, then dried and sleeved the 35mm rolls of Ektachrome and delivered them to the art room, where freelancers cleaned, cut, and mounted the slides in glass and dropped them, in chronological order, into carousel trays. The pasteup artists were putting together another six hours of camera time, and I was running about two hours ahead, so I had time to spend.

I drove to a wide boulevard of car lots. It was around seven o'clock, and they were closing up. I pulled into a new- and used-Chevy dealer with brightly painted banners: We're crazy!!! Through a row of clean bright cars, under strings of bare bulbs, I stopped at a Corvette and checked the driver-side door; it was unlocked so I climbed in, grabbed the wheel, and said, vroom, vroom.

A woman, blonde and tall in a miniskirt and low-cut sweater, came out to assist me. She wore foundation along with mascara and precise red lipstick. She had a face like a beauty contestant and zero sex appeal. She asked me if I was interested in the Corvette and I said not really. She told me she was going to buy a Corvette for herself and she only had to sell one more car for her commissions to equal the purchase of said Corvette. She told me therefore she was ready to give me a crazy deal because she wanted the sale, real, real bad. I told her yeah sure, and my eye caught, six cars down, a white Camaro. It looked at me with its

headlights and wagged its tail. It was slung low and lean with wide tires and diamond-studded wheels. It was a year old and still pristine. The saleswoman had the keys, so we got inside, and I cranked the ignition. The previous owner had done something with the mufflers, glass-packs maybe, guttural and sexy, it was beautiful; it vibrated my scrotum and made me grin.

The saleswoman told me the engine size; she told me about the guts and the gewgaws, the miles-per-gallon and the horsepower, but I didn't pay any attention. This was not love based on numbers and mechanics; this was a Barry White love song. Oh baby baby. You know I need you.

I pulled to the street and tromped the gas and fell back into the bucket seat and shot rockets from the tailpipes. It was all I could do to contain a hillbilly yeehaw. The saleswoman told me she was going to give me the bargain of a lifetime, and though I doubted it, I was still going to buy the car.

We spent thirty minutes in her sales office filling out forms and telling lies. She didn't care if I was good for the loan or the monthly payment or whether I had insurance or a valid license. All the financial and governmental institutions were closed until tomorrow, and she didn't care that I was likely high-risk. She wanted to sell the car tonight, and I wanted to buy it, and as a bonus, she took the Toyota as a down payment.

I left the lot in my new car. I was high and happy. The driver's seat gave me a love-filled hug. The radio was newfangled and the speakers surrounded me. I sampled genres and found an FM shit-kicker, John Anderson, Waylon Jennings.

I cruised to the Pacific Coast Highway and went south. A misty ocean breeze. Two pelicans high in the sky. Inland to Santa Ana, I turned onto a street I knew to be popular with sisters of the night. I stopped at an intersection, eight crisscross lanes and four

signal lights. In the center island, a go-go girl was dancing the Frug, the swim, the monkey, and the dog, drunkenly waving and gesturing to the potential clients jammed together in traffic. She wore a bikini top and white hot-pants, a wide belt with a sparkling valentine buckle. She was an exotic mix of breeds, slight and sinewy with a high-boned face and a cheerleader's smile. She was sexy and nasty and completely out of her head. She looked like a fun date.

I got nervous, not because of the hooker but because I was out of film. I braked into the right-turn lane and crawled along the curb, looking around, assessing the situation. All four corners were open to commerce. Two mini-malls, three gas stations. On the far corner across two intersections and a dozen lanes, going the other way, a One Hour Photo Shop. I scanned for cops and didn't see any, though there was a lot of traffic I couldn't see. I put out my cigarette, turned off the radio, tooted my horn, and took a straight line, going against every light, in front of every car. The Camaro maneuvered through traffic like a shape shifter. I dodged irate traffic all the way across, slid into the out lane of the little shopping mart, circled pedestrians and parked cars, found a slot, parked, and looked quickly out at the intersection—she was still there—then ran into the One Hour Photo. I took out my wallet and said, Tri-X, one roll, thirty-six exposure. The place smelled of familiar chemicals. The nondescript guy behind the counter began browsing the film rack, and I told him, all the way to your right, then back one row, down at the bottom, green and yellow. I paid and opened the box and left it on the counter and didn't wait for change. Back in the car, with my Nikon between my legs, I loaded the film while repeating my traffic violations and pulled to a rest at the center island, where the hooker was still center stage, wild and toxic. I put

the Camaro in park and revved it, growling at the other cars, keeping them at bay. I was in love with my new car, and for the moment, I was in love with myself.

The hooker pulled up her top and flashed her tits and a hundred male drivers got hard-ons and honked encouragement. She was laughing maniacally, off her nut. She twirled to the Camaro and yelled through the open window. "Hey stud, how would you like to make love to me? Huh, what? Who are you? Who are you?" She beamed me a radiant smile, then threw her arms up high and bowed to traffic and flashed her tits again. "I'm the best lover you're ever gonna get, Mister Whoop-de-doo. Cinderella dressed in yella. I'm the best kinky muff in motherfucking America. How'd you like to make love to the best muff in the world, Mister Studly Fartblossom?"

I told her yeah, I might like that, and would she like go for a ride in my rocket ship. She shook her ass at the southbound lanes, then opened the door and climbed in. I shifted into supersonic and left fiery tire-tracks on the pavement.

"I want to take your picture and I'll pay you fifty bucks."

"Give me the fifty, give me the fifty, give me the fifty. Shit fuck. Fifty dollars and seventeen cents. Going once, going twice, sold to Mister Studly Fartblossom."

"I'm gonna find someplace private where we can get out and take some pictures."

"I'm gonna find someplace private where we can get out and take some pictures. I just said what you just said. What's that called?"

"Copycatting."

"That's it. Pete and Repeat were in a boat and Repeat fell out. Who was left? You're lucky you got me because I'm the best model in the world. That's a proven fact. Who are you? Who

are you? Who are you? Ha-ha, just kidding, I know who you are. You're the lucky motherfucker that gets me for fifty dollars. I'm hot shit and I know it and so do you and so do I." She stuck her head out the window and screamed three long movie screams then came back inside and said, "Toot, toot. Cocksucker, motherfucker." She started laughing insanely, loud and shrill, her body flailing about with each exhalation. She couldn't turn it off and I was afraid she would fling herself out the window.

I drove us to a small parking lot behind a two-story commercial bunker, gave her fifty dollars. "Let's get out and take some pictures." I grabbed my photo gear from its new home behind the driver's seat.

She leaped from the car and hit the pavement twirling. Her hair was long and thick and curly. Her butt was perfect. She smiled like a movie star and she looked like a movie star. Her eyes shone brightly of madness and possibly PCP and I was utterly charmed. She kicked her legs high and straight and yelled. "V-I-C-T-O-R-Y, victory, victory is our cry! F you see Kay tell her tough titty. Cocksucker, cocksucker."

I chased her around, focusing, while she made kinetic art, which I froze at a sixtieth of a second. When I was done I said that was great and where can I drop you?

Back in the car she directed me. "Turn right then go left at the light then go straight for about a cunt-hair. You're taking me home. My kid's home all alone and I kinda wanna see her again. Home, James, you're my big-shit chauffeur now. Just keep going this way. Follow that car. Follow that car. Follow that motherfucking car, James, Mister Raisin Bran Man. No, not really, I'm just fucking you around. Cocksucker, motherfucker.

"I was the number one model in Las Vegas for six whole years. I'm famous and everybody wants to touch me. You ever heard of

Valentine McCandy? Because Valentine McCandy is my name that's who I am and you're probably not even anybody."

I had no idea where we were. The neighborhoods were crumbling block by block as though I were at the wheel of a time machine. I said, "Are you sure you know where we are?"

"Go this way and then left at the light, James. Can you drive a little faster, just keep going straight don't turn for a while, just keep going straight for a while. I know exactly where we are, just keep going straight. I need to kind of get home faster because my kid Queen is all alone. I bet you can never guess who Queen's daddy is. Not in a million years but I'll give you a hint. He lives in Las Vegas."

"Wayne Newton."

"You guessed it, Hot Pastrami. Wayne Newton. He likes me to lick him all over, and he likes to lick me too. But I need to teach him a lesson. Tom Jones too. Tom Jones wants to marry me and he thinks Queen is his baby but she's not. I wish you could drive a little faster. I'm getting kind of worried about stuff. We're getting closer. Make another motherfucking left. Fire fire, run for your life. I need to go to the bathroom."

"Yeah, so do I. You can't possibly know where we are. I don't even think we are still in California."

"That's real funny. I know exactly where we are. You just got to go another mile or so. Ouch, ouch, that hurts. Stop it, you're hurting me. Stop hitting me. Ouch, ouch, that hurts, motherfucker. Ha-ha got you again, wasn't anybody hitting me. Nobody can fucking goddamn hurt me, no way, never. If you want to, you can come inside and make love to me. I don't mind. But most of the time I only make love to famous people. I can tell you a secret but you can't tell anyone because then my life would be in danger and they would try to kill my baby."

I crossed my heart and took a vow of secrecy.

She had an amazingly beautiful face, which never sat still. She bounced in the seat and touched my thigh, my arm, my neck. Her breath was hot and close. I could feel drops of perspiration forming in my armpits.

"I used to have fifty million dollars, but I gave it all away to people who aren't as pretty as I am. Maybe you could help me out a little bit with some more money, because I need some more money to help protect my baby from getting killed. I could dance for you. I'm the sexiest dancer in the world. And I'm not just saying that, it's a proven fact. Turn over there and park, this is it. COCKSUCKER! Who are you? I've really been gone a long time, I hope Queen is okay. How come everything is all funny?"

I parked and I told her I was going to come in with her, check the baby and use the bathroom, maybe stay long enough to watch the sexiest dancer in the world. I told her I had another thirty-some-odd dollars she could have.

The neighborhood was beaten-down and dark. There were werewolves in the shadows and vultures in the trees. I climbed out and looked at the Camaro and fell in love all over again. I accompanied my funny valentine up the walk.

"When I was in high school, I had my own tutors and I had a maid who was fat and she had to do everything for me even when I wanted to do it myself. I don't understand what's going on. Okay, here we are. Something's wrong with me."

The sky was gray and the ground was brown. The entire south side of the road had been razed. Tall weeds between hills of trash. Two adolescent girls, barefoot, in shorts and halter tops, sat on a mound of dirt, holding hands and staring at the empty sky. On the north side a row of crumbling stucco single-story apartment buildings. I followed Valentine to a back door framed with little

piles of dead toys, empty cans, and a thousand cigarette butts. She turned the knob but it was locked. "Somebody locked the door and I need to get in there to take care of my baby. Somebody locked the door." She rattled the knob and knocked on the door. Her face turned green and she began to wobble.

I said, "You know what? I don't think I should be here after all. I think I'm gonna go." But I stood there, knowing I should flee. I heard the lock unlock and the door opened and there was an old, bewhiskered white guy standing there holding a BB rifle. He was big and homely and wrapped in a fuzzy purple bathrobe. He pumped the gun, three times. Valentine looked at him then looked at me. "Who are you? Who are you? Help, help, somebody save me." She fell to her knees and regurgitated great splattering globs of fast-food réchauffé. She retched loudly, echoing the night with the sounds of dying creatures. The guy with the gun gave it another pump and aimed it at me. I turned and walked away quickly. I heard the gun spit a BB and I quickened my pace. Back in my new Camaro I cranked it and put a cloud of dust behind me.

It took me twenty minutes to find a familiar thoroughfare and then another ten minutes of going the wrong way. Back in Long Beach I stopped at a little burger joint and ordered a chicken-fried steak sandwich with onion rings and a Coke.

Back at work, the building was closed and I used my elevator key and rode to the top. I went into the bathroom and took a sit-down with my head in my hands. I was on the down side of the adrenaline buzz from my new Camaro, the adventure with Valentine McCandy. My head was filled with loud television snow, and I was suddenly very sleepy; I'd only slept for four hours the night before and had used seven beers to knock myself out. My neck and shoulders were cinched, tangled knots. I hugged myself

to warm and contain myself, then did push-ups on the edge of the sink and whistled "Cry Me a River," finishing with twenty squats and deep breathing.

At the sink I washed my face and hands and combed my hair. I looked in the mirror and practiced expressions. I did sexy and cavalier, tough and scary, goofy and retarded. It seemed my body was rotting away from the inside at an early age, but so far, I'd been able to maintain a hard outer shell. I looked like a solid cocky superman, and no one was the wiser. I'd inherited vanity from my mother. Looking good had always been a high priority and low maintenance. All it took was a charming smile, and everyone became my pal. Growing old in a crumbling body, unable to fuck, unable to turn on the sexual stimuli of those who turn on my sexual stimuli: those were my fears. I'd earned the physical pain and I could live with that. But I wanted everyone to love me, and if I lost my robust charisma, I had nothing to fall back on.

Putting on my best face, I went to the video room to see if Vicky Chow was still around. She was. I asked how come, and did she love it so much she just hated to go home?

"Yeah, I should probably just bring a sleeping bag to work. Camp out, make s'mores in the kitchen. Actually, I'm ready to go in about ten minutes. I'm supposed to meet someone to see a movie. You have something really yucky on your right boot."

There was a colorful chunk of Valentine McCandy's vomit, still moist, on the pointed toe of my boot. "Aw, yipes. That is gross. I'll be right back." I ran out and into an account executive's cubicle. I found a box of Kleenex, grabbed five or six, and cleaned my boot.

Back in Vicky Chow's room I said, "Sorry. I don't know what that was or how it got there or where it came from."

"Where exactly do you go on your lunch breaks, Scot?"

"Uh, I don't know. Denny's, IHOP."

"No, really, where do you go on your breaks? I hope I'm not crossing a line here. Word around the water cooler is that you go out taking unflattering pictures of unfortunate people. I do like you, and maybe the person who told me about your pictures was just conveying her own prudish reaction. You can tell me if it's none of my business."

I had a bad habit of showing my photographs to people, forgetting I was in America, land of the puritans. I was looking for praise and all too often thought others would see the brilliance of my noble endeavor. I should have known better. I'd been trying to convince people of my brilliance for years, but so far, my fan club was small. In the darkroom, watching the images magically appear, I saw art and fuck-you realism where others saw pornography, exploitation, and misogyny.

I presented my defense: "That's pretty harsh, 'unflattering pictures of unfortunate people.' I take pictures of prostitutes. I've been doing it for a couple of years. I try to keep it honorable. I'm trying to say something but don't ask me what yet. I want to make a book and I want to do gallery exhibits. I'd like to shock people into empathy, but I guess it's kind of one of those incidences of preaching to the converted. I think I'm a good guy. I want to be a good guy."

"Do you pay them?"

"Yes, I pay them the same as if I were an actual john, which I guess I am. For the most part, they're born victims, you know, exploited and fucked over and damaged beyond repair. Most of them don't stand a chance of growing old. I know it sounds screwy, but if I can pay them enough to buy a ball of crack, I've helped them get through another day." I rested my defense leaving the verdict to the jury, Vicky Chow, but she still had questions.

She held her pretty head in her hands and studied me. A cute little wrinkle of suspicion crossed her brow. "So is it a political thing, the pictures you take, or do you just really enjoy the company of prostitutes?"

"I don't know. I always wanted to be a war photographer, and this is as close as I'm gonna get. But yeah, I get a kick from rubbing elbows with the sleazy side."

"Rubbing elbows? That's the extent of your rubbing?"

"Yeah, pretty much. They're not really very attractive. Uh, that doesn't sound good, does it? What I mean is they're kind of sad and uh . . . I think I should get going. You've got a movie, I gotta get back to work. Remind me sometime and I'll show you the pictures."

I made an awkward exit, hoping I hadn't blown my chances with Vicky Chow. I wanted to eat in Vicky's kitchen, watch television in her living room, and sleep in her bed. But how would Ms. Chow, or any other upscale gal I might pine for, feel about my lowlife indiscretions? In this era of awareness, a compassionate guy like me, an exponent of feminism, would never actually have sex with these unfortunate sisters of the night. It was other guys, lower-class grunts, guys with bad grammar and ugly wives, guys who frittered their hourly wages on cheap whores and then lied about it. The thing I found most amazing was that everybody believed me when I told them I only photographed the prostitutes, nothing more. If someone had told me the same thing, I wouldn't have believed him.

In the kitchenette I put on a pot of coffee, then went to the production manager's office and picked up a new stack of work orders, including changes and reshoots. I shot and processed film for the next five hours. Everyone else had gone for the night so I killed the lights and locked up.

Outside, against a night-blue background, under the light of a street lamp, the Camaro was aglow in the mist, like an over-exposed nude on high-speed film. With wheels invisible in the shadows, my new car looked like a hovercraft, ready to zoom through space. I composed the scene, in a five-by-seven format, and blinked.

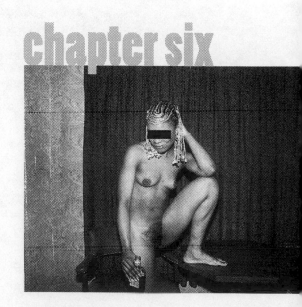

chapter six

homebody

1988

Men are pigs. They piss on toilet seats, spit in public, and wage
wars. They show women the back of their hands and expect grati-
tude in return. It's embarrassing, being a man. I never wanted to
be one of the guys. I endeavored to rise above my base instincts.
I was enlightened, empathetic, in touch with my feminine side.
And if sometimes I acted like a jerk, I berated myself as if shame
would redeem me.

Driving northbound on the 5 toward Santa Monica, away from San Diego, away from Sylvia and away from Dashiell—the worst and the best of my life—my Camaro growled and nipped the heels of slower-moving vehicles, my right foot angry on the accelerator. I had the Pretenders cranked up and every inch of me was moving, every nerve buzzing, like flies trapped in a bottle.

Twenty minutes ago, Sylvia was on the floor, akimbo, hissing up at me with all the venom she could muster. I'd put her on the floor, I'd shoved her hard in the sternum and she'd gone down. "That's what you wanted all along, isn't it?" I said. "That's what you want from me. You want me to knock you to the floor. Well, there you go, you fucking cunt. You got what you wanted."

She told me to get out and never come back.

For the last month or so, Sylvia and I had been unusually cordial. We'd even started having sex again, though it was far from the original experimental sex that had led us, sweaty and stupid, to full-blown love. We'd spent the two previous weekends, along with Dash, as a family unit. We saw friends and went to the beach. We sat on the living room floor and played with action figures. Then, in a single blow, I knocked her down. And now, I was grinding my teeth at eighty miles an hour, chain smoking, my neck in a painful twist. I wanted to bite through the steering wheel.

In Orange County I slowed and veered to the right, following a familiar pathway of boulevards and avenues toward illicit, anonymous sex.

On Harbor Boulevard in Anaheim, through a wet February haze, I cruised by the magical world of Disneyland. When I was six, around Dashiell's age, I came to Anaheim with my family on one of our summer vacations. Disneyland was in its freshman year, and so we helped to christen it with our attendance. My father made

8mm movies; I wore a Davy Crockett coonskin cap and made faces at the camera. My big sister held my hand. My baby brother slept in his stroller, eyes closed, his little monkey face the most kissable thing I'd ever seen. Now, thirty-two years later, Anaheim was a sweet memory, until I turned east and exceeded the speed limit to an area that wasn't on the tourist maps.

The cityscape began to rot, block by block, and the mighty empire declined. Overhead a helicopter added to the racket. From the sidewalk, a kid threw a dirt clod that exploded on the car in front of me. At a bus stop, a mummified old woman sat holding the hand of a girl, a teenager, who had the pudgy body, puffy skin, and innocent face that characterizes Down syndrome. The girl was singing loud, off-key, jumbling the words to "Jesus Loves Me."

A block later, a young streetwalker with beaded braids that coiled around her head and wiggled down around her ears signaled me from the curb and directed me to a motel that looked like a faded 8mm movie. I curbed my car, locked up, and went to introduce myself. My hands were still shaking from the ordeal with Sylvia. My loathing for Sylvia, at this moment, was at a peak, and I would blame her for every stupid thing I did for the rest of the day.

The hooker was waiting for me at the open doorway of a lower-floor room. A couple doors down, standing next to an ice machine, two big, ugly urban guerrillas were plotting genocide. The whites of their eyes were red. They give me spiteful looks that should have turned me around, back to the car, back to the freeway headed elsewhere. But I was punch-drunk with animosity and bravado. I looked at them with blind eyes, as though they didn't exist, then went inside with the hooker, closing the door and locking the bolt, the chain, and the doorknob.

My marriage to Sylvia was doomed from the beginning. I knew I was making a mistake, a big mistake, but I believed I couldn't feed and house myself without management. And to some degree, I'd gone passive, like a dog whacked on the nose, allowing Sylvia to tug me along. In turn, I puffed up my chest like a rooster, hiding my inner chicken-shit beneath the plume. For reasons that later escaped me, love had taken me captive.

My first marriage, when I was twenty-one and she was seventeen, was to a girl named Danielle. Danielle and I were equally untamable. We ran wild together for seven years. We had our problems, but we never, ever, told each other lies. Sylvia and I lied from day one, about who and what we were, about our flawed and damaged psyches. Because we were both too smart not to see through each other's fabrications, we began piling up regrets and resentments early on. Now we had seven years of bad memories we could sling back and forth like slaps to the face.

In the motel room, in Anaheim, I still couldn't clear Sylvia from my mind. What I had done to her, about an hour ago, was physical, the hurt temporary, but what she had done to me would fester for years to come. Hate radiated from my body like Keith Haring squiggles. I was banking on the whore to provide a welcome distraction.

The motel room was standard issue though a little high-end for this neck of the woods, well laid out, like accidental feng shui. Metallic wallpaper with diagonal trees and vines. A king-size bouncy bed, heavy blackout curtains down to the floor. It was perfect for pictures.

The prostitute wore short-shorts and a T-shirt; she was compact and sexy. Her voice was whispery, her breath hot and whiskey-tinged. "How much money you got? What do you want me to do? I'll do whatever you want, and I don't care what it is."

"I want to take your picture and I think I'd like a blow job. I'll start the bidding at twenty bucks."

"You need twenty dollars just for the room. This is a good room. Twenty more for pictures, naked, whatever you want me to do. Twenty more, get your juice off, whatever it takes, I don't care."

Earlier today I'd withdrawn $120 from a ready-teller for my weekend with Dash and Sylvia. I'd spent less than ten so far and still had a wad to fritter away. "Here's fifty for start to finish, how's that?"

She put it in her bag, then brought out a pint bottle of Crown Royal whiskey, unscrewed the decorator cap, and took a hit. Drinking, she explained, was what she needed to do; it was all she cared about and she didn't care about anything else. "So now you tell me what you really need? What do you really want for your money? Your face is all red and I think you want more than what you say you want. You want a strip show? You want to hurt me? If that's what you want, go ahead, do it. Long as I drink I don't care about fuckin' nothing."

"I don't want to hurt anybody, but I'm good with the strip show. Get up on the bed. I'm gonna get my camera out. My name is Scot, who are you?" I set the Nikon at f8, one-thirtieth of a second, and I loaded four fresh batteries in the flash like torpedoes.

Standing on the bed, bottle in hand, she got naked from the waist up. She was sinewy with smooth skin and round, perky tits the size of fists. She had a nasty smirk, sexy and fierce, as if she could rip out my jugular with her teeth, kiss me with her bloody lips. She looked as if pain was nothing new and she could take it or give it with equal aplomb. I snapped a picture, and she peeled off her cutoffs and posed in her pantyhose, which whispered like a zipper when her thighs brushed together. I exposed another picture and my camera got an erection.

"My name is Sheba and that's my real name and not my slave name. But if you want me to be your slave, I don't care. You want to fuck me? Go ahead, make me do it any way you want. You paid for it so come and get it." She smiled like a jackal and took another big bite of whiskey. I set the camera on a table and told her I wanted to take more pictures, but I'm gonna take my clothes off first. I take better pictures when I'm naked.

"Know what I see in you, ah, Bob? That your name, that what you said, your name is Bob?"

"Yeah, but you can call me Scot."

"I can see that you hate me. Just like everybody else, you hate me. But I don't care. You want to fuck me in the ass, Bob? You want to make my asshole sore? I don't care. Go ahead and make me."

Initially, I'd been scheduled to work today as we had a big job going through and due on Monday. In order to spend the weekend with Sylvia and Dashiell, I had worked straight through from Friday morning to early Saturday morning, today. Tomorrow, I'd say adios to my little family at noon, then drive back to Long Beach to shoot and process reshoots and changes, until the whole shebang was ready to fly to Las Vegas for a 9:00 p.m. show on Monday. That was the plan, first draft.

It was around 10:30 a.m. when I had arrived at Sylvia's apartment in student housing at UC San Diego. I'd circled the lot, found a space, and rumbled the Camaro into a slot. Earlier I'd pulled off Interstate 5, in San Juan Capistrano, for gas, cigarettes, and coffee. I had also purchased and eaten half of a large, segmented Tootsie Roll. The other half I took from the wrapper and worked in my hands until it resembled a turd, then put it in my pants pocket.

The campus housing area was spacious, rolling, green, and manicured. Apartment buildings were two-story brick with four two-bedroom units each. Sylvia and Dash lived in the family section; young academics with young children were all about. The atmosphere made me itchy and irritable.

My education, such as it was, ended after twelve years at the bottom of the class. I wished I had a formal education just as I wished I was six feet tall. My idols were intellectuals, writers, artists, filmmakers. My favorite women were the ones who corrected my grammar. I'd rather be me than a student, but still, I was absorbed with envy. I smiled at a cute young mother pushing a baby-filled stroller. She blushed and I felt better about myself.

A cool soft-focus haze from the nearby Pacific was slowly burning away. Sylvia's upper-floor apartment came into view. Dash was out front playing with a girl around his age, a cute little dark-and-light mix with thick black hair that draped over her upper half like a shaggy poodle. Dash was dressed in a red hooded sweatshirt, jeans, and tennis shoes. His silky blond hair low on his forehead like a surfer boy; his perfect little face and deep blue eyes lit up like a rocket when he saw me. He ran to me and I quickened my pace and captured his little body, squeezing his love and innocence. I brought him in for a landing and asked, who's your friend? Her name was April, he told me, and she lived with her mommy and daddy over there. I pointed in the other direction and said, "What's that over there?" They turned to look and I took the Tootsie Roll from my pocket and tossed it a few yards to my left. Dash and April turned back to me with question-mark faces, and I explained that I had seen Big Bird but he had flown away. April looked at me like I was insane, but Dash was accustomed to my goofiness. He grinned and shrugged.

"Wow, look at that," I said. "Dog poop. Yum, yum." I walked over and picked up the Tootsie Roll and gave it a lick.

April screamed. Dash's jaw dropped. It was hard to put one over on Dashiell, but I had him this time. I took a bite and gave it a chew, worked the thick brown spit through my teeth with my tongue like Divine in *Pink Flamingos*. Dash yelled, "No, Daddy, don't," and ran toward me but then changed his mind and began backing away, out of my reach. April was jumping up and down and looked as though she might start crying. I swallowed and took another bite. "Mmmmm-mmmm, sweet and chewy. Better than a warm glass of pee."

Dash said, "What is that? That's not real."

"It's a dog turd, but it tastes like a Tootsie Roll. Want a bite?"

Dash came a little closer. "Let me see."

I held out my hand, the last remaining Tootsie segment in my palm. He came closer and took a long look. It looked like poop but it also looked like a Tootsie Roll. Dashiell decided to trust I wouldn't really let him eat dog shit. He said, "Okay," and took the phony turd, smelled it, and then put it in his mouth. Now April really started screaming and it dawned on me, maybe I'd gone too far.

"It's just a Tootsie Roll," I told her. "It's candy. It's a joke. I threw it on the ground when you weren't looking. See, look, Dash is eating it too. It's just candy."

Dash said, "I'm eating poo."

From up above, Sylvia came out and looked at the ruckus down below. "What's going on out here. Why is April crying?"

"Hey," I said. "How's it goin'?"

It took Sylvia about ten minutes to placate April, who, as it happened, was under Sylvia's supervision while her parents were out running weekend errands. To my great dismay, Sylvia didn't

see the humor in my Tootsie Roll caper. By traumatizing a tot whose well-being was Sylvia's responsibility, I was getting off to a bad start. Once we had the kids playing quietly in Dash's room, I affected a swagger and grabbed a handful of Sylvia's ass, pulled her close to me. "I was thinking about fucking you on the drive down. I've still got kind of a boner."

Sylvia wasn't in the mood. "I'm not in the mood for playing grab-ass. You know what? I'm really never in the mood to play grab-ass. I'm an adult. I'm the parent who grew up."

"What? You're above groping?"

"I'm above being groped by a thirteen-year-old. I've got a busy schedule and I didn't get a lot of sleep. If you want to play games, go in and play with your son. If you can do that without your adolescent high jinks."

"High jinks? Thirteen-year-old? You didn't get a lot of sleep? I've been up since yesterday morning."

"Yeah, but that was your choice. I need to go over to Mom's and I've got to go to the grocery store. Can I trust you here with the kids for a couple of hours, or do I have to drag them along with me? I set up a pot of coffee. All you have to do is turn it on. I need to go, I'm already running late. Why were you so late getting here?"

"I thought I was right on time. Go ahead and do what you need to do. I'm fine here with Dash and his friend. They'll be fine. But I gotta know something. I gotta know if you're going to mellow out so we can have a nice weekend. Because if you're not, I'm gonna drive back up to Santa Monica and sleep for twenty hours."

"I'm sorry. I just wasn't ready to calm down a little girl upset by your shenanigans. We'll have a nice weekend. We're going to Stephen's for dinner and some of his crazy friends will be there.

He's looking forward to seeing you. I've been taping *Lonesome Dove*. You can watch that until I get back."

And with that she went. I turned on the coffee, then went and checked on Dash and April. "Hey, guys and gals, how's it goin'? I was thinking I'd make up a batch of vomit cake for a snack, you want some?"

※

Sheba and I were naked. My camera lens and my stiff pecker were both aimed at her. She was smiling. "You got a nice dick for a white boy. It's big, but part of that's cause you so skinny."

"I'm not skinny, I'm small boned and all the rest is muscle."

"How come you still takin' pictures? 'Cause I don't think pictures is what you really want. Bet you'd like to gag me with that big white dick. Isn't that right? Hard dick like a gun, huh, Bob? You wanna shoot off in my face? See if I care." She climbed back onto the bed, on all fours. "Come on, Bob, you want to hurt me, then stop fucking around and hurt me." She sucked down another shot of the Crown Royal; she was nearing the end. She smiled and licked her lips.

※

Sylvia had a desk with a computer set up in the little dining area. We had bought the computer together before the split. I wanted it to write my great American novel, but Sylvia had custody because she needed it for school, which was deemed both more important and less cockeyed than my literary ambitions. She was proficient in DOS and Word Perfect 4.0. I was still learning.

I took a cup of coffee to the desk and, after three false starts, got booted up to a directory and went looking around. I wasn't looking for anything particular, just window peeking through

Sylvia's life trying to find out how much money she'd been making and reading letters she'd written to friends. I opened a file name LIST. Fuzzy bright yellow type on a green screen, a long scroll of names. It took a few seconds to figure out what I'd found: everyone, from beginning to end, Sylvia had ever had sex with. No big deal, a fun list we've all made a time or two, kind of a personal boast. But this was different. Some of the names, a few, were from the years we had been married, the years I'd been in Saudi Arabia, in New York—the years I'd been with her in the same bed every night. A rush of nausea bent me forward and I suddenly needed to go to the bathroom.

Sheba told me I looked like I was going to explode and if I wasn't going to hit her, or hurt her, maybe it's because I wanted it the other way around. Maybe she should slap me. She didn't care one way or the other. "Is that what you want, Bob, for me to slap your face?"

I told her I didn't know, but, yeah, maybe, and hadn't fully considered it when she caught me completely off guard, slapping my face with a flat roundhouse, knocking me sideways. A swarm of electric mosquitoes buzzed my head. My first reaction was to double my fists and knock her cold, but I pulled back. "I don't think I want to play rough. Actually, I know I don't want to play rough. It's not a good idea. Not today."

"I think you do, Bob. I think you want to hurt me real bad. Go ahead, I don't care, just go ahead and fucking do it."

When my mother divorced my father, she broke his heart, which is not something I blame her for; everybody gets a little heartbreak,

it's part of life, like wrinkles, abortions, and crabs. I tried to be a good shoulder for my pop to cry on, but I understood why my mom dumped him. The thing I didn't understand was his surprise; the breakup had been coming for years, everyone else saw it, but he was in shock. How could he not know she didn't love him anymore? I swore I'd never be like him, oblivious of my own life.

At Sylvia's, in the bathroom, I saw who I was in the mirror: a cuckold sap. Had I really been that obtuse? When Sylvia and I had first fucked, she was in a relationship with another guy. Had I really believed a woman who would cheat with me wouldn't also cheat on me? I prided myself with my powers of observation; I was the guy who could explain the movie that no one else understands—the over-plotted novel that's too tangled for the average reader. I could anticipate Sylvia's next sentence, word for word, before she opened her mouth. Yet, the LIST had been right there, on the green computer screen in fuzzy yellow text.

There had been a guy at the end of our relationship I'd known about, but the marriage was already over; we had both, by then, reneged every vow. I probably would have let the whole thing blow over, except the guy, a pumped-up ex-military killer of some sort, kept coming around trying to ingratiate himself. When he told me he wanted us to be friends, I had to put my pacifist ideals temporarily aside, pick up a tire iron, and lay the motherfucker out, sending him hobbling off to the emergency ward, never again to darken my door.

But still . . . the LIST and the names it bore, there had been nothing personal toward me on their account; you offer the average guy a piece of ass, he's gonna take it. He's not going to care about her husband, his wife, or much of anything else beyond his inflated dick. Sylvia's transgressions, however, were a personal betrayal with an intimacy I'd never experienced.

Rummaging through Sylvia's medicine cabinet I found her Valium stash. I shook one out from the brown plastic container and swallowed it. I put the container back where I found it, then took it out again and put it in my pants pocket. Dashiell and April were in his room watching *Honey I Shrunk the Kids*. I kissed Dash on the back of his neck, putting goose bumps on his arms. Sylvia often accused me of trying to turn Dashiell against her, but she was wrong, I always lied to Dash about Sylvia. I always told him his parents were equally no-fault; we had disagreements that had no right and wrong, no good or bad. But right now I wanted Dash to hate Sylvia as much as I did. I didn't want anyone to love Sylvia, ever.

On the couch in Sylvia's living room I picked up a *Time* magazine and thumbed through a depressing article about the greenhouse effect. Humankind was collectively murdering the planet, but I couldn't concentrate. The LIST wouldn't leave me alone. It seemed to me Sylvia was an angry feminist who behaved like the kind of men she hated the most, as if hidden away in the folds, she had a dick that made her act like a typical male jerk. I had never felt as self-righteous as I did at that moment, and I hated Sylvia with all the fervor of a glassy-eyed fanatic.

My neck and shoulders were on fire, but the Valium was slowly melting, spreading its tentacles, massaging my brain. It had been more than twenty-four hours since I'd slept, and I was suddenly overwhelmed with exhaustion. Laying my body down, hugged tight to a pillow, I closed my eyes.

I opened my eyes and Dash's face was close to mine. I kissed his nose. He said, "April and I are going to make a swimming pool in my room. Is that okay?"

"I guess so. Do you have a diving board?"

"No, we're not going to do that."

"Okay, you're a sweet boy and I love you. You know that?"

"Uh-huh."

"You guys want anything to eat?"

"Not vomit."

"No, cookies or a sandwich or something."

"No."

"Okay," another kiss on the nose. "Have fun."

I closed my eyes and went away again, though not to where I wanted to go. I dreamt my least favorite recurring dream: I was in the childhood room I shared with my brother. It was summer and my body was in a sweat. It was late at night and everyone was asleep. A single nightlight flickered yellow up from the bubbling lava down below. The windows were opened but screened for bugs, the curtains flung aside, dark blue shadows animated by the hot breeze. I could hear the sound of a sharp knife cutting open the screen. A killer climbing through the window, coming for me. I couldn't move, for if I did, the killer would kill me for sure. The thing about this dream was that I figured it out. When I was a preadolescent, we had a Peeping Tom in the neighborhood, and his shadow had crossed my ground-level bedroom windows and terrified me, more than once. Years later it dawned on me: It was a kid I knew; he lived a couple doors down and was a couple of years older, and he was most likely trying to window-peek my sister and had the wrong room. Even with this knowledge the dream remained effective, and when the killer was all the way in the room and standing over me, smiling and evil, my eyes closed tight, petrified and soaked with perspiration, my only possible recourse was to work out a scream that would wake up the whole house, chasing the specter away. And now, on the verge of

a movie-land scream, a hand gripped my arm and shook me and Sylvia said, "Wake up. Scot. Don't scream."

Over time, sharing my bed, both Danielle and Sylvia had learned to sense my shrieks coming on. Even from a deep sleep, they would wake, momentarily, long enough to wake me before the screams started.

As my head cleared I saw that Dashiell and his friend April were standing in the room. Dash looked primed to cry, and I noticed that Sylvia's face had turned red and she had grown horns. I said, "Uh, how's it goin'?"

While I was sleeping, keeping watch over Dash and April, they had carried dripping plastic buckets of water from the kitchen and bathroom and emptied them into a semi-inflated rubber pool in Dash's room. They had puddled the apartment in the process. Sylvia assured April she was not in any trouble and hoped she could still spend play days with Dash now and again. She clearly didn't want to traumatize the girl more than I had already done. She sent Dash and April outside so that we might have a discussion.

Sylvia waited until Dash and company were out the door, then she detonated.

❈

In the motel room, Sheba had a tight grip on my erect penis, tugging me forward to the bed. I was reeling in place, immobilized with hate and a hard-on.

"Something real wrong with you," Sheba said. "You want to hit me? I know you do, I can feel it. You like how that feels, you want more? Maybe you want to get even, knock me down, put your dick in my face. Go ahead, I don't care. Hit me, slap my face, make me do what you want."

※

Sylvia called me a failure on all accounts, an unhappy jerk, too weak to walk upright like a man. I would end up friendless and bitter, and my son would hate me because he would realize what I really am, a worthless, vengeful, and bitter misogynist bastard, too stupid to see my own reflection in a mirror. She said she could take Dashiell away from my bad influence; with a snap of her fingers she could strip my legal rights. She said I didn't deserve Dashiell's love and she would someday take it away. I said I was sorry a thousand times, admitted I was an idiot, but what's done was done, so let's clean up the mess and put it behind us, it's only fucking water. But she wouldn't stop, berating, beating a long-dead carcass, assaulting me with all the anger, from all the wrongs, of her lifetime. I stood there with her every breath up close and in my face.

※

Sheba's pint of whiskey was down to backwash. She drained it and threw the bottle across the room. She perched on the bed like a cat, spit whiskey-tinged lubricant into her palm, and applied it to my penis. "You want to hurt me so bad it hurts you just thinking about it. Isn't that true, Bob? How come you don't say nothing? How'd you like to bite me, huh? Go ahead, bite me, bite my titties. I don't care." She jerked my penis, again and again, told me to do something, anything, other than just standing there moaning like a fucking sissy.

※

And through all the hurtful things Sylvia could dredge up and spew at me, it was not the words so much that put me in a

clinch. It was the tone. Sylvia could take a tone that chan-
neled demons, a tone that bored through steel, pinned me to
the ground, and rubbed dirt in my face like a schoolyard bully.
No matter how I struggled I couldn't make her stop. I couldn't
move, as if someone had come through the bedroom window
to murder me and the only thing I could do was scream my
way clear of paralysis, loud enough to wake every sleeping soul.
Then I remembered: The LIST.

I yelled non-words and hit Sylvia hard, with the heel of my
hand, and she went to the floor.

※

I yelled non-words and ejaculated on Sheba's tits.

※

I left Sylvia's without slamming the door. Dashiell and April were
sitting on the bottom step. Dash came up, meeting me halfway,
into my arms. "I'm sorry, sweetie, I'm not going to be staying like
we planned. I gotta go now. Sometimes your mom and I kind of
hate each other, but no one ever hates you. I love you and so does
your mom. However, just between you and me, I'm the good guy
and your mom is the bad guy. And no matter what she says, you
and me belong together." I desperately needed to wipe the hurt
from his face.

The sky darkened above us and Sylvia came out. She said,
"Why are you still here? I don't want you around Dashiell. I don't
want you poisoning him against me. Dash, you and April need to
come inside now. Say good-bye to your dad."

We said good-bye, without tears, though we both got runny noses.
I legged it to the Camaro and set the coordinates for Anaheim.

I got dressed but Sheba didn't bother. She hadn't left the bed, had wiped my semen from her chest with the bedspread and crawled under the covers for an afternoon nap. For the first time in a couple of hours my breathing was back to normal. I said so long to Sheba, unlocked the three locks, and opened the door. The two thugs from the ice machine were waiting for me. My heart accelerated and I couldn't catch my breath. The larger of the two nodded into the room at Sheba, then to me, "She take all your money?"

"Indeed she did, and now I'm busted."

He yelled into the room, "Sheba! Sheba. You take all this man's money?"

From the bed Sheba told him I had more. She'd seen it in my billfold.

He grabbed me by the arm and gave me a hard jerk.

"Wait, wait, wait, alright? I'll give you what I got. Let's stay calm, alright?" I took out my wallet, removed the sheaf of money and handed it to him, then opened the wallet to show him the empty frown.

"What's in the bag?"

"It's a camera and it's old and battered and not worth anything to you and I'm willing to fight to keep it."

This made him laugh.

"There," I said. "I made you laugh, brightened up your day a little bit. So how about if you just let me get the hell out of here? Have a nice day."

"Go on. Git."

Across the parking lot to the curb where my car was parked, I keyed open the hatchback, pulled back the carpeting, opened the wheel-well, and picked up the tire iron. The muggers were back at the ice machine, watching me with bemused expressions.

I replaced the jack handle, reassembled the flooring, and closed up the hatch.

Getting mugged is like a car crash. It happens fast, too fast for the real fear to set in, as your brain is busy calculating survival. But then, five minutes later, or maybe an hour or a year, your body gets cold and starts to shake and you feel like crying; fear and anxiety puts a cold sweat across your forehead and you want to hide beneath thick winter blankets. I sat in the car while the instant replay looped round and round in my head. I cranked the ignition and turned on the heater, full blast. I wanted to gear the Camaro into drive and leave a black smear of rubber on the pavement, but my flight was impeded by a brand new and rather frightening physical anomaly.

When I was in high school I had a beautiful 650-cc BSA Hornet motorcycle with a custom tuck-and-roll leather seat, a candy-apple red paint job, straight pipes without mufflers. I only weighed 125 pounds, which gave me a great advantage in drag races. From stoplight to stoplight I could beat any other bike and most of the cars in town, and I could jump, from the rolling hills of the Missouri Ozarks, like Steve McQueen in *The Great Escape*. The cops took to chasing me for sport, and we all had a pretty good time. Then one fine day, flying through the air, showing off for a couple of giggly girls, I took a spill and ruined my cervical spine and lower back. I was punishing myself for being an idiot.

So when things went wrong—an arm that goes numb for a week or month; shooting pains; stiff neck; twinges here, there, everywhere; muscle cramps and jittery fingers; nerves that hum like a generator—I would grit my teeth and not give it a lot of thought.

Getting mugged had set me shaking, which made sense, but my leg, my right leg, was Saint Vitus's dancing, independent of my

brain, and that didn't make sense. I grabbed my thigh, holding it down like a small animal; my motor control had thrown a belt. I kicked and kicked and kicked like a junky in the throes of withdrawal. I thought maybe this time it was something more, something serious going on with my body; maybe I was dying. AIDS, cancer, MS. My time was almost up and I would die unfinished, and without accomplishment. I closed my eyes and attempted meditation, which doesn't work all that well with an obsessive mind. Searching for happy thoughts, I imagined getting out of the car, going to the ice machine, kicking the crap out of the gangsta duo, and taking my money back.

It took about ten minutes to regain control of my extremities and another ten to forget about it. It was 3:00 p.m. when I got to Santa Monica. It seemed like it should be midnight. I walked to a walk-up ready-teller and attempted to take out sixty dollars, but I only had twenty available, my life's savings. I needed some sort of financial stability if I was ever to be the parent I wanted to be, but even so, being flat broke and thirty-nine years old didn't bother me all that much. If money was the root of all evil, I kept myself pure.

At Gus's apartment complex I parked out on the street. The apartment building was two-stories, enclosed with a pool in the middle. At night when the pool lights were on it reminded me of William Holden in *Sunset Boulevard*. Gus's place was on the second floor. He had a small deck overlooking the pool, with sliding glass doors into the living room. For no real reason, rather than walking up the steps to the door, I climbed a tree up onto the deck and pressed myself into the glass door, looking inside. Gus was on the couch watching television. I tapped on the glass with my fingertip. Gus turned and saw me peering in like a

nightmare. He yelped and jumped nearly off the couch, grabbing his chest. He looked as if I had just taken a few years from his life. I knew it wasn't funny and I would apologize profusely. But for the moment, I couldn't stop laughing.

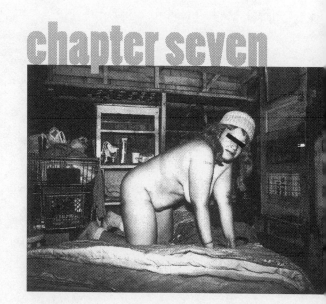

chapter seven

rat fink

1989

For five days a cold-blooded rain trampled Greater Los Angeles. The locals were in a tizzy, stacking sandbags like sopping diapers around iffy foundations. Hillside homes slipped and slid down the muck on the six o'clock news. Heroes in helicopters fished drowning idiots up from the now-flooded L.A. River, and freeways trundled forward at three miles an hour. I loved the rain, the hipster patter on the pavement, windshield wipers smearing

my Technicolor view. It was dramatic, like the quiet that follows gunshots, and romantic, like a good-bye fuck.

The storm had trickled to a drizzle. The streets were silent; the low rumble of my Camaro, king of the jungle. I was solitary, following Atlantic Boulevard in Long Beach, somewhere in the netherworld, with nowhere to be, nothing to do, and a vampire thirst I needed to slake.

Stopped at a corner next to an old school building, I got a little surprise. It was Long Beach Polytechnic High School, where my father had gone in the 1930s. I'd never seen it before, but I knew all about it. John Wayne had gone here for a couple of years; Van Heflin and whacky big-band leader Spike Jones had graduated from here. Actress Laraine Day had been a year ahead of Pop. In 1933 the Long Beach earthquake leveled the high school, and for his last two years, he attended classes in government tents. I even knew a Poly High cheer. Zim zam goddamn, who in hell are we? We're hidey tightey Christ almighty, we're the Poly Bees.

※

Three blocks later in the shadows, on the sidewalk, a working woman in tatterdemalion camouflage crawled up from a foxhole like a battlefield ghost and signaled me with a reticent smile. Pulling to the curb, I tipped my imaginary hat and opened the passenger-side door, and she climbed in. She was made of flesh and blood. Her face was doughy and freckled, her eyes narcotized. She wore a stocking cap from which spilled matted plaits of unwashed hair, and in the crook of her left arm, a faded, red rose tattoo, hypodermic thorns in the tangle of vines, red and abscessed.

She spoke through a carious yet winning smile. "What's your name? Mine's Rose. I'm really glad you stopped for me. I'm clean,

so you don't need to worry none. I don't got no syph or AIDS or nothin'! You're not a cop, are you? Turn left here. You got anything to smoke? Turn right. How much money you got to spend? You got anything to smoke? What's your name?"

"I'm Scot. Go through the ashtray, there might be a roach. Welcome aboard."

"Scot, huh. Scot Scot po pot. Go left at the light. I got a garage. I live in it. Hey, here's a roach. A good one. Got a lighter? Go that way. You're good-lookin', I don't see guys look like you much. What do you wanna do? Turn right up here. Go slow, we're almost there. You got a lighter in here? It's really a nice car. How much you pay for a car like this? Where's a lighter?"

I handed Rose my silver Zippo, a recent gift from a nonsmoking girlfriend. "I only have twenty bucks to spend and I want to take your picture. Where we going up here?"

Rose flambéed the joint and pointed us west and then north where the landscape began to lose its healthy glow. I could hear the Long Beach Freeway and see an orange mist of lights above the structures. It was late and the liquor stores were gated for another three or four hours; bums curled into sleep like guard dogs in the doorways. Rose sucked smoke and studied the lighter on which a Big Daddy Roth Rat Fink was enameled in black, white, and lavender. She gave me a sidelong casing and dropped the lighter into her pocket.

"Gee whiz, Rose, where'd the lighter go?"

She fished it out and gave it back to me along with a shrug and a grin.

She took us down a long dark and bumpy street and told me to park at the curb. I killed the ignition but left the lights on for a minute, scanning the neighborhood. This was the left edge of Long Beach, a block or so from the L.A. River. Capitalist

bombs had dropped from the sky. Old, once-proud single-story homes were slumped with shame. The bars on the windows were newer than the paint jobs. Inebriated mailboxes, stuffed with wet trash-mail, tongues hanging out, unchecked until the third of the month. The road was rutted and muddy. I saw an old guy, faded gray and spectral. He ran tiptoe through marshy weeds from behind one dead oak to another.

Rose was sucking roach remnants through her burning fingernails.

"Did you see that guy?"

She ate the ash and chewed the nail. "What guy? I din't see no guy."

"Over there, playing peekaboo."

She put a friendly hand on my arm. "Let's go inside, Scot. C'mon, isn't nobody out here anywhere."

"I want to know who that guy is. Is he a friend of yours?"

Her smile went away. "He's shit. He's nobody. Don't pay him no attention."

"Is he going to be a problem?"

"He won't do nothin', c'mon, let's go inside."

A veiny streak of lightning delineated distant storm clouds like a monochrome newsreel of World War II. The rumble of thunder was somewhere in the future, beyond my audible range. I grabbed my backpack from under the seat and followed Rose up a skinny sidewalk, through a chicken-wire gate, to the back entrance of a ramshackle two-car garage. Rose keyed the padlock, pushed open the door, and we stepped inside. She pulled the chain of a bare bulb. "Watch where you walk; it's been rainin'."

The floor was muddied, puddled, and sloped. The plank walls, pockmarked and soft with rot. Three shopping carts filled with plastic bags and castaway clothes; dead and wounded furniture;

a large galvanized trash can filled with old *TV Guide*s. Nothing of current value, no one's keepsakes, childhood books, or toys— nothing lost, missed, or remembered fondly.

I found a semi-dry spot and set down my backpack. The air was thick with mildew and sour with the taste of mold. A low-hanging cobweb caressed my face with sticky, translucent fingers. I slapped it away, but not before a gaggle of make-believe mites ran into my hair and down my spine, making my skin itch like a nettle rash. I shook myself like a wet dog, took a breath, and lit a smoke.

"Here's twenty bucks. I want to take some pictures."

Rose sat on a slim and stained sleeping bag draped over an ancient mattress and springs. Snuggled in the folds, next to Rose, a big fluffy black cat opened its eyes and yawned.

"Hey, kitty-cat, how's it going?"

"That's Big Mama Hoodoo. Me an' her is sisters from another life. Can Big Mama Hoodoo be in the pictures too? Want me to take off my clothes?"

"Yeah, yes, to both questions. That'd be good."

I checked the camera and flash settings while Rose undressed. "You sure all you wanna do is take pictures? I'm clean. Do you like blonde girls? I gotta frien' that's blonde and real pretty. You could take her picture; she lives in the house here. She's clean too. You'd like her; she's real pretty. You take pictures of pretty girls alla time, I'll bet. Good-lookin' guy like you. We should go and meet my frien' and you can take pictures of both of us. You got any more money? You wanna meet my frien'?"

"Maybe later. Let's go ahead and take some pictures now."

Rose posed, on hands and knees, next to Big Mama Hoodoo, and pretended she was the cat's sister, cocking her head and saying meow, meow while I clicked the shutter. She was a natural, like a

little kid playing dress-up. She stood up and jumped up and down on the mattress flapping her arms.

I motor-drove my thumb and burned film. "That's good, that's great, just a couple more, do that again, yeah, that's perfect." I shot to the thirty-sixth frame, then wound it up and began packing my gear while Rose got dressed. I always shot Kodak Tri-X when photographing hookers. As I was putting away the Nikon, I realized I'd set the film speed for 800 recently and forgot to put it back to 400. I would need to push-process the film, and the photos would be grainy with clumped-up black tones and blown-out whites.

I was obsessing over my stupid mistake when a sound, the sniff of a runny nose, drew my eye to a large hole booted in the bottom corner of the garage door. The creepy guy I'd seen outside had his head in the hole and his eyes on me. I jumped a foot and yelled, took three quick steps to the hole and kicked, but missed. Gravel scattered as he ran away. "Jesus! Who the fuck is that guy?"

Rose was pulling up her pants. "He's nobody. He means nothin'. Forget him. You wanna meet my frien'? She's real pretty. She lives right here in the house. C'mon Scot, you'll like her."

I had shot up the last of my film and so my rationalization for staying, hanging out with Rose and friend, was shot to hell. However, the photo session with Rose hadn't sparked my libido and my libido needed sparking. I needed a hard belt of something dark, dangerous, and ill-advised before heading to Gus's place, where I would toss and turn in my makeshift nest and not get to sleep until it was time to get up again. Maybe Rose's friend would appease my addiction.

We went from the garage to the house and around to a door with a boarded-up window, both shamefaced and misanthropic. Rose knuckled a shave and a haircut while I kept watch for the creeper. By now I had ascertained the old guy was probably not a

physical threat; he was more afraid of me than I of him, but still, I didn't want him sneaking up on me.

Rose and I shuffled and said nothing for thirty seconds or so before an anxious female voice squeezed through the keyhole: "Who is it?"

"It's me, Rose. I got a frien' for you."

Inside, the sound of a something heavy scraping across the floor. The door opened a crack and a couple of shaded eyes took us in.

"Oh god, Rose, who is that with you? Oh god. I look like shit. Oh god, oh god. Is he okay, Rose? Do you know what you're doing?"

I donned a friendly face. "Sure, I'm okay. I'm a good guy. I'm safe and sane."

"Uh, alright, shit, come on in." She opened the door and backed away, veiling her face with her hands. We walked into the kitchen and she ran into a bathroom. I closed the door behind us. Rose said, "Help me with this," and began pushing an old weighty kitchen table up against the door. "Bunch of niggers came in last week. Knocked out the window. Stephanie jus' told 'em get the fuck out. Din't you, Stephanie?"

"Yeah," Stephanie yelled from the bathroom. "Yeah, Rose. Who is this guy, Rose? What's he want?"

Rose herded me like a blue-ribbon stud to the half-opened bathroom door. "He's a photographer. He's my frien' and he jus' wants to meet you. His name is Scot."

Stephanie poked her head out to give me a quick once-over. She said, "What do you want?"

"Companionship."

"Are you serious?"

"Sort of."

"Can you help us with some money?"

"Yeah, maybe, probably. Not a lot, but sure, okay."

"Oh god, I don't know. Okay, alright. Go into the other room while I get ready, both of you. I'll be there in a minute."

In the living room a cluster of three nicotine-hued bulbs hung from the ceiling by a single wire. The walls were blotchy, piss yellow, damp and pliable. There was no furniture. In the center of the room a plastic garbage can sat collecting drops from the leaky ceiling above. Next to the garbage can, on the floor, sat a big ugly white guy. We both tensed. He growled and jumped to his feet. His eyes were bleached-out blue and flitting nervously. He had a bulbous fetal-alcohol-syndrome forehead. Rose took my arm and pulled me forward, serving me up: "This is Clay, Scot. He's cool. It's alright, Clay. This's my frien' Scot. He's jus' here to see Stephanie."

"Hey, how's it goin, Clay?"

He sniffed around us to the kitchen, bristling like a bulldog. With a nasal bluegrass twang he muttered, "Ahs gonna talk to Stepney."

Rose and I sat on the floor in front of a large overflowing orange ashtray, a *People* magazine, a *TV Guide*, *The National Enquirer*, a *Vogue*. Rose bummed a Kool King, which I lit for her, clinking my Zippo open and shut.

Stephanie blew into the room like autumn in the Ozarks, with Clay storming in on her heels. She had fixed her hair, applied foundation, mascara, lipstick, and slipped into a clean white cotton dress and plain pumps. Rose hadn't lied; Stephanie was very pretty. I wanted to grab her and hold her and run away with her. She looked more out of place than I did. She sat next to me, Indian-style, and offered me her hand. "I'm Stephanie."

Clay linked into the circle and spoke, gruffly, at me, "Why're y'all here?"

It was apparent Clay was low on intellect, but it was just as clear that he could and would kick my ass without prior notice. He reminded me of certain childhood friends, long since banished from my life. "I don't know why I'm here," I told him. "It just sort of happened. I guess I just want to hang out for a while before tomorrow starts everything all over again. How's that sound?"

"Whatta y'all want?"

Stephanie took my arm and admonished Clay, "You leave Scot alone. He's here to see me. Be nice or go to your room."

Clay lowered his eyes and snorted phlegm.

Rose said, "Scot's my frien', ain't you, Scot? Me and him took pictures, din't we? Scot gave me twenty dollars jus' to take my picture, so's I told 'im I got this frien' an' she's real pretty. That's you, Stephanie. You're the one that's real pretty. I's right, huh, Scot? Don't you think she's real pretty?"

Stephanie was the queen and absolute ruler of this little monarchy. She said, "Shut up, Rose."

Rose shut up and scrunched hurt into her face.

Now Stephanie spoke directly to me, excluding the others. "You don't make sense," she told me. "What you told Clay, that you just want to hang out with us. That doesn't make sense, Scot. Look at us. Nobody anywhere would want to hang out with us. I don't think I should trust you, but I'm going to because I think I like you."

"Gee," I said. "I think I like you too."

Rose had been rocking in place waiting for a turn to talk, and when she finally did, she yelled, "You got anythin' to smoke, Stephanie?"

"Shut up, Rose. Don't you know when to just shut up?"

Clay opened a fist and voilà, a milky-white ball of crack cocaine. He smiled and said, "Ahs got dis here."

Stephanie said, "Jesus, Clay!"

Clay was clueless. "Wha' I do, Stepney?"

"I got a pipe." Rose was back in the saddle. "Lemme get the pipe. There's enough we can all have some. I'll get the pipe, okay, Stephanie? Scot don't mind, do you? See, he don't mind. Lemme go get the pipe."

"Sure, it's alright with me," I said. "Go get the pipe. I'm pro-drugs."

Rose crawled, on all fours, to the other room to fetch her paraphernalia.

Clay looked at the floor and said, "Y'all mad at me, Stepney?"

Stephanie reached a hand over to Clay and stroked his face. "No, Clay, I'm not mad. I just wish you would be more careful." Clay raised his head and smiled, his bad mood lifted high from her touch. His bottom teeth were missing. "Ah protect Stepney," he informed me. "Ah was all by mah-seff an' Stepney helped me. Ah's from St. Louis."

Stephanie tended to keep her head turned, hiding her left profile, concealing waxy splatters of burn scars starting an inch below her left ear and disappearing down the back of her white cotton Peter Pan collar. "That's nice, Clay. You need to settle down, now." She smiled at me, for the first time.

She was warming to me and I could already see us naked and sweaty.

Rose zoomed back into place with a well-charred glass pipe, which she handed to Stephanie, who placed the drug on a picture of Arsenio Hall in a porkpie hat, on the cover of the *TV Guide*, and divvied it up with a fingernail. She put the largest piece in the pipe and handed it to me. I handed it back. "You go ahead. I'll spectate."

She touched my arm, my leg. "I'll give you a shotgun. You'll like it." She had become friendly, and while I figured she still

didn't trust me, I thought she liked me, and it seemed she wanted me to like her, though it was possible she wanted me to like her because she was programmed that way and she didn't really like me at all. I guess all the same could have been said about me; I wanted everyone to like me, whether I liked them or not.

"Yeah, alright. I'll do a shotgun." I handed her my Rat Fink lighter, the ritual torch. She spun the wheel and sparked the wick. The coke melted and crackled into a thick, rich smoke that smelled like exploded firecrackers and mothballs. Stephanie sucked the life from the rock and inhaled down to her toes. Without exhaling she took in another. This one she held in her mouth. She put her free hand at the back of my neck and pulled our faces together. She put her mouth on my mouth and blew narcotic smog into my system. I took it in and held on to it. My extremities went tingly. My heart marched double-time and my head fragmented. My balls and butthole vibrated and I got a boner. Stephanie pulled away and we both exhaled dizzy whooshes of spent smoke. My fingers were throwing sparks.

Stephanie put a hand on my cheek, kissed my other cheek, and whispered into my ear, "If you have money, we can get another rock. Just me and you."

"Uh, I dunno, maybe."

Our private moment shattered when Rose jumped in with, "My turn my turn my turn." I had forgotten we weren't alone, forgotten where I was and who I was. Clay and Rose were waiting their turns at the pipe. Stephanie handed the pipe and my lighter to Clay.

Clay looked at the lighter, then at me, and said, "Rat Fink!"

I said, "Yeah, Big Daddy Roth."

He plucked up one of the remaining chunks of dope and started the process. Rose objected. "It's aposed to be my turn, Stephanie.

Why's Clay get a turn before me? It was my idea. I got the pipe, din't I? I brought you Scot, din't I? It's not fair, I gotta sit here and wait while everybody else gets alla good parts."

Stephanie said, "Shut up, Rose, or you'll have to go wait outside. I know you don't want that. Elmo's out there. I saw him when you came in."

This got my attention. "Elmo?"

Rose raised her volume. "Don't you tell him, Stephanie. It don't matter nothin'. C'mon, Stephanie, lemme have a turn at the pipe. I brought you Scot, din't I?"

"Elmo? The Peeping Tom?"

Stephanie turned to me. "Rose's husband. He was beating her up, so I put Clay on him. Now he's all weird."

Drug residue exploded from Clay's lungs and he giggled. "Ah hit 'im real good with muh club, huh, Stepney. Hey Scot, y'all wanna see muh nigga-knocker?"

"Do I want to see your club? Is that what you're asking?"

"Uh-huh, wanna see?"

"Maybe later." Or maybe I said, "Maybe later gator." The smile on my face was starting to hurt.

Clay palmed my lighter and handed Rose the pipe and a book of matches. Rose lit up and sucked and held it in until she was red. She exhaled blue smoke and held up her hands, making kitty claws with her fingers, saying, "Meow, meow, purrrrr."

I couldn't sit still and needed air.

Stephanie took my arm and whispered, "Let's take a walk, Scot, just you and me."

We rose like smoke, and a thousand crystal gnats blinkered around my peripheral vision. We were nearly out of the room when I made an about-face, retraced my steps, and knelt down

next to Clay. "Hey, buddy, you got my lighter?" He took it from his pants pocket and gave it to me.

＊

Stephanie and I walked together under a spooky moon. I thought about my father growing up in this neighborhood and wondered if he would recognize it now. I didn't pine for simpler times; I didn't believe the past was ever better, only different. The street ended at a chain-link fence. A weedy ditch sat between us and the L.A. River, which started here in Long Beach and ran like a great concrete sluiceway up through Los Angeles forty-eight miles into the San Fernando Valley. The sidewalk was broken into chunks. Curbs were flooded. Yards were mud and weeds, rubble and ruin. Everything organic was dead.

"When I was a little girl, I lived in Connecticut," Stephanie told me. "We used to play Step on a Crack, Break Your Mother's Back. Did you do that?"

"Not really. We didn't have cracks where I come from. We just had holes."

"You're funny. Why did you take pictures of Rose? Are you making fun of her? Are you making fun of all of us?"

"I don't think so. I don't know. Maybe, sorta. I like to take pictures, and I can't afford real models. It's just what I do."

"Do you want to take pictures of me?"

"Yeah, but I'm out of film."

"Do you want to sleep with me? You can. I want you to. I'm not really a whore, but I do need some money for coke. Just a little bit. My family had money. I went to college for three years. You went to college, too, I can tell."

"Actually, higher education didn't work out for me. I answered

a different calling, you know: sex, drugs, rock and roll. If I could do it all over again, I'd skip high school as well, get a head start on the bohemian lifestyle thing."

"You don't like to be serious, do you? Rose told you that I'm pretty. Do you think that I am, Scot?"

"Yeah, sure, I think you're pretty. I think you're very pretty. Prettier than I'm used to."

"I have scars all over my back and part of my neck."

"Yeah, I know. Doesn't make any difference to me, I kind of like them, but I expect it bothers you a lot."

"A boyfriend in New York said I stole his stash. I didn't steal, Scot. And I'm not addicted to anything. He threw a pan of hot bacon grease on me. I never took his stash. Do you believe me, Scot? I never touched his stash."

"I believe you. And even if I didn't, it doesn't change anything. The guy was an asshole."

"I was in the hospital for a while." She touched me, cautiously at first, squeezing my left biceps, then hooking together our arms. "Do you really think I'm pretty, even with the scars?"

"I think you're beautiful, Stephanie. I'm an idiot for not having more film."

"Really? Will you stay with me tonight, Scot? Do you want to sleep with me?"

"Yeah, I do. But, I don't know, I should probably go soon."

We turned a corner. Two doors up, a couple of kids sat on a curb, plunking rocks into puddles, breaking curfew. Stephanie directed us toward them.

"Do you have twenty dollars?"

"Uh, yeah, sure."

"Let me have it. I'm going to get us a rock."

"They're selling drugs? They should be selling Kool-Aid."

"Their people are watching us from the house. Just be quiet and let me do the talking."

"Yeah, alright."

We approached the little guttersnipes with a smile. They were black and skinny. They both wore baggy clothes with big pockets. The little one was eight or nine, about the same age as Dashiell. The older boy I guessed at thirteen. The side of his face bore a pinkish discoloration shaped like the map of Texas. Both boys nodded at Stephanie and glowered at me. The littler guy spit through his two front teeth at my boots. The strand divided into four parts: three hit the street and one went down his chin.

I took out my wallet and gave Stephanie my last remaining twenty, the last of sixty dollars originally earmarked for child support.

The little guy spit again. This time he bulls-eyed my left toe. I wiped my boot on the back of my right leg and gave the kid a grin.

Big brother said, "Can't take your money, Stephanie. Don't know your friend."

"Take the money," Stephanie called the boy by his name, which I didn't get. "Get me a bag. He's with me and that's all you need to know. Take this twenty and go get me a bag and hurry up. I don't like standing out here."

Big brother looked at me for a while, then he looked at Stephanie and mumbled something I didn't get. He gave the twenty to his little brother along with a push, and the little guy ran through the front yard and disappeared into a single-story dump with a detached garage and three dead tires in the driveway. We waited without talking. I lit a smoke and blew smoke rings, poking my index finger through the holes. A cool, wet breeze was blowing; street lamps flickered. I thought of clever things to say but kept them to myself.

A few minutes later the kid was back with the goods, which he gave to Stephanie. "Next time don't bring nobody else," he spat. "Mama said so."

As we walked away, I wondered about the future of America and I thought about Dashiell and I hoped he didn't grow up to be like me.

We headed home, Stephanie's left hand holding my right in a soft young lover's grip full of hope and sexual urgency. In her right she squeezed a white-knuckle grasp on the rock cocaine. After a while she took my hand and spun herself under my arm like a smooth dance step. She put her left hand on my neck, her breath on my face. "You hurt, don't you, Scot?"

"Huh?"

"When you don't think anybody is looking, you twist your neck. You've got a lot of tension in your neck and shoulders, and I think I can make it better. I've got magic fingers."

"That'd be nice, I guess, I mean, if you could. Nobody ever noticed before, or they just think I'm neurotic. It's kind of weird, you know, your noticing. Tell you the truth, right now, I'm kind of tight from smoking that speed."

"I thought so, I can almost read your mind. It's like I already know you, Scot. I already know you, and you already know me. It's fate that we came together like this. You and I are different than everybody else and I think we belong together. We could be good for each other."

I couldn't think of a reply so I kissed her on the lips, the way a hero kisses a virgin. Her eyes were hazel and for a moment I thought she was going to cry.

"Let's stop here for a little bit, Scot. I don't want to go back yet. Let's just talk. Do you ever go dancing?"

"Uh, do I ever go dancing?"

"Yeah, you know, to the clubs. I used to go dancing all the time. God, I love to dance. That'd be really nice if you and I could go dancing sometime. When I was in junior high I took ballroom dancing lessons at the country club; seems so strange now. I was shy and skinny and the boys made fun at me because I was flat."

"Me too, sort of. I mean, nobody made fun of me because I was flat, but I took formal dance lessons. My mother bred me for society and success."

"Mine too. If you don't want to go dancing, maybe we could go to a movie sometime. I read a thing in *Vogue* about a Woody Allen movie that's supposed to be funny."

"*Crimes and Misdemeanors*. I, ah, saw it the other night. It was alright, had a good ending."

"Oh. Maybe we could see something else. Sometime. You know, together."

"Yeah sure," I lied. "I'd like that."

Long pause.

I took my ever-present tube of Blistex from my shirt pocket and rubbed a soothing dab on my lips.

"Can I have a little of that?"

"Yeah, sure," I held out the tube to give her a squeeze. "No not that way," she said. She took my hand and the tube, squeezed a blop on my index and brought my finger to her lips, rubbing it in.

"I guess we should get moving," Stephanie said after a bit, giving me a tug. "I think I want to get high again. You know?"

"Yeah, I do."

Back to walking, rain clouds shrouded the moon, and wind-blown shadows animated weedy front lawns. One of the shadows

took human form. It was Elmo. He kept to the side and just ahead of us, bounding from one inadequate hiding place to the next. I maintained a close watch. The crack-cocaine concussion had finally stopped vibrating, and my heartbeat was almost back to normal.

At the house, the lights were all on and the door stood open.

Clay sat on the floor in the living room, hunched over an opened can of Colt 45 malt liquor, holding it with both hands as though he was strangling a small animal. Rose sat, her arms lassoed around her knees, rocking on her butt, smiling like a happy baby. "You get anythin' to smoke?" she asked us. "I could use a little sumpin to smoke. I got that twenty dollars Scot gave me, Stephanie. If you want, I can give you it for sumpin to smoke."

"Yes, Rose, we got a bag and you can have some. But you should give me the twenty for later."

Rose dug through her pockets for the crumpled bill.

When Clay saw me he gleamed a prospector's grin and shouted, "Hey Scot, hey Scot, looket I got, looket I got!" He set down his can of malt liquor and picked his club up from the floor. He swung it around like a caveman felling a mate.

I waited until the club came down for a landing and knelt next to Clay. "That's a pretty cool club, Clay. Can I see it?"

"Ah made it all, jus' me by mah-self." He handed me the club.

It was nice, for a club, carved from dark wood, lathed into a half baseball bat, shined with shellac. "This is nice, Clay. You made it all by yourself, huh? That's pretty impressive." I handed it back and gave him a friendly pat on the shoulder. "You got any more of those Colt 45's?"

"Inna icebox. Go 'head, get you one."

I thanked him and went into the kitchen. In the fridge, two cans of Colt 45 and half a Reese's peanut-butter cup sat alone.

No basic food groups, just like home. I heard a sniffle at the open door and took a look. It was Elmo. I jumped a foot and yelped, as before. Elmo had a haunted appearance that weirded me out; he was translucent, like Casper the friendly ghost. He was holding the cat, Big Mama Hoodoo, curled and purring, in his arms. "Hey Elmo, I don't think you're supposed to be in here."

He froze, closed his eyes, and played invisible. He wore a stocking cap that was a twin to the one Rose wore. I pretended I couldn't see him and walked back to the other room. I took two long drinks of cold brew. It washed away the evil crack taste and massaged my speed-sore neck and shoulders.

Around the campfire all eyes were on the peace pipe, which was prepped and ready to launch. I sat on the floor and handed Stephanie my lighter. She clinked it, cooked up the crack, and aromatized the room with the sharp gunpowder smell. I increased my malt liquor intake. Stephanie vacuumed smoke, and then, at the same moment, we all looked up. Elmo, still believing in his invisibility, stood watching us from the doorway. Big Mama Hoodoo had stopped purring. Stephanie spoke softly, holding in smoke. "Get him out of here, Clay."

Clay was up and moving fast. Elmo turned to run but didn't get far before Clay began swinging his customized cudgel. A glancing blow to the back of Elmo's head sent a bloody divot of hair spinning through the air. Elmo dropped Big Mama Hoodoo, who let out a yowl, which sounded like *ouch*, and flew out of the room without touching the floor.

Rose jumped up and ran after Elmo and Clay through the kitchen and out the back door. I left my can of Colt 45 and got up to follow. Stephanie grabbed my hand and attempted to pull me back down to her. She blew smoke up at my face. I broke her grip and trailed the others outside.

Clay stood victorious, beatific, in the moonlight. He held his club skyward, looked at me, and puffed with pride. "Ah fucked Elmo up real good, huh, Scot?"

"Yeah, buddy, you sure did."

Elmo was flat on his back in the mud. His eyes were open but unfocused, his face bloody and puffed up like rotten fruit. His right arm was doing electric flip-flops. Rose was on her knees at her husband's side.

"Big ol' Elmo, you was gonna take care of us. We was gonna be high alla time. I was gonna be your pussycat, meow, meow, meow, 'member that? You was aposed to keep us high alla time, 'member, Elmo?"

She went through his pockets, pulling out a handful of change and tattered green singles. "You got some money, Elmo?! Where'd you get all this money? I could be gettin' rock with this. Where'd alla this money come from?"

Stephanie came out of the house and down the steps. She wrapped her arms around my waist as though she might pick me up and carry me away. "Let's go back into the house, Scot."

"What about Elmo? He's kind of fucked-up. Maybe we should take him to a hospital."

"Just forget about him, Scot. Forget about all of them. They're nothing but trouble. They're not like us. Let's go back inside and get high and go to bed. Just you and me, Scot. Together." She ran a hand up my inseam and kissed my three-day stubble. Standing here, on the bad side of Long Beach, my father's boyhood stomping grounds, in the midst of this little dysfunctional family, I thought about how I might have ended up here myself. Then I realized I was here, this was where I ended up, and I needed to get the hell out right now.

I broke away, took out my keys, and walked toward the car. "I'm sorry, Stephanie, but I think I need to go now."

"Please don't leave me, Scot. I don't belong here. I belong with you. I'm not even supposed to be here. I'm supposed to be some-place better, just like you are."

I looked at Clay, Rose, and Elmo in the yard, then into Steph-anie's eyes. They were glassy and wet. She was right. She didn't belong here, but I couldn't fix that. I couldn't even fix myself.

"I'm sorry. I have to go now."

I legged it to the car, climbed in, and cranked the motor. Stephanie walked back toward the house and I watched her go inside without looking back. Two blocks later, when I shook a Kool from the pack, I realized Stephanie still had my lighter and I would never see it again.

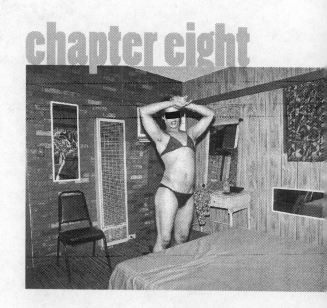

chapter eight

easter

1990

The one and only time I kissed Tina was on a Saturday night in April. I held her cushy body tight and close so that she could feel my erection. She kissed me back with tongue and passion, and it struck me this was the best kiss I'd had in a while. But Tina broke the kiss, pried herself from my embrace, and said, "No, Scot. We're not going to do this. I'm not going to do this."

"Are you sure? Because I'm not so sure."

She was real sure. Plus, we'd had too much to drink, and she was sure that anything beyond this kiss was not what I really wanted.

I told her yeah, okay, you're probably right. But I didn't mean it, and I don't think she did either. We both wanted to fuck, and we wanted it loud and nasty. But Tina couldn't trust me for the commitment that fucking might bring about. My arms were still wrapped around Tina's body and I didn't want to let go. I was ready to say just about anything to put us level and naked on the couch, but I unwrapped her from my arms and took a step back. "That was nice, Tina. I'll see you in the morning."

※

I met Tina ten years back. I had a seven-month gig at a studio on Wilshire as a yearbook photographer, one of a crew of four bread-and-butter photographers who, daily, loaded the company van with equipment and drove to high schools as close as Hollywood High and as distant as Mojave High, where we photographed the graduating students in caps and gowns, coat and tie for the boys, fuzzy boa drapes for the girls.

Tina was the head photographer; she photographed the families, businessmen, children, and babies of a clientele long established by the family-run studio—sixty years in the same Miracle Mile location. Tina's position was year-round and she didn't work with us school crews, the smokers and jokers looking forward to unemployment checks after the season was spent.

Tina was cool; we liked each other right away. She was short and cute with blue eyes, blond hair, and an Eastern European beak. She had big, squeezable tits and a round butt. She was single, self-sufficient, leftist, and arty; she laughed at my jokes and owned her own home. Her passion was photography, and she

was good at it. When I showed her my Kodachrome collection of off-kilter portraits, she praised it and made me feel like the artist I wanted to be.

The end of the season brought my layoff, which coincidentally coincided with the breakup of my seven-year marriage to Danielle. Eight months later, I hired on for another season with the studio and Tina was still there. A romance might have bloomed between Tina and me but for a part-time receptionist, newly hired, a hot and nasty little number, twenty years old. Her name was Sylvia. Shortly thereafter, Sylvia and I left Los Angeles— Sylvia forever, and me for the next six years.

Back in L.A., six years older, a father, and now unattached, I gave Tina a call.

And then, on a Saturday night in April, I kissed Tina. Why wouldn't I? We went to groovy restaurants a couple of times a month, and Tina always picked up the tab. Museums, art galleries, culture. Often, on my custodial weekends, Dashiell and I stayed at Tina's little hillside Silver Lake bungalow. We went to kid-friendly restaurants, children's museums, and the zoo; went horseback riding and to movie matinees. Tina had a love thing for Dashiell, which added to her high score. She marveled at my whore photos, and I proclaimed them *art*: political, humanitarian. Tina was a pacifist and a feminist, and I tried to be that way too. I wanted to be saintly and pure of heart, but try as I might, I was tainted. Along with the big lie—I never had sex with the hos I photographed—there were other things I couldn't share with Tina. She was serious about the world we lived in, and I didn't think it was worth the worry, sadness, and misery. Was I in love with Tina? Maybe, sort of. Though for me, I couldn't really grasp True Love without first getting my dick wet. Therein, our conundrum.

I awoke, at nine, the morning after kissing Tina. My bladder was pulsing, my ears were ringing, and my mouth was dry. I reached for my watch and a glass of water on the night table. I wrapped my head with my arms, ratcheted my neck, and made six loud cracks. I took my daily starter dose of Dristan and Blistex. I took pause and looked at the little body sleeping next to me. When Dash and I stayed at Tina's, we slept in her bed; she slept on the living room couch. I could hear her in the kitchen and I smelled coffee.

Dash came alive, opened his pretty blue eyes, reached out his hand, open palm, and ground my nose flat into my face. "Smashies," he said, in a drowsy voice. Smashies was a variant of the titty-twister.

I waved a white flag, said, "Hey, Bonehead, good morning. What's that on your pillow?" Above his head, an Easter basket, woven of multihued plastic strips, a pubic tangle of green cellophane, two-color pry-apart candy eggs, a six-inch-tall chocolate bunny, three plastic World Wrestling Federation action figures: the Undertaker, Macho Man Randy Savage, and the Ultimate Warrior.

Dashiell took inventory with a smile.

I grabbed him, squeezed him, kissed his neck, and got a love rush. "I gotta pee," I told him. "You need to pee?"

"Huh-uh." He was ensconced in the world of action figures, too busy to go pee.

"Okay, then, why don't you show Tina what the Easter Bunny brought."

"There isn't an Easter Bunny."

"Yeah, well, no shit, Scooby Doo. I'm gonna go pee and comb my hair, and you can go tell Tina thank you, because she's the one who paid for Macho Man and the Undertaker."

And thus began a promising day.

❋

Sunset Boulevard, two-fifteen Monday morning, pale black sky, misty. If I goosed the Camaro, I could be at Gus's place in Santa Monica in fifteen minutes, drinking myself to sleep. Life was all fucked-up and I was stressed tight; my eyes vibrated, street lamps had watery glows, everything jiggled, and I knew sleep would never come, even with libations. I was lighting one cigarette after another and had my index finger in a Kool box, fishing out the fat joint that had been waiting there for a day and a half. My mood was low.

To my right, Sunset and Vine, I spied a streetwalker walking with the traffic, taking furtive peaks over her shoulder, checking me out, shaking her bootie when she ascertained I wasn't the law. I could spot a whore a block away with something akin to gaydar, like my dick was a divining rod. I pulled to the curb and opened the passenger-side door. "Hey," I said. "How's it going? Come take a drive with me." He had a big afro, tight slacks, and a nice ass. He was bigger than me, firm and a little beefy, with enough Afro Sheen in his hair to lubricate a half-dozen muscle men. He wore just a touch of lip gloss and a pair of glasses with large round lenses that looked like they should have windshield wipers. In a certain light he looked like a brown Charles Nelson Reilly, who once honked and winked at me on Santa Monica Boulevard.

I pulled back onto Sunset, bit the twisted ends off my reefer, and pushed in the lighter. "My name is Pinky," he said, leaning to me, putting his hand on my arm. "I've had a hellacious Sunday, and if I start crying, just tune it out, honey, know what I mean?"

"I think I do, Pinky. I'm Scot, I could use a good cry as well."

He looked at me with a gritted smile. "You think I'm just some whore, but that's so wrong I'm not even going to laugh. You don't know anything about me."

"What, where'd that come from? I don't know you at all. I'm not casting aspersions, I'm just some john. Are you working or not?"

"Maybe I am, honey, and maybe I'm Madonna Ciccone. Reason I'm here is because my day, all day and all night, has been like double-S shit, S-H-I-T."

"Well, I'm sorry to hear that. My day got fucked as well."

"Mine has been way worse than yours, honey. You've never, *never* had a day like me."

"I have no doubt. Tell you what, you tell me your fucked-up day and I'll tell you mine, then we go someplace and take some pictures. I'll give you twenty bucks."

Pinky puzzled his brow. "What about your jollies; don't you want to get your jollies? I can deep throat like a porn star. Fifty, like twenty-twenty-ten, is what I need. I've gotta get all of that or more, or I can't go home."

I lit the joint and sucked heat into my lungs, held it for a count of ten, and my brain let out a sigh. "At the moment, sex is not uppermost in my head, but you never know, sometimes things happen."

"I know you. Don't I? I know you from somewhere, honey. I know I know you. You take pictures like look-at-me-and-smile, don't you?"

"Yeah, well, I just told you that."

"But I already knew it before you told me."

"I don't think I know you, and I don't think you know me, but if you want to think one thing while I think another, I don't mind." I offered him the joint but he shook his head, so I took another hit and held it in until my ears buzzed.

Pinky's hands flew about, an ebb and flow of mania in his voice. "That guy, the fucker, like a mean dog you gotta back away from.

He's there, in my apartment, my home. I don't even know the asshole, but I know he's a fucker. I'd like you taking my pictures. Raunchy pictures?"

"Raunchy as you want to be."

"You should come home with me, honey, throw that fucker out of my apartment and tell him I don't have to give him any money. The fucker. The stupid little fucker."

"I don't think I'm the guy you need to give another guy the boot. I can give you the fifty you need and safe haven for a while, but you gotta elevate my mood. We're headed west here, if you don't mind I'm just going to drive a while."

"Want to know what happened?"

"What happened, you mean your lousy day?"

"I woke up sometime a while ago in the daytime, honey, then everything went double-B bad."

<center>❋</center>

Dashiell climbed into the backseat of the Camaro and buckled himself in. Tina sat in the front passenger seat. Into the Hollywood Hills we soared. It was a beautiful day, winding, climbing, palm trees and spaceships bolted to a beveled landscape. When the sun shines in Hollywood, everything is pretty, bright like ice and clean as a summer rain, which never happens in Southern California. And sometimes the landscape burns and crumbles, and it's all lowbrow and shamefaced. I love it both ways.

We arrived at a thirty-year-old split level, high above the boulevards, nose to the air snubbing those below, and snuggled into the wooded mountainside. I parked at the curb and we walked up a winding sidewalk, a parallel white-rock garden with blooming cacti. Through red double doors and through a maze of rooms, people, and jazzy hip-hop music, hugs from complete strangers,

Tina's friends and family. Everyone was telling me how beautiful Dash was and Dash affected a scowl, hoping the conversation would turn elsewhere.

Eleven people wove through our threesome: two of Tina's sisters; a brother-in-law; the brother-in-law's brother and his girlfriend and her two kids, boys; two of Tina's friends, one of which brought a date, along with another kid; and, finally, some guy who had a diapered toddler wobbling about, a girl I think. Three of us were photographers. Two were painters, one who painted houses and the other a rising star on gallery row. One woman was a successful sculptor—her art displayed throughout the pad, abstract pregnant women, squat and three feet high, oval slits for their eyes. One woman was a freelance production manager who worked on documentary films. One guy was a gaffer and a union man.

Everyone was educated. They had Smith Barney accounts and they recycled. They were political, left of left; they volunteered their time to worthy causes and wore baggy clothes of quality cut and design. They owned Saabs, Audis, Volvos, and one guy, the photographer, had a restored red and black 1966 Mustang Cobra. They attended peace rallies. They were atheists, agnostics, lapsed Catholics, and secular Jews. At Christmas they went caroling together and at Easter they had an Easter egg hunt in the backyard, which is where we were now.

The kids, five of them between the ages of four and ten, along with a few helpful parents, set out exploring the yard for candy-filled plastic eggs. Tina went with Dash, and I sat on the deck a bit alone in the crowd, keeping a low profile, listening to conversations, watching Dash and Tina, hoping they would find enough candy for me to forage a chocolate handful. It was clear

to me that Tina and her crew of arty, like-minded successes were the people I should have been hanging out with all along. But it was too late for that, and I was ill at ease and a little envious; I couldn't relate to their progressive wholesomeness. At heart I was a hustler; given the opportunity and know-how, I would have picked their pockets and stolen the Mustang.

Someone behind me said, "Just a single aspirin a day thins your blood." Someone else said, "The death penalty is murder every bit as much as murder is murder." Someone was talking about Leni Riefenstahl, and I wanted to hear more, but the conversation, amalgamated with the tintinnabulation and audio imagination already in my head, sounded like a carny midway, barkers and thrill rides. I was all alone. In my shirt pocket I had a fat joint nestled like a little piggy in a box of Kool Kings. Even though I knew it would only take me further from the social discourse, I was looking for an opportunity to fire it up.

I went back to thinking about last night's kiss and where it didn't lead. Tina and I had always dated other people. We both made mention of this one or that one over a dinner now and then. But recently, I'd had a couple of dates with a woman who was turning me upside down, and I'd made no casual mention to Tina.

I'd quit my full-time job after two years. It was a good gig but took up too much of my time. Besides, after two years of gainful employment, my debts had somehow tripled, and I was still crashing with Gus in Santa Monica. I'd been freelancing optical camera work on the swing shift at a computer graphics company, which is where I met Carol, a computer artist, who worked the day shift. Two years my junior, Carol was from San Francisco; she'd been an art major at Berkeley during the revolution.

Her hair was flaming red and her ass wiggled nicely. We talked a couple of times, at the end of her shift and the beginning of mine. Two or three weeks back, the ides of March, she walked into the camera/darkroom, coy, with her hands behind her back, inquiring to my health and well-being. "I was thinking," I said. "You should give me your phone number and I can call you and we can talk about stuff."

She said that was a good idea, she liked talking about stuff, and then unballed her hand to reveal her phone number and name on a yellow Post-it.

"Hey, kismet. Do you like food? Maybe we could go out for food sometime."

Carol said, "That's a good idea. I love food."

Love in bloom.

The Easter egg hunt wound down and I was pleased to see that Dash and Tina had made a score. I'd harbored concerns that the health-conscious parents, in the stealthy guise of the Easter Bunny, might fill plastic eggs with trail mix, or worse, they might hide actual decorated hard-boiled eggs, but my paranoia was for naught, as Dashiell had a bounty of high-fructose goodies. I nabbed a couple of bite-sized Milky Ways before he set down the basket.

※

This is how Pinky's day started: He awoke at 2:45 p.m., and his first thought, a new day, filled him with dread. His body was cold, empty, shaky, his underarms damp. Pinky wore a pink rayon nightie that fell with a ruffle just below his midriff above matching thong panties. He had an erection that curved leftward with two inches taking the air above the elastic waistband. Taking penis in hand he squeezed with all his might. At times he wished he could pull it out by the roots; at other times he wished he could bend

forward like a contortionist and put his hard dick into his mouth and down his throat until he choked.

Pinky lived just off Vermont down below the groovy line at Sunset. A Hispanic neighborhood with primary colors, junk shops and taco joints, beautiful girls, wide women, and short men. Pinky's bedroom, on the first floor of a pink stucco apartment building, was small and cluttered. The walls, once white, were the color of dead oysters. The bed wasn't a bed but was a mattress on the floor. Glossy ephemera taped to the walls: Brook Shields, Grace Jones on the Golden Gate Bridge with James Bond, Tina Turner, Prince in *Purple Rain*, an oversized Valentine card of a couple of Smurfs kissing, a single eight-by-ten color portrait of Pinky in a high school graduation cap and gown: a golden tassel, hanging from the button atop the mortarboard and tangled in Pinky's afro, which puffed out below the cap like shiny black pom-poms. His glasses and his eyes were partially burned away with the white glare of a poorly placed umbrella light. His complexion was smooth and dark with high cheekbones that also reflected the white strobe light. His face would have been pretty if only he could strip away the contorted fist of anxiety.

Up and out of bed, Pinky dug a red kimono from a clothing pile, covered himself, and attempted to silently open his closed door, which stuck at the upper right corner and reverberated, like cartoon blubber lips.

First thing Pinky noticed in the living room, asleep on the couch, was an ugly little guy he'd never seen before. The room was strewn with a thousand junk food wrappers and empty bottles, drug paraphernalia, and the ash of spent narcotics. Pinky needed to go into the bathroom and the kitchen, both of which required he walk past the guy on the couch, and Pinky preferred

to avoid confrontation or even conversation with the stranger.

The guy was short and skinny, dressed in a grungy pair of boxing shorts, and seemingly out for the count. Pinky tiptoed from one corner to the next into the bathroom, locking the door and taking a seat. He held in a fart and aimed his pee just above the waterline to keep the noise down. It frightened him that anyone might hear his bodily functions.

Pinky wished he had taken the time to peek into the other bedroom to see if his roommate was home. Her name was Spice, and usually when strangers were flopped in the apartment, they were flopped in Spice's bed. Spice was a crack whore and Pinky didn't like her but needed her meager rent to avoid sleeping under the stars. Pinky had been homeless for nearly two years before moving into this dump. He dreamt of a permanent home, a two-car garage, a birdbath in the back yard.

From a plastic tube dispenser, Pinky pulled out a couple of wet wipes and cleaned himself between his legs, front and back. He flushed and held his breath, as the water circulated, as though it somehow helped to muffle the sound. Out of the bathroom, Pinky checked the other bedroom for Spice, who was not there. Pinky headed for the kitchen, and it was too late to stop his forward motion when he noticed that the stranger was no longer on the couch. And then Pinky and the guy were standing a few feet apart looking at each other.

The guy said, "You got any money? I need some fuckin' money."

※

Sitting on a plump leather footstool with a plate of homemade waffles, Tabasco scrambled eggs, homemade sausage, and seedless watermelon squares. A cup of coffee nearby and a chilly mimosa in hand. Tina was next to me on the tubby leather chair. Between

me and Tina, Dashiell was half on the chair and half on the foot-stool. There were eight or so other people in the room, arranged in a circle, eating and talking. I was trying very hard to not be contemptuous; I didn't want to categorize my fellow humans when I didn't really know them. Contempt, however, was always with me, and I didn't have the proper meds to chill myself out.

Dash was eating off my plate, but not very much. He'd already had a bunch of candy, though I don't think he'd had as much as I. The other kids were all somewhere else, playing together. The adults were having grown-up time. I figured grown-up talk is better for Dash than children talk; kids are mostly idiots.

I'd kept a step back for most of the adult conversation, but the talk turned to movies and I was considering expressing an opinion. The talkers were discussing ratings, NC17 in particular, because of two current movies: *The Cook, the Thief, His Wife, and Her Lover*, which just about everyone except me had seen, and *Henry: Portrait of a Serial Killer*, which no one, except me, had seen. No one supported censorship, though a couple of parents said they screened television and movies before allowing their kids to watch. That sounded like censorship to me but I kept it to myself.

Dash, nibbling at the food, moved in closer to me, sat half on and half off my leg, vying for my attentions. I gave him a hug and went to move my plate. As I set my drink on the coffee table, I glanced down and saw something of potential embarrassment, something I didn't want anyone else to see.

Yesterday, I had left Santa Monica around two in the after-noon. Traffic was heavy and it was nearly five before I stopped in La Jolla and had a bite to eat at a local coffee shop with my friend Stephen. I left Stephen around six and headed to Sylvia's to pick

up Dashiell. On the way, I picked up a whore and parked in an empty lot while she gave me head. It was quick and clean and I took a couple of pictures. The hooker was twenty to thirty, white with big red lipstick-y lips, and I gave her twenty dollars. I drove to Sylvia's, where I picked up Dash. We arrived at Tina's in Silver Lake around nine. I put Dash to bed, and with lights turned low, Tina and I talked and drank and snacked and then kissed, and then went to bed. Sunday morning I got up and dressed in the same clothes as the day before; I traveled light.

And now, I noticed, on the button fly of my faded blue Levi's, two fat lip-prints, vibrant red lipstick. I forked the last little syrup-soaked waffle square, popped it into my mouth, and set the plate over my crotch. I looked around the room, and it seemed that everyone must have noticed and now they would notice how I used the plate to hide the kiss print. But no, I'd been marked this way since yesterday and nobody had noticed, or at least nobody said anything. Even so it was time to excuse myself to the bathroom and attempt to remove the scarlet letter pasted on my barn door.

Pinky's eyes were wet and he had the sniffles. "Then he hit me," he told me. "Like in the stomach, for no reason except he's a fucker. I was almost barfing and I'm on the floor, can't even hardly breathe, and the fucker goes, like, 'Bitch you gotta go get me some money.' Tells me I gotta go suck you-know-whats until I've got fifty dollars and I don't even know who the fucker is. It's my apartment, not his, you know what I mean, mine and Spice and she wasn't even there, and she's like the skank who brought the fucker there in the first place. He's supposed to be Spice's pimp, but not mine. I never had a pimp, never."

"You hungry?" I asked. "You want to get something to eat?"

"I know you, I know I know you," Pinky said. "But you don't even get it, you know. You can take pictures and I can strip and shake like a Solid Gold Dancer and I can give you deep throat but you promised me money and I don't see it. I trust you, you know. I really do, honey. But I can't go home without fifty dollars."

"I'll give you the money, I promise. There's a twenty-four-hour IHOP up here; we'll get a bite and I'll pass a check, or if I can't, we'll find a ready-teller. I'll buy you some pancakes and we can talk art and politics, and then we can go somewhere and I'll take a couple of pictures and I'll give you fifty bucks and a ride home."

We passed the Crossroads of the World building: a big blue planet Earth atop a space-age steeple, a round art deco structure with porthole windows fronting Hollywood's first shopping mall. I could see the black-and-white past like an old Movietone newsreel: klieg lights and premieres, Bacall holds a cigarette and Bogart lights a match. A block later the International House of Pancakes was bright and ugly. On both sides of the street extravagant old Spanish architecture mixed with crappy strip malls. Inside IHOP in a puffy yellow booth, an elderly couple looked at me with blank expressions. She had fifty pounds over him, a platinum bubble hairdo and pinkish makeup with greasy specular highlights. He looked like Arnold Stang, an actor from the 1950s and 1960s, skin and bones and a face that triggers bullies into action. I smiled at her and then at him but they didn't react. Pinky walked next to me, gingerly holding my left biceps with both hands. "Is that okay? You know, if we look like we're together, you're not, like, embarrassed?" He pushed his chest into my arm, and I noticed he was wearing a bra.

"We can pretend all you want, Pinky. I don't think this will put a stain on my social standing. Nobody gives a shit."

"I do, I give a big S-H-I-T."

"That's great, good for you. Let's scoot into this booth here." Pinky scooted in after me on the same bench seat, up real close. He leaned his head on my shoulder, but my shoulders were wound pretty tight and I couldn't keep them still, rolling and stretching the sore muscles, Pinky's head bouncing. I told him no offense, but I didn't want Afro Sheen staining my shirt. He lifted his head but stayed close. The waitress brought us menus and I told her coffee and a few minutes to make up our minds. Pinky put his right hand on my left thigh and rubbed it around tenderly. "This is how it's supposed to be, honey," he said. "I'm not a whore and you're not a john, you know what I mean? This is awesome, isn't it, Scot honey? This is something going to last like a long, long time."

"Hey, listen, you want to snuggle up while I eat pancakes, that's fine, but after we take pictures, you're never going to see me again. I know things are fucked for you, but other than feed you and give you fifty bucks, I don't think I can do much. I've got my own shit to contend with."

Pinky batted his lashes at me, and through his thick glasses, they looked a little like porcupine prickles. "But for now, just for now, we can like each other."

"Yeah, sure."

Pinky blew in my ear, and his sour breath reached my nose. He moved his hand, covertly under the table, from my thigh to my fly, smiled at me, glanced down, as though checking to see what his hand was doing. "Oh, honey," he said. "Someone has been naughty, naughty. Is that lipstick?"

<center>❊</center>

In the bathroom, Dash and I peed together, crossing our streams in a pee-pee sword fight. I went through a half-dozen toilet paper

squares trying to wipe away the lipstick but to no avail. I considered going back out to the party and accidently-on-purpose pouring a cup of coffee on my crotch to mask the Revlon smear. I decided to ignore it and hoped everyone else would too.

Out of the bathroom, Dash and I explored the house, which was orderly and sleek, wood floors and swami rugs. In the master bedroom, a large Ansel Adams, Moonrise Over Someplace. It irritated me and I realized I couldn't be friends with the people who lived here. "I don't like that picture," I told my seven-year-old son.

"Why, what's wrong with it?"

"Nothing really, I just don't like it, it kind of puts me in a bad mood." Dash's hand in mine, I turned and tramped into another room. The kid's room.

The kids were on the floor watching a video, *Beetlejuice*, on a jumbo television. I didn't really register the kids one way or another, but I thought Dash would like *Beetlejuice* and I told him so. He agreed and tried to convince me to stay and watch it with him. We settled on me coming back in a little while to check on him. He took a spot on the floor and I rejoined the party.

In the living room, I couldn't remember anybody's name. I crossed the room to Tina's pretty side. A woman on the couch turned the conversation toward me, and I felt like I should run away. "Tina," the woman told me, "showed me and Brent two of your pictures. I thought they were very interesting; we both did." She pointed her nose at a guy two chairs down, reminding me this was Brent, and Brent gave me a nod to verify his existence. The woman continued, "How did you ever get started on a project like that?"

Everyone was looking at me and I figured I looked like a spaz; my neurotic twinges triggered, trying to sit while covertly covering

my telltale button fly. Addressing the room, I said, "Yeah, it's fucked-up. Well no, that's not what I mean. I was working in Long Beach for a while, you know, optical camera, I do optical camera, freelance, corporate, uh, boring." I wasn't functioning properly. Tina thought I was smart and funny and I knew she would like to see me demonstrate that at this moment. "Anyway, I worked nights a lot." It was all true, but I was making it up as I went. "And when I left at night, on my way to the freeway, I would see a gaggle of working girls." Now my standard joke, "I can't afford real models," but it didn't work. "You know, I don't know, I try to make good pictures of bad things and I try to make mine different than anybody else's."

"Yeah," Brent threw in and shared with the room. "They're like Diane Arbus pictures." Now I was sending telepathic lasers at Brent's brain trying to give him cancer.

And then a pause, and then I heard the worst sound I've ever heard. Dashiell screaming with pain and agony. I turned cold and sick. I was up and running and into the children's room and Dash wasn't there but the other kids were and someone called my name and I went that way and Dash was still screaming and now he was not just screaming but screaming *Daddy Daddy*. Out the door, the concrete driveway of this split-level home, seven or so feet below the deck, which also served as the garage roof, which somehow Dash had fallen from. He was crumpled into himself and his left arm was very, very wrong.

※

At IHOP I had blueberry pancakes with eggs and bacon. Pinky wasn't hungry but drank three cups of coffee. Back on the street I found a ready-teller and took out sixty bucks, which was only there because my car payment check was still in the glove box.

I drove west onto the Sunset Strip, which was the first place I'd gone upon arriving in Los Angeles in 1967. Everyone was beautiful and groovy, free love and drugs. Music. It was the most perfect place I'd ever seen. I supposed it was still like that, for seventeen-year-olds from the sticks. Now, driving the Strip at three-thirty in the morning in the Camaro with Pinky bouncing about next to me, it all seemed somehow illogical, like dreams and reality on a crash course.

Pinky was hyper, leaning into the dash, watching everyone on the street. "Wish I had some coke," he said.

"Yeah, so do I."

"We can totally get some, I know a bitch, sells fat dimes."

"No, not tonight Pinky. I'm going to find us a room and take some pictures and then I'm going to drop you wherever you drop and then I'm going home to sleep for a while and then I'm going to wake up and go be loving and responsible."

"Are you mad at me?" Pinky's eyes were watery. "Don't be mad. I like this, whatever it is we're doing. Don't be mad at me."

"What the hell are you talking about? Why would I be mad at you? You're the perfect date."

"I don't know. I need to tell you something, honey. I need to tell you I need fifty dollars, or I can't go back home."

"I got that missive earlier; we'll cash out in a while. Try to relax."

Mötley Crüe was on the marquee at the Whisky A Go Go and a bunch of redneck punks were loitering about. When I was a kid back in Hicksville, I had a record album, *Johnny Rivers Live at the Whisky A Go Go*. Somehow that seemed monumental or maybe ironic, and I thought about how it can't really have any meaning for anyone but me. I turned left on Doheny and we flew down two steep blocks to Santa Monica Boulevard, turned east through West Hollywood.

"I used to live a couple of blocks from here," I said, pointing my chin at the clubs, the eateries, the impeccably gay denizens. "Know what I see, Pinky? When I look around this part of West Hollywood, you know what I see?"

"Faggots."

"No, not at all. I see no one spitting on the sidewalk."

"You're not going to get all radical, are you, Scot? You're not going to go all gangster, please don't do that, let's just be boy-friend and girlfriend for a while."

"I'm the sanest person here. Why would you even ask that? I think you hear things I don't say."

"I'm just afraid you don't like me."

"I love you, Pinky, my pet. What more can I say?"

Eastward back toward Hollywood, passing the Pleasure Chest, a super-sexual-supply store that barred me from coming back be-cause I was photographing the dildos; Paris House, rent a naked girl and photograph her in a private room, great fun for sixty to a hundred bucks; the Pink Pussycat, get your gay porn on a big screen and pretend you're Joe Buck. Next, on the sidewalk, came the rent boys, all the reasonably priced pretty boys on the auc-tion block, rough-and-tumble boys stroking their dicks through denim, tight T-shirts, flexed from head to toe and then, the twinks, sad, skinny, and shameless, and the scared husbands from the Valley pulling to the curb, trying to act like they're straight while bartering for blow jobs. I grew up in a time and place where homosexual liaisons were more shamefaced than going to a whore. When I was sixteen I saw a guy fuck a sheep and if I'd called him queer he would have come after me with a pitchfork. But I always liked the creative culture of queerdom as well as the outlaw status; doing things I shouldn't do was what I did best, and homosexuality was by definition against the laws of all the

almighty gods, who, in my opinion, could go fuck themselves.

On Santa Monica Boulevard at Fairfax, Pinky pointed to a blond bulge of muscle in front of a low-slung burger joint with kinetic neon signage, his thumb in the air as though he was headed for Route 66. "I've seen that ho a lot and I think he wants me."

"Yeah, should we go back and pick him up?"

"Yes, yeah, really, honey, you mean it?"

"No, sorry. I don't mean it at all, just a joke."

"You shouldn't joke me, that's all bad gyrations, man. You've never had to sling your personal stuff just to get enough money to go home."

"You don't know that, Pinky, and I was just making a dumb joke. You gotta stop being so defensive. I like you just fine, and besides, I'm paying you for your time."

"All forgiven, clear skies ahead, let's kiss and make up."

"You said it, Pinky." I touched my right cheek. "Put it right here."

Pinky gave me a kiss on the cheek and I think it made us both feel a little better.

※

On the pavement beside Dashiell, holding him. His left arm was fucked-up way beyond home remedies. But I didn't want to believe it; it didn't make sense. Someone called 911, an ambulance was on the way, and it was becoming real and there was nothing I could do other than what I was doing, holding my broken little boy, trying, trying, trying to fix the pain with tenderness and kisses and lies, telling him it's going to be all right. I was afraid of his arm, afraid of touching it, moving it, causing more pain; I didn't want to look at it. Tina was with me, I realized, holding me as I was holding Dash, attempting to ease the pain. For a moment I was in love with Tina, then I focused on Dashiell, and there was nothing else in the world.

Dash was sniffling, the hand of his unbroken arm in mine, his head in my lap. I told him how much I loved him, how lucky I was to have him for a son, because there is no better son than he, anywhere. I told him I know it hurts but it will get better. I told him his arm was broken and when I was a kid I used to break bones all the time, one time I even broke a bone in my back and I broke the little finger on my right hand three times. I looked into his eyes and tried to transfer his pain to my body, which was already fucked-up and unimportant, but it didn't work, I couldn't make it work. Silence all around, and then the ambulance wailing up the hill to take us to the next scene, more surreal, but maybe, hopefully, somehow better. Less fucked-up.

⁂

I found a crappy motel and checked us in for a photo shoot. Pinky had decided we were going steady. "Oh this is awesome, Scot. I want to kiss you and kiss you. We should get in bed under the covers, honey. Play Boy Scouts."

I had used this motel before, two walls of ugly chewed wood paneling, two walls of fake plastic bricks, above the swayback double bed an artistic mirrored-tile arrangement. "Sounds tempting, Pinky, but for now, why don't you strip down to whatever is comfortable and I'm going to document the moment."

"I love you too, Scot honey." Pinky had an imaginative memory. "I want you to take pretty pictures of me just like you did last time." He flung his shirt and pants to separate corners before I'd attached the Vivitar flash to my Nikon. His body had no augmentations; he was all man, hairy chest, empty bra cups, and bulging panties. He had a boner, which he slipped out of a leg hole. He took a pose, then another and another.

Dicks are like the men who have them; some are attractive and some are not. Pinky's dick was purple and shiny like fish guts, skinny and curved like the arrow on a fifteen-mile-an-hour sign. But the pictures were good and I wasn't obsessing on other aspects of my life. "Turn around, show me your ass, and peek at me over your shoulder."

Pinky licked his lips, "Hallelujah, Scot, take my booty. I'll shake it and you take it." He pulled his panties up into his butt-crack like a thong and asked me how does it look and please, please tell me it's hot and sexy sexy sexy.

"Your ass is hot and sexy sexy sexy, Pinky. Sizzle sizzle."

Now Pinky was on his knees, perched at the edge of the bed, jerking himself off, his dick so curved he could cum around a corner. "I can't spew, Scot honey, I need more. You know what I'm talking about, you got to give me more, show me your dick, let me see it. I need it need it need it. Jack it for me, honey."

I told him yeah, sure, no problem, then let my camera dangle from the strap and flopped my most insincere body part through the center of red lip prints.

※

An ambulance like a fast-forward of shapes and colors and then the hospital, Children's Hospital on Sunset and Vermont, where I was behind a white curtain, next to the gurney where Dash was tucked under a sheet, his good arm hooked to an IV, his disfigured arm concealed beneath a small fuzzy white blanket. He was quiet, drugged on something sleepy, but still awake, keeping his eyes on me, looking like he'd scream if I moved from his view. He was completely dependent on me and I'd never felt so needed, so important. I had never felt so desperately that I had to find magic, I had to change the intricacies of time. Why can't I just fucking close my eyes and change absolutely everything?

I was impressed by the medical professionals, and I thought I might be lucky this is where the ambulance dropped us—what could be better for a kid than a hospital just for kids? Tina was with us; she drove the Camaro over and parked it in the lot. A friendly nurse with a clipboard asked me about insurance and I told her I think Dash has Blue Cross, but I don't have the card with me, his mother does that, and she will take care of it when she gets here, and oh fuck, I need to call Sylvia and explain to her that our son got fucked-up on my watch, at a party where the adults were drinking mimosas while the children went unsupervised.

Dashiell's left elbow was broken into a couple of pieces, which required a surgical procedure. He would go home tomorrow afternoon with a cast and a couple of industrial pins. I kissed his face and a nurse injected another dose of sleep-tight and he nodded off. They wheeled him away and I held in a shout; how could I not be with him, every moment? What if he hurts or wakes and I'm not there? I didn't yell but went to the nearest men's room, pissed, and smoked a cigarette. Then I got change in the gift shop, found a phone, and called Sylvia, who exhibited quivering emotion but didn't freak out. When she told me she would be there in less than three hours, anxiety hit me like a snort of methamphetamine. Three hours later Sylvia arrived, and Tina, who had been by my side through the interim, said hello so sorry to Sylvia, and then with a sad, heartfelt hug, she said good-bye to me. Sadly this good-bye became forever and I never saw Tina again.

Dash would be alright, his arm back to normal in five or six weeks, including a stay-at-home week. Sylvia and I were momentarily bound by the love of our son, Dashiell, who we loved more than anyone we ever loved, way more than we ever loved

each other. Tonight, with all that day had brought, we were civil. Things got shaky, however, when Sylvia asked me how it happened. "What, exactly, happened?"

"He fell from a garage roof, sort of, and landed on his elbow."

"He was on the garage roof?"

"No, not really, because it was a split-level kind of fifties architecture thing, house. I think it was about seven feet."

"How did he fall? What was he doing on a garage roof?"

"Not really a garage roof. I think actually it was the garage roof he fell on."

"How?"

"I don't know. I didn't see it happen."

"Who was watching him? Weren't there other kids there?"

Just telling her this made me flinch. "The other kids were watching *Beetlejuice*. I don't think anybody was watching Dash."

"So all you really know is that you weren't watching him and now he's in surgery."

"Yeah, I guess so."

She closed her eyes and took a couple of deep breaths, then changed the subject, though we both knew that someday the subject of my lackadaisical parenting, and Dash's subsequent accident, would come back to haunt me.

Somehow it became 2:00 a.m. and Dashiell was asleep in a room with another kid and an empty bed. Sylvia decided she would stay through the night and be with Dash when he awoke and I should go get some sleep and then back here for when they discharge Dash, midafternoon. She would go back to San Diego, where she had a busy life that needed taking care of, and since Dash couldn't go to school this week, he would stay with me, at Gus's, because I didn't really have anything going on anyway and I could bring him back here in five days for a checkup and then

drive him back down to San Diego and surrender him to her. I told her okay, sure, see you later. And then I went out looking for a whore.

<center>▪</center>

On Vermont Avenue down below Sunset I could see Children's Hospital in the rearview mirror. It had been three hours since I'd left Dashiell and driven off the lot. I could see the dawn in the east. I parked at the curb in front of a pink apartment building that looked like it used to be nice. I was dropping Pinky off.

I dug out my wallet and flipped through the bills, two twenties, a five, three ones. "Oh shit, Pinky, I guess I didn't think about your fifty when I paid the motel; I've only got forty-eight dollars. I'm sorry. Here, take this and I owe you a couple."

Pinky slugged me in the arm and then again in the other arm. "Ouch, fuck," I said, "hey, I said I'm sorry."

Pinky was crying. "I told you, I told you, and I told you fifty times, I need to have fifty dollars. We gotta go back to the bank machine on Sunset, you gotta get my money. How could you do this to me, I thought you liked me, and I've been like in love with you all this time and you don't even notice."

"Ready-teller's empty. This is it, my life savings. I'm sorry if I'm two bucks short, I really am. There just isn't anything I can do."

"You gotta go inside with me. You gotta tell that fucker you're my pimp and nobody else owns any of me. You gotta, Scot, you gotta tell that fucker to leave me alone."

"I don't know, Pinky, you figure I can just go in there and give the guy a couple of karate chops and toss him through the window?"

"He's littler than you, and you got bigger muscles."

"Really? No, no. I don't know." I lit a smoke.

"He's stupid too, Scot honey, you're bigger than him and stronger and way smarter. You gotta come in with me. You got to."

"Yeah, alright, I'll go in with you, but I reserve the right to turn tail and run."

Sidewalk, gate, steps, third door down, cracked and dirty. I was wondering if I should go back to the car and get the tire tool—I'm a bad motherfucker with a tire tool. Pinky gave me his key, on a key-chain with a miniature Barbie. "You go first," Pinky told me, "and don't take any shit."

I pumped up my arms and put on my crazy face. I keyed and opened the door into a gray room of sidewalk-scavenged furniture and a tarted-up babe in underpants and a Lucky Charms T-shirt. Directly behind me, hands on my shoulders, Pinky whispered, "That's Spice."

Spice was hardly awake; she looked at us and laughed. The television was on: *Little House on the Prairie*. "You're just like all the rest of the cunts," she said. "Leave me alone."

Pinky emerged from my shadow, looked around. "Spice, where'd that guy go?"

"What guy, you the one got a guy standing there."

"The guy that was here. The fucker hit me in the stomach. Is he coming back?"

"Nobody coming back. Go away and leave me alone."

Pinky insisted I case the joint, make sure the guy wasn't hiding under the bed. He pushed me through the living room into his room, and thankfully, the fucker wasn't there. I scanned the room and determined there was no reason for me to be here. On my way out, I noticed a high school yearbook portrait of Pinky, thumbtacked to the wall and looking about ten years old. "That's your senior portrait?"

"You know it is, honey. Hollywood High."

"Really, what year?"

Pinky walked over and looked at the picture, then looked at me. "Class of nineteen eighty."

"Wow, you know who I think took that picture?"

chapter nine

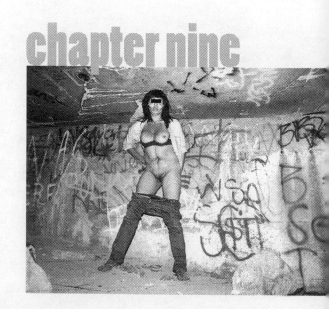

nicotine alley

1990

I opened my eyes and looked at the ceiling. The lights were off and the ceiling was blue-noir. My heart was thumping in the middle of my head. My face felt like I'd been holding my breath, and my neck was hot and prickly. Three days ago I'd had cervical spine surgery. I was wearing a cervical collar, two smelly plastic pieces Velcro-attached around my neck to keep me from swiveling or nodding my head. Problem was, it felt as though my neck

was pumping up like a balloon and the fucking collar was stran-
gling me. I touched my fingers to my face and neck, and it felt
like the red rubber balls we used for dodgeball when I was a kid.

"Carol," I said. "Can you wake up? I need you to wake up.
Something's not right."

Carol was a sound sleeper, but she was tuned into me and woke
quickly. "What's wrong?"

"Turn on the light and look at me. Something's wrong. My head
feels like it's going to fracture and my neck is pulsing. It hurts."

Carol flicked the nearest switch, looked at me, and didn't
scream. "You don't look right at all. I'm going to call the hospital."

"Yeah, okay. We should probably just go there. I'm going to see
if I can get my jeans and shoes on."

"Don't. Don't do that, wait until I can help you. I should call
an ambulance."

"No don't, I can't afford an ambulance, we can drive. It'll
be fine."

⁜

It was just another night and I was walking down a bumpy trail
away from the road, away from the headlights and streetlights,
where no one could see me, not even the person two steps in
front of me, a prostitute named Pepper. She followed a path made
of instinct and I followed her earthy scent, and when she stopped
I did the same. "It's not far," she said. "We're almost there."

Earlier in the week at MacArthur Park, I'd funded a chunk of
crack cocaine for a whore I'd picked up, and kept a little pinch
for myself. Ten minutes ago, in the car, in the Barney's Beanery
parking lot, I smoked the pinch, two hits. I knew within the first
couple of seconds it was a mistake. Then I took the other hit. Bar-
ney's was a funky eatery in West Hollywood known for celebrity

sightings and a history of homophobia. It had been in this Santa Monica Boulevard location since the 1920s, when it was part of Route 66, which coincidently had originated, going both east and west, in Springfield, Missouri. The fact that a left turn out of the lot could take me all the way back to my roots seemed astounding in my druggy, runaway brain.

I was too stoned to just sit there, so I drove onto the boulevard and realized I was too stoned to drive. Three blocks east, my favorite Oriental massage parlor sat in a group of connected low-end joints and stretched toward the Hollywood Freeway. Pepper was too tall to be a woman and when I first saw her, she saw me as well and gave me a covert little two-fingered wave to show me she was working. I pulled to the curb. She came aboard and directed me to a spot close by, somewhere below the freeway. Walking through the dark, I felt like I was drawing to a movie jump-scare. My eyeballs were vibrating and I was seeing tracers. "I need to ask you to slow down a little," I said. "I can't see in the dark." I'd left my cane in the car because I was a macho dumb-ass, and I was walking like a peg-legged drunk.

Pepper was a head taller than I and looked like a tent-show savage from my youth. She had haunted eyes and the sharpest cheekbones I'd ever seen. She was friendly and could see I wasn't a threat. "When I was a boy, I was mean," she said. "I'm big and not pretty; sometimes people are afraid of me. People just look at me, think I'm crazy. Men are mean to me."

"Yeah, well, men are assholes. I think you're kind of pretty. Here, face me, look at me." My father photographed thirty or forty weddings a year. When photographing a bride, he advised me, look at her through the eyes of the groom, who on that day believes she is beautiful. I focused by feel and the flash highlighted

the angles of her face and suspended her head in a bright holy halo. "Wow," I said. "You look amazing."

"Now I just see spots," she said. "Moving green spots."

I didn't see any green spots but I was getting bright purple streaks.

"You're different," she said.

"Yeah," I said. "You too."

Beams of light from the freeway swept through waist-high weeds like heat lightning. The moon came out of hiding and I could see again. She motioned to a great chunk of concrete like a dam holding back the dirt and freeway trash. "On the other side of that thing," she said. "That's where I'm staying."

※

Two weeks before my first cervical spine surgery, still looking for a diagnosis, I found myself on a metal X-ray table, prone, my hands to the sides. A nurse technician pushed a needle into my spine and hit a nerve, a pointy icicle in a rotten tooth. I lost control of everything. I couldn't even beg for mercy. The technician, a kid in his twenties, told me to hold still, we were just getting started, and I realized that today was the day I stopped telling people fuck you.

The procedure, a myelogram, began in earnest when the guy with the needle pumped a heavy slug of substance into my spinal cord. He flipped switches, tilting the table headfirst, and the mixture slowly shinnied down to my cervical center. If the slug continued to slide, it could drip into my head, and if it did, the guy told me, it was going to hurt. I should raise my head, my chin, as high as possible, he said, cutting off the slug's downward slip and slide. I was having the procedure because my neck was too fucked-up to tilt back my head. I was locked in tight with no sign of escape.

I closed my eyes hard, but I could still see it coming. My brain pulsed like electric feedback and I thought my teeth might break. The technician increased my tilt and told me to raise my head higher, which I was unable to do. The muscle and bone in my neck was straining so that I could hear it, a sharp whine, and the fucking slug just kept coming. There was a small video monitor about a foot from my head. A camera set in a cold metal machine above the back of my head groaned and whirred all the way to the ceiling, with cranks and numbers, glass panes, and green light. It reminded me somehow of a train depot in St. Louis when I was five and bought a Batman comic book for a dime. Then I was back in the present straining every muscle in my body to fight the heavy thud, like a boot, stomping my head from the inside out. I would have murdered for relief.

Carol had a little place down the street from the Vista Theater in Los Feliz, a cozy one-bedroom with a small deck under a leafy ceiling and a bed we slept in every night. When Dash spent weekends, we set up a little two-person tent on the deck. My new physical problems had center-punched me only a month after I moved in with Carol, which seemed very unfair for her. We were, however, comfortably cozy and fucking a lot, though now, when I climaxed, my lower half vibrated and kicked out of control. If I came on my knees, I would spring forward like shot out of a cannon. In missionary position, I learned to dig my toes into the mattress, push up with my arms, and create a shimmy effect that put a big smile on Carol's face.

The night after my myelogram, I was moving about like a geriatric. Carol coddled me, fed me, and worried over me. Wiped out but nocturnal, I didn't consider sleep. I tucked Carol in around eleven, then I took a couple extra prescription Percocet, smoked a joint, and opened a bottle of red wine. I had a typewriter in front of

the two-seater couch on a TV table. I was writing stories. I'd been retarded in my formative years and writing didn't come easy, but it was a lifetime goal and I was learning sentence by sentence.

An hour later I was deep into my imagination. The doors to the deck were opened, and from the quiet street came a loud honking of a car. It stopped, then started again. Then it stopped for a while. I was typing in a frenzy and loaded and numb and didn't really give a shit. Then it started again and continued. It woke Carol, who straggled into the room. She said, "What is that asshole doing?"

"What asshole?"

"Whoever is honking." Carol walked out onto the deck and went on her toes to look over the plank-fence enclosure. Then Carol said, "That's your car."

My Camaro. I was already three payments behind when things went haywire; the repo guys were still cruising Gus's place in Santa Monica. I knew I wasn't going to be able to keep it, but I would keep it as long as I could. I'd parked it across the street, a couple doors down under a streetlight. It was a beautiful car in the pool of light, but the driver-side door was open and there was a guy inside tearing apart the steering column to get to the starter. This was not a repo guy. My trusty Camaro was doing the smart thing, which was honking, trying to alert me; it was being kidnapped. I had on underpants and socks; Carol was yelling, "Hey, hey, you get the fuck away from that car." I dove into my boots, grabbed my cane, and stumbled out the door.

I was physically unable to hop, skip, jump, or run, but I was gathering speed down the concrete incline, stiff legged, bouncing a bit, like Frankenstein out of control, my torso ahead of my legs, swinging my hook-cane like a primitive nunchuck. The guy was

finally out of the car, but rather than run, he was standing there looking at me; he had my backpack, which I kept stored on the floor behind and under the driver's seat. My Nikon and Vivitar flash were inside that backpack. I was three or four yards away. He was medium-sized, ugly, and young in a dirty T-shirt; he could probably take me down in a couple of seconds. But he didn't know that, and I was brandishing a weapon of sorts. Carol, in a robe, was now only a few yards behind me, and I think if the kid so much as touched me she would have gained superstrength and knocked him into outer space. When he turned to run, my Nikon fell out of the backpack and hit the pavement. He kept going and I couldn't catch him, so I stopped trying and watched the cocksucker go until he was gone. My Nikon, which I had bought in Saudi Arabia in 1983, was smashed beyond repair. I didn't cry but I wanted to.

＊

When I finally went to see a doctor about my out-of-control ills, I went to Harbor UCLA Medical Center, County Hospital. Where the penniless came to get fixed and student doctors came to get practice. I was there nine hours before I could sit with a doctor and explain my symptoms. I was forty years old, and the only thing I felt good about was testing negative for AIDS. The jury was still out on multiple sclerosis. I couldn't remember a time when I felt more sorry for myself.

I talked to a young neurosurgeon, a schlub who had a face I wanted to slap. He told me I was lucky to have come on a day when he was seeing patients, because he was well ahead of the curve. I told him I was thankful and I told him I couldn't raise my right foot off the ground; both legs would sometime fibrillate beyond my control. He said, "Fibrillate, huh? Most of the patients

I see don't know that word."

"Yeah, well," I said. "I guess it's a lucky day for both of us."

※

I'd been awake for three hours and out of surgery for five. A cervical collar was wrapped around my neck, which hurt but not much more than usual. I turned my body and yelped when my right hip exploded. I said ouch, fuck, shit, piss. Chucks of bone had been removed from my cervical spine and replaced by a hunk of bone from my hip. Successful surgery, contrary to what I'd been told, was not a cure but a temporary halt of the degeneration of two vertebrae, C5 and C6, and the accumulating bone spurs that had permanently damaged my spinal cord, short-circuiting my nervous system. The doctor had failed to alert me to the negative effects of excavating bone from my hip; it fucking hurt.

Carol had been at my bedside when I woke, but visiting time was over and they gave her the boot. In some ways the surgery had been harder on her than me. The operation had gone on for seven hours, four hours longer than we expected. There were complications and they had gone into overtime to untangle a mass of knotted nerves. Carol, who was not an optimist, spent the extra hours walking the halls, nibbling Xanax. Afterward, when the neurosurgeon stopped by to give me his moronic thumbs-up, he told me I had the spine of an eighty-year-old, and oddly, I think he thought this tidbit would cheer me up.

The guy in the bed across from mine moaned a lot and kept his curtain closed. The guy in the bed next to mine was a sad twenty-something Hispanic kid with AIDS, told me he used to suck and fuck for money, told me he got what he deserved. The

guy in the catty-corner bed was a dumb hick with ruined lungs. He was permanently hooked to an oxygen tank. As soon as he saw I was up enough to see him, he took a couple of hard hits of oxygen and whispered as loud as he could, "Hey, buddy. You got any cigarettes?" It was sitcom funny, but the idea stuck in my head. I wanted a smoke. I'd been a smoker from age nine, and the more I thought about it, the more the craving set in. Menthol and tobacco, Kool Kings.

First time at County Hospital, there was a small crowd outside by the glass double-doors at the front of the building, smoking and shuffling about. A big muscle-bound guy with a lopsided face and pale blue eyes reminded me of an illiterate hard case from Missouri I'd watched beat the crap out of another poor sap. There was an underage girl in blue-jean short-shorts, platform shoes, and a tube top. She had foundation makeup spackled over a grouping of pinkish zits on her cheeks, raw red painted lips, and a white filter-tipped Salem making smoke signals from her long orange fingernails. She looked like she wanted to fuck everyone, and she looked like she could do a good job of it. I gawked at her a little too long and she gave me a nasty look, spun around and wiggled her ass, blew a plume of smoke, and then walked away.

Inside County Hospital, there were signs high on the walls in Spanish and English, and none of them told me anything I needed to know. I took a spot in the first long line, like standing on go in a board game, and I waited. When I made it to the woman in the window, she was helpful and gave me a ream of forms to fill out and directed me to the next window. The questions on the forms were mostly easy. I owned nothing, I had no money, I had Carol's address, and that was it. The medical history forms took a while longer. I

couldn't remember not being in pain, both blunt and shooting, in my back, my neck, my shoulders and arms. I'd been fucked-up and misdiagnosed since the 1960s, but what I had now, loss of control and spazzing limbs, was all new. I turned in my forms, waited in another line for an hour, and then finally went into the waiting room.

There were a hundred or more people in the waiting room. They were sick and angry, all shapes and sizes. They were depressed, and if any one of them was not depressed, that person was retarded. No one had health insurance. There was not a single product of the American dream. Every life was in shambles. I found a seat and looked around for the underage girl, but didn't see her. An unsightly little guy next to me laughed for no reason. "You just get here?"

"Yeah, sorta."

"Gotta get here goddamn early in the morning you wanna see a doctor. You got a long wait for nothing. You got a long, long goddamn wait."

I excused myself and went outside to smoke.

I heard the zing of cars and trucks on the freeway. Pepper, the friendly transvestite whore, was leading me across a concrete culvert. I helped myself up the culvert with my hands, took a couple of steps more, then stepped on something soft, like a duffel bag full of water balloons. It was a bum passed out in the weeds and it yelled, "fucking fuck what." I had a case of hyperreflexia and I was zoomed out on crack cocaine. I did spastic dances with little provocation and no control. I jumped high enough to know that landing was going to be a problem.

My feet hit the ground but didn't take hold. I fell like a brick from the freeway above and I bit my tongue. I could see stars. The

bum was up and staggering around like Charlie Chaplin. He was taking jabs and swings, knocking his DTs to the ground, and soon stumbled and fell and stayed down, mumbling then quiet. Pepper looked like an American Indian spirit ready to guide me through the swamp or maybe scalp me. "Are you alright?"

She gave me a hand up, and I followed her to a little clearing at the base of a great slab of freeway. She had a folding chair and a sleeping bag, a pile of clothing and bedding. I took the chair. I was breathing like I'd been running. I fired a cigarette and could feel the smoke in my feet. Shadows moving from a quiet wind flitted across Pepper's face, which had the surprised look of too many cosmetic surgeries. But still, it was full of unique beauty and innocence.

"Can you give me that thirty dollars now?" She sat on the clothing pile, close to me. I fished the money from my wallet and gave it to her.

"For pictures," I reminded her. "I'm going to take pictures of you."

"I know, you already said so. After the pictures, I can blow you and you won't need to give me any more money."

"No, I don't know. I don't think so, not now, anyway. Just some pictures. I think."

"Something is bad wrong with you," she told me.

"Yeah, no shit."

"You high?"

"Yeah, I am, but that's not what's wrong with me. I think being high is actually making things feel better."

"You got AIDS?"

"No, well, actually, I don't know. I think it shows itself in different ways, so no, I don't think so, but kind of maybe. What about you? What happened you're in a place like this?"

"I don't know. Things."

"Yeah, I guess sometimes things happen."

I heard a sound and a couple of voices close by in the dark. I jumped and nearly fell out of the chair.

"Ignore them, don't talk to them. Don't even look at them."

I looked anyway and there were three of them.

※

Carol was behind the wheel of the Camaro, barreling down the Harbor Freeway about a hundred miles an hour, honking and flashing the lights at any car that dared get in her way. I'd been right about not needing an ambulance; an ambulance wouldn't have been able to keep up with Carol.

I was sitting shotgun looking straight ahead. I'd removed the cervical collar, but my neck was swollen too much for me to turn my head or really do anything other than sit there. I tried not to moan, but a few slipped through my clenched teeth. I fumbled a Kool from the box in my jacket pocket and punched in the car lighter. Carol was intent on driving, but she was also intent on me; she was going to save my ass whether I liked it or not. "You are not really going to smoke that. This would be a stupid time for you to smoke."

"Yeah, well, you always think it's stupid to be smoking so it kind of doesn't count." The lighter popped out and I put the cigarette back in my pocket.

"I think I'm going to be alright; you don't have to drive a hundred. You don't want to get pulled over."

"It's an emergency," she said. "The police would give us an escort."

"I think maybe you and I have had different experiences with the police."

"I was at Berkeley in the sixties."

"Oh, yeah. I've got a headache and I swear it's as bad as or worse than when I had that fucking myelogram."

"We're almost there."

"Yeah, I know. It's going to be okay."

❋

The Hispanic kid with AIDS in the bed next to mine told me his name was Zazoo; I think that's what he said, it's what I called him for the next two days. I couldn't tell if he was here to die or just to suffer awhile before going back home or somewhere else to suffer and die without the once-every-four-hour shots of morphine.

The guy in the other bed with the oxygen tank told me his name was Pete. Earlier, after the trauma of having my catheter removed, I'd gotten up and walked, slowly and dizzily, to the nurses' station and back. This accomplishment had convinced Pete that I was capable of leaving the building, walking across the street to the mini market, buying cigarettes for all of us, which he, Pete, was happy to pay for as he had a twenty-dollar bill. Sadly, Pete was right; I didn't have any smokes, either, and since coming out of surgery, and after Carol had gone for the night, I'd realized I didn't have my Dristan or my Blistex. The more I thought about it, my lips started to burn and crack, I couldn't breathe through my nose, and I wanted a cigarette as much as I ever wanted anything.

As per hospital regulations, Carol had taken my clothes along with my wallet and anything of value so that nothing would be stolen while I slept, which I really wasn't doing anyway; one doesn't go to the hospital to sleep. I watched the clock until enough time had elapsed that I could request a shot of Demerol, which I requested and which a night nurse administered. I was

wearing a thin open-back hospital gown and my cervical collar. Zazoo was serving a death sentence, but he was still dexterous so he tied the four loops at my back. Not that I'm modest, but if I was going out into the world, I needed to cover my ass. I took Pete's twenty dollars and slipped it into one of the two paper hospital slippers, used my wheeled IV stand for balance, and bid the boys tallyho.

Before surgery the neurosurgeon told me I'd be on my feet and back to normal a couple of hours after the operation. He was either lying or deluded. My right leg acted much the way I imagine a prosthetic leg would work; I pulled it along and swung it forward from my hip, which happened to be where most of the pain was. I could pick up my left leg but kept stubbing my toes, tripping myself, because my foot wouldn't stay horizontal. Into a long dim hallway, rooms on either side, beds and flickering televisions, moans and sighs of surrender, the damned and the doomed. I'm not one of them, I told myself. I'm not one of them. I'd been repeating it all my life. I'm not one of them. Wasn't I meant for something more? How could I be just another one of those people? How did I fuck up so badly?

The walls started pulsing and I got dizzy; I thought I was going to puke. I broke a cold sweat and hung on tight. I thought about a James Brown performance where he kept collapsing to the stage floor and was helped back up by his assistants, who draped him with a robe, which he would throw off after a few steps, and get back to work. I went down to my knees and sat on my feet; low sounds of the night, the moans and farts and coughs, a woman three doors up sobbing, invisible crickets chirping somewhere nearby. I closed my eyes and remained where I was for a couple of minutes or maybe an hour. I traveled through time and space as though I'd dropped a tab of acid.

Back on my feet, I shuffled past the nurses' station and no one gave me a glance. Getting into the elevator I walked too slowly and got smacked by the impatient doors, which set off my right hip again. I rode down on my knees, my hands on the floor, growling through my teeth. I was burning double-time through the morphine fix. Ground floor, the elevator doors opened and I pulled myself back up to my feet like a pole dancer and baby-stepped out to the lobby.

There was a guy in drab gray pushing a broom and a trio of young doctors, stethoscopes hugging their necks, talking and laughing, which pissed me off. I passed them, my jaw clinched in determination, the handicapped tortoise pulling ahead. Someone somewhere far from here was fucking a gorgeous babe, watching a beautiful sunset, food and drink like I'll never afford. Blond boy doctor caught my eye, said, are you where you're supposed to be? I laughed and kept walking. Among the array of crazy feelings zzzzing though my body and my being, I realized I quite urgently needed to pee.

■

The phone rang at Carol's and she answered it and then said, yes, hold on for a second. I knew it was a bill collector. Gus had become fed up with the phone calls at his place, looking for me and hectoring him, so he gave them Carol's number. Carol handed me the phone.

"Mr. Sothern? Is this Scot Sothern?"

"'Tis."

"Mr. Sothern, this is Marie at Citibank. You have a Citibank Visa card with us, but the address is in Santa Monica. Are you living at a new address?"

"Yes, I am."

"Mr. Sothern, I'm calling because your Visa is four months

overdue and has, in fact, gone over your limit of six thousand dollars. We need to clear this up with a payment to bring you back to a current status."

"I'm sorry, but I'm not working anymore, and tomorrow I'm going to the hospital for a surgery. It's going to be a while before I pay anyone anything. If I could I would."

"We need you to make your payments tomorrow, or I'm afraid we will have to turn it over to a collection agency."

"I just told you I can't do that right now."

"If you could post a check tomorrow."

"My checks are no account; they won't do you much good."

"Mr. Sothern, could you give me your new address? We need to have your proper address."

"Yeah, well. Funny thing, I just realized I don't know the address here."

"Mr. Sothern, can we clear this up? You need to make up three payments before the end of this week. Do you understand this can affect your future credit rating?"

"Yeah, sure I do. Seven years."

"I'm sorry?"

"Seven years. If I never pay you, or anyone else, anything again, you, Citibank, will turn it over to a collection agency, maybe even take me to court. But if I still don't pay, nothing happens to me, because there is no such thing as debtor's prison and I don't own anything for you to take away and I don't have a job for you to attach my wages. The hitch is, I can't get credit again for seven years."

"Well, Mr. Sothern, you don't want that to happen."

"Yeah, I don't know. I kind of do want that to happen. I can tough out the years without credit, no problem; I've done it twice before. And except for the irritating phone calls from the likes of

you, I'd rather spend seven years without credit than seven years struggling to pay off a bunch of corporate fuckheads. Consider yourself ripped off."

"Mr. Sothern. We expect you to make a payment and honor your commitment. You made purchases."

"I'm sorry, I forgot your name."

"Marie, Mr. Sothern, we need to do something about this debt."

"Good-bye, Marie."

There were three of them and they were just kids, teenagers, but viciousness is not exclusive to age, so I was cautious. Pepper looked at the ground. She had seen more violence in her life than I had. She was bigger than any of us, but at that moment, she didn't look like it. One of the three kids, Hispanics, had a flash-light and another had cans of spray paint. They stopped to look through the shadows at Pepper and me; it's possible we looked creepier to them than they to us. I smiled and slowly raised my camera and flash, thinking maybe they wanted to show off, get their pictures taken, but I was wrong. I didn't get the words, but I understood enough to hang my camera, lens-down, between my legs. As they walked away, the guy with the paint called Pepper a faggot and a *puta*. We could hear them, as they went up closer to the freeway to create their graffiti art on the concrete canvas, and after a minute, we stopped listening.

"We don't really have to do anything," Pepper said. "You can stay here awhile, with me if you want to."

"Thanks, I think I'm too loaded to leave right now anyway. I'll stay until those guys leave. Then we can go up there and take a couple of pictures and I'll leave you alone."

"Would you ever kiss someone like me?"

"I don't know, I guess."

"Yeah, sure. I guess not."

A while later, after pictures, I kissed her and told her good-bye and be careful. I fell twice on the way back to the car.

※

Harbor UCLA Hospital was down the Harbor Freeway in Torrance, an area of Los Angeles County I didn't love. Leaving the main building, I walked to a tree, my left hand clutching the IV roller stand and my legs wobbling. With my right hand, I pulled up the hem of my hospital gown, squatted and peed for the first time since the night nurse had pulled out my catheter like a honeysuckle stamen. It burned and I shivered from my butthole to the back of my head and nearly fell into the puddle.

The plastic neck brace held me face-forward. To look right or left I had to turn my body. To look down I had to bend from the waist, and to look up I would need to hit the ground, flat on my back, which I was trying to avoid. Streetlights and stoplights and all the other light were in a soft-focus glow. My double vision had quadrupled. I was breathing through my mouth.

I kept expecting people—police or security guys, doctors or nurses—but no one cared who or where I was. I didn't matter. The liquor store was on the other side of Carson Street, six lanes and a median away. There was traffic but not a lot; to cross at a crosswalk, I needed to walk half a long block west, then a block to the liquor store, and then back to the crosswalk, and so on. I decided to jaywalk, and once I stepped out onto the street, I was committed to my stupidity. Cars were coming from both directions. The bars were imposing last call, and the drunk drivers were on their way home.

I could feel headlights on the sides of my head but to look both ways or either way would mean stopping my forward motion to turn my body. I tried to step up my pace, and a car, a truck, and another car flew by, two lanes up ahead. Somebody honked a single honk and I jumped, tripped, and fell, pulling my IV stand, with the bladder of saline and smaller bladder of drugs, whatever they might have been, down to the pavement.

There was a string of cars in my lane speeding from the green light at Normandie Avenue a block to my left, gathering steam. I grunted and growled through my teeth and set the stand up on the four little wheels and pulled myself up, hand over hand like climbing a rope. From the drip-bag hooked to the IV stand, four feet of rubber tubing was connected to the needle in a vein at the top of my left wrist, under an X of beige tape. The needle had inadvertently pulled halfway out and was bent like a safety pin. I looked at the spike and the bruised skin in the blue streetlight night and gave it a little push trying to help it back home. In a moment of clarity, I remembered that I was in the middle of a busy street at three in the morning. I was supposed to be in my ward, in bed crashed out of consciousness from the trauma and residue of invasive surgery. I held the shaft of the IV stand with both hands, like I was paddling a boat forward; I started walking and made it to the other side.

I walked through a patch of gravel and roadside trash. The soles of my feet were sensitive to the extreme; a simple prick with a stick would set my leg into a hillbilly jig. The hospital-issue paper slippers offered little resistance to the elements. I opened my mouth and whooped. My ears were ringing and my eyes felt like they might pop out. I was breathing through my mouth, and my throat was too dry to swallow. My lips had a pulse. The liquor store had a yellow and red light-box above the double

doors, across the front of the building, that read, liquor store. The building jittered like an old refrigerator.

Inside, primary colors tweaked extra bright. A round, brown cashier behind the checkout counter looked at me with no change of expression. Maybe idiots in hospital gowns were regulars; maybe on my way back to my room across the street and up four floors, I'd pass some other guy, like me, crossing the street for a pack of smokes. I padded around until I found a display of Dristan and then I couldn't find Blistex, so I settled for a cherry-flavored ChapStick. I put them on the counter and struggled to extract the twenty-dollar bill from my slipper, then addressed the brown, round guy. "Hey, how's it going? Give me a Kool Box."

"Sorry, we're all out of Kools."

"Oh. Fuck. You got Marlboros? And hey, let me know if there's enough left for a tall can of Budweiser."

※

The day I came home to Carol's for the first time from the hospital, Sylvia drove Dashiell up from La Jolla to spend a couple of hours. I wasn't looking my best but I wasn't scary and Dash acted like he didn't notice anything different about me. He was in my arms and on my lap so fast, Sylvia and Carol were both in mid-sentence telling him not to jump on me so quickly, to be careful, your dad is fragile, not like normal. I hushed away any concerns and would have let him ride on my shoulders if he had asked. I believed Dashiell needed me to not be fragile and so I wasn't. A while later, when they were leaving, Dash and I hugged; I kissed his neck and we both got watery eyes.

Two days after surgery, one day after being released from the hospital, I was back. This time in the emergency room, or actually, an empty corridor a couple of turns from the operating room. Carol had walked me into the ER, where we weren't expected, even though the neurosurgeon, whom Carol had talked to via phone before hauling me here, had told her we would be expected. Inside a rectangle of white curtains with a bed, I changed into a gown and Carol helped me onto a gurney. A while later, I was wheeled to the X-ray room, where an extremely ugly technician gave me a hard time because I couldn't straighten my neck for a good exposure. He didn't really give a shit about me, and I thought about telling him how ugly he was. My face was green, Carol had told me, and puffy, and my neck looked like a body builder's neck, on steroids, and I was still better-looking than this dumb fuck and it made me feel shallow but a little better.

Back in the darkened hallway, Doc Bergman stopped by, talked quietly with Carol for a minute, like they were discussing organ donations, then took a look at me. For the surgery, my cervical spine had been accessed from the front, through a surgical incision just below my Adam's apple, and afterward, the edges of skin had been melded together and taped shut. The doctor looming above me tore off the tape and then used both hands to open wide the wound. Carol turned pale and the doc poked around. I couldn't feel anything beyond the overall hurt, the surreal shock.

"I have a big hole in my neck," I said, whispery and strained. "You just opened a big hole in my neck, didn't you?"

"You have a hematoma," he said. "It requires a simple surgery."

"What's that mean, I have a hematoma?"

"Like a blood blister, you have interior bleeding and the blood has nowhere to go. I need to find the leak and seal it."

"Is this something that happens a lot?"

"No," he said. "Not to my patients it doesn't."

"Except it just did."

"Yes, well. I'm reserving an operating room for 8:00 a.m. I need to get some sleep before going into surgery. Carol can stay with you here, and the nurses will be checking on you. We are going to start an IV saline drip along with something for the pain. I'll see you in a few hours."

It hurt to talk. I told Carol she should try for some sleep, but I knew that it wasn't going to happen for either of us. She told me she loved me and I told her I loved her and it didn't feel like something I would renege at a later date. I told Carol not to worry but then realized I didn't really know if she, or we, should worry or not. The doctor said it would all work out, but I wasn't putting much stock in anything he said.

For the next few hours, I listened to footfalls, ghosts in fleeting conversations, and buzzing fluorescent lights. I thought about death and I thought about my life and what it amounted to. I thought about all my unaccomplished accomplishments. A few weeks earlier, I had thrown a makeshift darkroom together in Carol's tiny utility room and I'd printed eight-by-ten photos of about fifty of the whores I'd photographed when I still had my Nikon. I wondered if my work would outlive me. I'd just gone through the 1980s, and I thought about all the guys, younger than me, who had died from celebrating the sexual revolution. Death was very dramatic and I dearly loved my drama, but just like all those guys who died too early, my story wasn't finished. I'd get other cameras and I would make other pictures and someday, hopefully before I died, I'd get a bit of the notice I'd coveted all my life and make a little money. I could accept who I was, but I could never lower my expectations.

Four o'clock in the morning and the hospital room glowed green from bad lighting and flickering night lights. The guy in the bed across from mine was asleep or dead. My other roommates, Zazoo and Pete, were both awake, preparing to take a walk and have a smoke. If we were apprehended smoking in the dorm, we would be in trouble with the authorities, Pete explained. We should, therefore, follow him to a forbidden corridor, Nicotine Alley, where we could smoke ourselves dead and tell each other lies.

Zazoo was brown and pretty, young and tragic. He wore a blue bathrobe that looked like it was made of sponge rubber. He'd been stripped of flesh and weighed half of what he should. Like me, he hung on to his IV roller stand, used it as a makeshift walker. Just watching him standing there made me want to cry.

Pete was sixty and crass, reminded me of every idiot I'd ever known. He was a big guy who waddled around chewing his tongue. He had slicked-back black hair thick as crude oil and a face with purple age spots that looked like splats of bacteria. Rather than an IV roller stand, Pete had a hand-truck of sorts, on two wheels and carrying an oxygen tank. We followed Pete down a hallway and then another. I looked in every open door, and sometimes people looked back at me. One guy, naked, a nervous white face like a swarm of maggots, sat on the edge of his bed and beckoned me with a crooked finger like some apparitional fuckhead going to punch my ticket to a netherworld. I turned away.

Our smoking lounge, next to a stairway, three plastic Laundromat potato-chip chairs, orange with imbedded golden glitter; in the darkest corner, a little pile of cigarette butts and ash, a squished Coke can. I passed around the pack of Marlboros. Before lighting up, Pete turned off his oxygen. "Don't want to blow myself up," he said. "Not yet anyway."

"Yeah," I said. "What are you waiting for?"

"Waiting till things get real bad, you know. When I can't smoke no more, that's when. Smoke a fuckin' twelve-gauge when the time comes."

"I can't die yet," Zazoo said. "I don't deserve it."

"That don't make any sense," Pete said. "But I bet you die before I do, and I bet you go to hell for being a fuckin' fairy."

"You're kind of an asshole, aren't you?" I said to Pete.

"No more than you," Pete said.

"Yeah, well."

We sat taking the first hard drags from three lit butts. I got dizzy and my lips buzzed. Pete coughed and hacked and took another drag. Zazoo hung his head. "I was a whore," he shared. "I gave AIDS to other people and I knew I had it."

I couldn't think of anything to say, so I smoked my cigarette and then lit another. I thought about when I got out of here. I was never going to run or jump or even walk without a severe limp again. Sometimes I found comfort in feeling sorry for myself. Sometimes I felt like the unluckiest guy in the world. In truth I was a white American male born with every advantage. With few exceptions, the rest of the world would always be worse off than I. All I had to do to see it was turn any direction. I snubbed out my smoke, but Pete and Zazoo were still puffing away. I shuffled back to the room. I rolled onto the bed flat on my back and buzzed the nurse for a dose of painkiller.

chapter ten

the ballad of auntie bea

1997

It had been six years since I'd had a fulfilling bowel movement, because of the pain meds. I took laxatives with every meal and I slipped suppositories up my rectum like a gambler slugging quarters into a slot machine. I wore clear super-dreamy prescription patches of fentanyl, changed them every two days, and then cut them open to chew out the last drop. In spite of the stupor and depression, I swam laps at the local YWCA for an hour every

morning and I liked to take long walks at night, usually to a bookstore. Later in the day, after Carol left for her shift as a creative in a computer image factory, I'd smoke some pot and sit at the desk and write for a few hours. When I wasn't swimming or walking, I was writing, reading, or watching television.

I seldom took pictures, though my pop had sent me an old Rolleiflex twin lens, a camera I'd first used as a freshman in high school taking pictures of baseball teams—photos I sold for a buck fifty each. Every so often, Carol and I would get naked and shoot a roll or two of twelve-exposure Tri-X. The camera fit in my hand as naturally as my dick.

Carol and I were married in 1991. She got a paycheck and I got SSI disability, which was better than a real job and one of the reasons I'm a Democrat. We moved to a nice two-bedroom rental across from an elementary school in Glendale, and Dash moved in with us. Sylvia was putting herself through law school and needed the break. The deal was he would live with Carol and me for the next three years, finishing grade school here, then move back down to La Jolla to live with Sylvia through middle school.

So for three years, I was a house husband and full-time father. It was a reasonably happy time. Dash was sensitive and almost always stayed close to my side. He never did anything that required discipline, and I pandered to his every wish. I never lied to him about anything, and I don't think he ever lied to me, and even if he did, so what? That's one of the things kids do. Dashiell grew up and the years fell behind.

In high school, Dash attended a private school for oddball kids in San Diego. At fifteen and ready to ritualize his virginity, he plotted his first sexual adventure with an older girl who volunteered to make him a man in a bathroom stall at a Misfits concert.

It sounded like fun to me and I bought him a couple of condoms. I worried like a parent does and asked that he call me the next day and let me know how it went. It didn't work out as he'd hoped, but he wasn't damaged by it, so it was okay. He didn't give me a detailed narrative but told me as much as a father needed to know.

I was lucky to have Dash for a son and I'd always felt lucky to have had the father that I had. When I was in eighth grade, my pop took me into the bathroom for a closed-door conversation. I sat on the toilet lid; he stood by the pedestal sink. He began by telling me he was doing this because my mom told him to, then he asked me if I knew what rubbers were, and I said, "Galoshes?"

"No, ah no," he said without realizing I was joking.

"Yeah, of course I know what rubbers are," I said.

I'd bought a couple of condoms from quarter machines in a gas station bathroom, tried them on, and jerked off only to find I liked it better without, but I didn't tell Pop that. He told me I could come to him anytime with sex questions. I told him sure thing, you bet. He smiled and gave me a pat on the shoulder.

A year or so later, 1964, when I was fifteen, I had a friend, Mitch, who was seventeen with a car and a driver's license. At my insistence, one September evening around eight, he drove us to the part of town that made him nervous and got me excited. Springfield, Missouri, dubbed the Heart of the Ozarks, had a population of about a hundred thousand. Originally it had been two independent towns, North and South, and since we seldom crossed Division Street to the north side, it seemed like our half was still a small town. Only a few blocks from neighborhoods of extravagant post–Civil War Victorian homes, the black area, N-Town, was especially small for this part of the country. In 1906 three innocent black men were lynched in the town square, and fifty-eight

years later, they still steered clear. I had an exact address a guy at school had given to me and found the boxy little white house at the edge of Silver Springs Park, the only park and municipal swimming pool where blacks could go. The park was considered an unsafe place for white people. The air was humid and sticky; lightning bugs blinked and hovered over empty spaces of weeds and rock. The homes seemed tiny to me. The inhabitants were people I couldn't relate to, and I thought maybe they could give me a new thrill, one I couldn't find in Honky Town. The road was dirt and the address was an old single-story, planks and shingles. Three bouncy steps up to an unpainted porch. The front door was half opened and the screen door was shut. The television flickered like headlights through a row of trees. I could smell the smoky interior, and I had a hard-on. Mitch was still on the bottom step, ready to run. I knocked hard twice and then gave a friendly yell. "Hey, anybody home? Knock, knock, company is here."

A tall guy between thirty and sixty, black and skinny in a snazzy blue suit a size too big, came to the door. His eyes were red and he looked at me through the screen. "Howdy," I said. "Does Auntie Bea live here?"

"Aunney Bea?" He looked up into the air, over my head, and smiled at the moon. He had a short beard, so black and tight and shiny it looked like plastic. "You want Aunney Bea, Mister Howdy? For what?"

"Is this the right place? Are you Jake, Uncle Jake?" Along with the address, I had the names, Jake and Bea, Uncle and Auntie.

"Maybe, Bea may." The guy smiled and wagged his head, maybe even tapped his toes. "You got a reward for Uncle Jake, Mister Howdy? Two dollars."

Two dollars to get laid; I got twenty a week working at Sothern's Studio after school, darkroom and retouching, answering

the phones and pilfering money from the pop machine. I took two bills from my wallet and Uncle Jake opened the screen door and took it. I could tell he realized he should have asked for more.

"Hey, hey uh, Scotty." Mitch was talking to my back. "I'm gonna wait in the car."

"No, man, come on. What's your problem?"

Mitch's problem was black people. "It's a school night," he said.

"So fucking what? You been a freshman for three years. You need to crack the books all of a sudden?"

"Hey, fuck you, Scotty."

"Alright, sorry, come on, fuck man, the natives are friendly. It's no big deal." Mitch followed me in slowly and never moved away from the entrance. The living room was a box, dim yellow mixed with blue light from the portable television on the floor; we were all lit up like Frankenstein's monster. "Where is she?" I asked. I was excited and ready to stick my dick in just about anything.

"Unlax, sit easy," Jake told me. "Aunney Bea be be, you be, me be, Doc. Real soon."

There was a kitchen chair in front of the tube, which is where Jake sat. I sat on a greenish couch that sunk slowly from my weight, which was slight. I was 120, my Levi's were twenty-seven, twenty-nine. I was a runt but I made up for it with guts and stupidity. Mitch was a big dumb guy who knew how to fight, which, along with the car, is why I hung out with him. Mitch didn't want to be here; he was on foreign soil. He assumed Negroes carried straight razors to cut up peckerwood like us. I knew better; they were more afraid of us, and with good reason. I wanted to be here. I wanted the blacks and the hoodlums and every other angry soul who had so much less than I to accept me as a brother who could feel what they felt. I couldn't accept that people hated me because I was lucky. I was embarrassed of my affluence and pedigree;

the truly cool people were the ones who understood how fucked-up everything was, and I wanted to take my place among them. Also I was here because I had a compulsive need to be the crazy motherfucker all the other kids at school talked about.

The Fugitive was on television, a guy falsely accused of killing his wife, on the run from the law and doing good deeds along the way. "Hey, you know what would be funny," I said. "If that guy, Richard Kimble, really did kill his wife." Mitch looked at me with complete incomprehension and Jake smiled and bopped his head like he was listening to James Brown. He showed me a fifth of murky brown wine in a square bottle, looked like Karo syrup. He tilted it up and took a long suck and, when he tilted it back down, let out a hot happy belch that smelled like sweet rot. His bottom teeth were gone and a long bungee cord of wine-spit connected at one end to his lower lip and the other to the bottle's mouth. The lip-end broke and wrapped the bottle neck like a wet string around a Maypole. He handed me the bottle. "Drink up, cowboy," he said. "Getty-up, little crocodile. Go go go go go. Boom, baby."

I took three hard drinks as quickly as I could, and when I downed the last one the other two were on their way back up and had to be reswallowed. When I got my breath back I laughed. I held the bottle out. "Hey, Mitch. It's your turn." I knew he wouldn't take it, but I couldn't help myself. "Come on, man, you don't want to insult Uncle Jake, do you? You gotta drink or he'll give you a voodoo curse."

Jake thought that was funny. He said, "Voodoo hoodo, oh Momma, you know you do." Mitch looked like he might lose control and kill me so I handed Jake the jug.

I took a short pack of Kools straights from my pants, offered one to Jake, and took one for myself which I tamped on my

lighter. Jake said, "Kools are cool and fools are fools. My kingdom for a light."

The lighter was a cheapo flip-top I'd picked up earlier at a Rexall store for fifty cents. I'd pulled the wick out an extra inch or so and overfilled it with lighter fluid so that when I spun the wheel the flame was ragged and about the size of a campfire. I gave Jake a light and he turned his head sideways to avoid setting his pomaded conk ablaze. He blew a thick smoke ring, like a ghost doughnut, and stuck his finger through the hole.

Auntie Bea came into the room from a dark hallway. She was about five feet tall and built like a chaise lounge with pillows. She wore a slippery pink slip over bare skin. Her face was Hershey brown and her lips were pink. A cap of short hair like Wooly Willy magnetic man shavings. Her nose was broad with big round nostrils. She was somewhere under forty. There were pretty girls at school who I wanted to fuck, one I had fucked, and some who might come around if I put in enough time and effort. The girls in *Playboy* represented everything a red-blooded American white boy wanted to dip his wick into. But for me, Auntie Bea was as exotic as all the places I might never see and nasty as a wet dream. I was adding variety to my life, becoming well-rounded. I was having a good time and had high hopes for the pleasure to come.

In Auntie Bea's bedroom, with the door closed, she said, "You got to tell me what you want to do."

"Huh? You know, I don't know. I want to, you know, fuck." I was pulling off my shoes. The room was dark but for a little lamp with a yellow and green shade made like palm leaves, a narrow metal tree trunk, three little monkeys, See No Evil, Hear No Evil, Speak No Evil. There was a single window with a paper shade, more light coming in than going out. A crooked chest of four drawers, dark and old, like something you would find in a barn. A

single iron bed and mattress with a single sheet and pillow. It was the saddest room I'd ever seen, but that did nothing to subdue my erection, which was pulsing like a croaking frog.

"You all in a hurry, sir. I'm a take care. It's what I do, sir, I take care."

"Yeah, no, sure, you take care of me, I'm not in a hurry. I just wanna do everything slow, you know."

"Go ahead, get on the bed there," she said. "You a cocky thing, huh, big sir?"

"Yeah, sure." I was taking off my shirt.

"No, uh uh, Mister, you don't need to be taking all that off. You just pull down your pants and I'm a take care of you."

"No, uh, mam, uh, Auntie Bea. I want to get naked. Is that alright? It's no big deal if I get naked, is it?"

"Go head on, put your things there. Go head now and give Auntie Bea two dollars. We're not bare naked for free, sir. You got to pay."

"I gave Jake two dollars."

"Now you give two dollars to Auntie Bea."

It wasn't a problem; I would have given her everything I had. I took out my wallet and gave her a five thinking I was a big shot, thinking I'd get extra pleasure for extra gratuity.

She put the money in a bureau drawer and took out a jumbo-sized jar of Vaseline. She removed the lid, inserted two fingers, and scooped out a jelly icicle that glowed from the lamplight like a yellow nightlight. Bea's hand disappeared under her flimsy slip and she went up on her toes for a second as though trying to snap the top snap of a tight pair of jeans. She wiped her hand on a folded rag on the dresser and sat next to me on the bed. She took my dick in her hand and leaned in to take a look and for a magic moment I thought she was going to put it in her mouth.

"You clean, sir?"

"Uh, yeah. Germ-free. Clean and good-looking. I gargled Listerine and spit it out the window on the way over here."

"You a funny one. Here, get over here."

She rolled to her back, pulled up the slip, spread her legs and pulled up her knees and there it was, black and pink rimmed with impenetrable pubic hair like black foam. "Wake up, sir. You gonna look at my snatch all night? Move over here, get between my legs."

"You're not all the way undressed. Take off the rest of your clothes."

"You just go on now and move in here. I don't need to be taking off nothing."

"I don't know, uh, Auntie Bea. I gave you five bucks and I gave Jake two, and it's only supposed to be two for the whole thing, so you can at least pull it on up, let me see, you know, all of you."

Auntie Bea rolled her eyes and stripped off the slip. "Titties, sir. They called titties."

I was on my knees between her legs. Her breasts were large, firm and floppy at the same time. Her nipples were as large as a baby's face. She grabbed my dick, pulled it and fitted me into her, to the hilt. I fell forward and wrapped my arms around her, made soft cool body contact everywhere I could. The top of her head was under my chin and her hair smelled like peppermint. She wrapped her arms around my skinny waist, held me close and then started moving her pussy up and down and around, gripping and pulsing. "Come on, sir. Be a good Mister Sir. I'm a take care."

I was speechless, holding on tight and hardly moving. I knew I was already on my way home. Bea pulled my body tight into hers. Her vagina hula-danced up and down my fully flexed peter. I closed my eyes and melded my body into hers. Auntie Bea grunted

and I whooped and a minute later she was out of the room, in the bathroom, running water, and I was wiping Vaseline and sex off my dick with the towel. I took a sniff and it was sweet, like fermented foliage, motor oil, and sweat. I would forever travel back to this moment as I sniffed through the rest of my life.

Back in the living room, Jake was watching a local commercial on the tube, some hillbilly clown with overalls and a missing front tooth. Mitch was gone. Jake smiled and winked, told me come by and see them again sometime. I told him he could count on it. I expected to see Mitch waiting out in the car, but he had taken off. For a guy who could fight he was a real pussy.

I learned to write by reading just as I'd learned photography by osmosis, coming of age in a photography studio. I knew my photographs were good but didn't always trust my writing. Most of the time I thought it was good, and when I was high I thought it was great. I was doing what I'd always wanted to do, but recognition and remuneration for my creative endeavors seemed impossible. I mailed dupe slides, color and black-and-white, to every gallery, every publisher, every magazine, every everyplace. I mailed query letters and manuscripts to every editor and every literary agent. I sent screenplays and treatments to agents and studios. I had a four-inch-high manuscript box overflowing with rejections letters, and many of my queries went unanswered. They had to be wrong about me because I had to keep going, and if they were right I had nowhere to go.

Stupid people from all over the globe came to Hollywood to write bad screenplays, to sing, dance, and act with no voice, no rhythm, and no talent. Most were cut from the herd and laughed out the door, yet all of them, every one, believed with the same

conviction that I had that they were genius misunderstood. What if, in fact, I was one of them?

"You're not one of them," Carol told me. "If you were, I wouldn't be here."

"On this road?"

"In this car, with you."

"Yeah, well, what if I'd been an idiot but still cute and sexy?"

"If you were an idiot, you couldn't be cute and sexy."

"I can be a pretty big idiot."

"Yes you can, and when you are, it's not usually very cute and sexy. You just never grew up, and I think you might be a little retarded."

"Yeah, me too."

We were on a mountain road somewhere around Los Angeles. Carol liked to drive mountain roads while I held on to the seat. She had a 1983 Toyota Tercel; it was a little boxy and made me nervous, especially with Carol going through the gears at mountain-high rpms. Her window was down, she was smiling, and her pretty red curls blew in the wind. I was cowering and trying to hide it. I'd never imagined I would cower at anything, but after three fucked-up surgeries, my invincibility had been tested. I was older than I was supposed to be and pissed off, again, at the way things worked out

"Look up there. Can you pull in up there?"

A little road off to a clearing. Carol zipped past it, then turned around and went back at the first turnoff. We followed weedy tire tracks until we could no longer see the main road. There were clouds in the sky and concrete chunks on the ground that seemed to have landed here for no reason. It was calm and scenic. "How about if you take off your clothes and we take some pictures?"

On the rare occasions I made photographs, I was still using the Rolleiflex my pop had given me. It was a twin-lens extension of my yen and yang, and even though I'd all but quit photography, it was still what I did best.

We were having a nice day, and from where we were, we could hear and see the tops of occasional cars zipping by. Carol disrobed and I looked down at the turned-around image on the ground glass. I made black-and-white exposures, with poses and compositions that brought to mind the photographs of William Mortensen. After five exposures, I disrobed as well.

※

After having sex with Auntie Bea, I walked from the dirt roads to the sidewalks toward the lights of downtown. Closer to the city hub, three-story brick apartment buildings, Murphy-bed rooms without kitchens. On Central Avenue I saw black hipsters in fedoras, their sexy girlfriends with red lips and tight skirts, hair up in bouffants like soul singers. I bopped as I walked, hands in pockets, slumped forward like James Dean in *Rebel Without A Cause*. No one gave me more than a glance. I took Boonville Street down to Chestnut, where the gray-stone turn-of-the-century City Hall stood with a tower, a turret, and a pinnacle going up five floors like a faraway castle. I caught the number 4 bus, sat in the back, and practiced blowing smoke rings like Jake had done. At the bottom edge of downtown we passed within sight of Sothern's Studio, on a cross street. My father's car was parked in front so I pulled the cord.

The building, a red brick two-story from the 1940s, used to be a hotel upstairs, but my dad used the empty rooms for north-light studios. One room looked like a set from *Hee Haw*, another room with a wall of plastic foliage and dark wood planks—a rail

fence to pose against. He was the most creative person I knew; he was also an athlete, an avid tennis player and sportsman, hunting and fishing. I knew he loved me, but I was something of a disappointment; I couldn't hit a turtle up close with a twelve-gage, my hand-to-eye coordination was so bad I couldn't poke myself in the eye. I liked photography, sort of, and used it to give us a common bond. I thought it looked easy, but kind of dorky, making babies laugh, making everyone smile.

I went through a little covered alleyway to the back door and knocked. I waited a couple of minutes and then knocked again, a little bit louder, and a couple of minutes after that, my dad opened the door. "Hey, Pop," I said. "I gotta go take a leak." I rushed past him, through the workroom, frames stacked against the wall, trays of cheesecloth spread tight in six-foot squares, color portraits face up, drying on the racks. Black-and-white photography was still de rigueur in portrait studios, but my pop was progressive, which meant he spent a lot of time in the darkroom. He said, "Hey to you, Baby Boy. Does your mother know where you are?"

"Yeah, it's all okay. I was with Mitch Woodrell at the pool hall. He wanted to stay so I came here for a ride home." I kept going, through the camera room, past the dressing room, into the bathroom, where I shut the door. I didn't really need to pee, but my crotch had started itching and burning on the bus and I was freaking out. I dropped my jeans and underpants and studied my dick. The itching had gone away but the burning had intensified at the root, which was as red as bad acne. I wondered if I was going to go blind.

Maybe I wasn't really that stupid; I didn't believe I could catch a venereal disease that quickly. But at the same time, my sexual education came from other idiots who knew less than I. *Sperm* was almost a dirty word; I wouldn't say it in front of my mother.

Guys yelled *sperm* and then giggled. I knew I probably should have used a rubber, but rubbers were a safeguard against pregnancy; STDs hadn't yet been invented. Maybe I was that stupid, but my dick was on fire so I washed it in the sink with a bar of Lava soap.

From the medicine cabinet I found a tube of toothpaste, Pepsodent, and squeezed a worm onto my tongue, drank water from the tap, gargled and rinsed, blew my breath into my cupped hand sniffing for faint traces of wine and cigarettes. I was out of control, almost always headed for trouble, but I tried to hide my other self from my parents. I didn't want to upset them. I liked them and envied my friends who hated their parents, parents who didn't give a shit if the kids drank and smoked. I envied all the kids who probably envied me.

I held in the pain and went into the darkroom to watch, in the dark, as my pop exposed orange negatives to paper, set the timer, with its green phosphorescent numbers, and worked the prints from tray to tray. Thirty minutes later we drove home, where I pretended to do homework in my room. A while later all the lights in the house were out, including mine, and everyone was asleep except me. I'd discovered a blister about the size of a dime on the left side of my nut sack; I wasn't going to get much sleep. Later I refilled my cigarette lighter and climbed out my second-floor window, sat on the roof smoking and wondering why something as good as sex had to be so complicated and scary.

In the morning the blister was still there. I caught a ride to school with my dad on his way to work. I needed to talk to him, and even though it was a bathroom discussion, I did it in the car. "I got kind of a problem, Pop. It's not really a bad thing, well, ah. It's . . . I don't think there is really anything, you know, to worry about."

"Are you in trouble? Maybe you want to talk to your mother."

"No, no. It's about sex."

"Oh no, oh Scotty, boy, what did you do? Is there a girl? Oh, no no, that's just not possible."

"Yeah, well, you know, it is possible, but that's not it, there's no girl, Pop. Nobody's pregnant. It was, you know, a prostitute."

My dad hit the brakes, nearly spun the car around, pulled off into a gravel parking lot across from the graveyard, put it in park, looked at me, didn't say anything for a while, and then finally said, "What?"

"I've got a blister on my penis and I thought it was better this morning, but now it's starting to burn again, kind of on my thigh, next to my, ah, nut sack."

"A prostitute, for money?"

"Supposed to be two bucks, but I ended up spending seven."

"It's because you can't play baseball. That's what Dr. Green told us."

Dr. Green was a shrink I'd been seeing. "I don't think he's who I need to see. I need a pill or some kind of medicine, maybe a shot."

"Dr. Green told your mother and me that it's because of your eyes, because you couldn't play baseball when all the other kids were playing."

"I hate baseball, but I don't think I know what you're talking about. I've got a blister on my penis."

"It's why you get in trouble, you're trying to prove yourself. I don't know what to do about a blister, though. I guess we should drive over to Dr. Shultz's office, see what he has to say. You went to a prostitute, where?"

"I don't know, over by Silver Springs Park."

"Do you know what could happen, going to a place like that, in that part of town, at night?"

"I'm getting a pretty good idea."

"Was she, this girl, woman, was she a Negro?"

"Yeah, but you know that's okay, she was nice, it wasn't like creepy or anything."

"What did she look like?"

"I don't know. Kind of short and a little bit fat."

"Where was this?"

I was starting to wonder if my dad maybe wanted the address and any code words to get him through the door. "You know," he said, "I had a similar experience, but I wasn't as young as you are."

"Shouldn't we be going to the doctor?"

He pulled back onto the street and drove past the school. "You know, you're probably going to miss the first couple hours of school?"

"That's okay. I've got P.E. second hour, and coach Jackson's probably going to make us play baseball." Pop laughed and so did I.

Downtown at the medical building, the doctor was completely baffled, said it was a burn of some kind but couldn't offer a reason for it. He popped the blisters, patched the area with gauze, gave me a tube of ointment, and told us to call if it happened again. It didn't happen again, and a few days later, I reported to my father that everything was back to normal. He gave me a foil-wrapped condom, suggested I put it in my wallet. A couple of years later, a leaky cigarette lighter did it again: Fluid soaked through my pants pocket and went caustic on my tender skin. This time I figured it out.

My pop and I were different after that. I became the guy friend you tell stuff to, and for the remainder of his life, he told me more than I really wanted to know about his sex life and the five wives he went through, deleting the saucy details involving my mother,

at my request. He told me about his young life and secret experiences, and he wanted to know my stories as well. Sometimes he would ask, a little salaciously, about my girlfriends, but I clung to a corny-boy chivalry and didn't give out the nasty secrets of the girls I fell in love with. The whores, well, I'm still telling those stories.

※

Life in Glendale was okay. Carol went to work weekdays at three. I'd take a walk or drive to a bookstore where I'd look at books and sit outside by the fountain with a coffee and a pastry. My marijuana-infused mind would dip and sail through the blue sky. I'd watch people and wonder about the worth of their lives; you can't really tell the ones who grew up in Beverly Hills from the ones who survived the killing fields far away. Glendale is mostly Armenian, a swarthy lot with pretty girls who give ample time to makeup and hair, short tight dresses and heels. They never noticed me, but that was okay; I was happy just watching them wiggle by, leaving the rest for my imagination.

From my table sipping my coffee, I watched a woman, dark but maybe not Armenian: short jean shorts, flip-flops, a worn-thin T-shirt with the neck cut out to show her shoulders. She was skinny and maybe thirty-five with big rubber-suction lips, a generic nose, and pale, almond eyes with thick black smears of eye shadow. She was smoking a cigarette and she came and sat in the chair next to mine. "I know I don't even know you," she said. "But, just listen for a minute, please, please." She had a dark accent that I couldn't differentiate from a hundred others, somewhere east of everywhere else.

"I really, really need a ride home because I'm taking care of my mom, but I don't have a car, but I don't really need a car so much,

see. I live real close at my mom's house, which is just over there a couple of blocks. But I don't have the key and I've gotta get a ride to my brother's house, which isn't really far, but I don't have any money for a bus."

"Why me? What'd I do?"

"You just look really nice, and I'm really worried about my mother."

"That doesn't make sense. I don't look nice; I've practiced not looking nice all my life."

"You look nice to me, and I don't ask favors ever, ever, but I'd really appreciate it."

"Really?"

"Really, really."

"I'm sorry, I don't think so."

"But if you could, you know."

"How far does your mother live from here?"

"Just a couple of blocks and not all that much more to get to my brother's for the key."

"How about if you go to your mother's house and knock on the door, or if she can't come to the door, climb in a window."

"I can't do that. I could get in trouble. I can't just break in my mother's house, but it's not like that anyway. What I really need is the key, and I've got to get to my brother's house. It's not really far."

"Yeah, I'll bet."

"It won't take long at all. I know you're a nice person. Won't take ten minutes."

It had been seven years since I'd photographed a prostitute; my days of jerking off on whore tummies were in the past. I missed it for reasons beyond the illicit spurt. The whore pictures had begun as a sexual lark, but over time I'd come to feel the work was

important. The women I photographed were sad, used, and abused by everyone. Most of the world considered prostitution a lifestyle choice made by people who count for nothing in the first place. Making the images of light and composition that highlighted the existence of harsh and nasty places was a calling of sorts. I wanted to help these victims of circumstance and make them count. I had thought I was doing something good. Also, I missed the sheer thrills of running blindly through the dark nights.

"Yeah, alright," I told the woman at the bookstore. "Let's go."

Halfway through the parking lot, she noticed my cane. "Oh," she said. "Oh, I'll walk slow so you don't have to catch up to me."

"I appreciate it."

"Thank you, too. Thank you, thank you. Really I mean it, I'll show how much I appreciate it."

I didn't contemplate sex with her. At the very most I'd call up her image when I jerked off, and except for the jerking-off part, I'd tell Carol all about it when she got home. She'd tell me it was a stupid thing for me to have done, and I would agree. I guess I just really missed doing stupid things.

Her name was Andee, and as soon as we got in the car, she started touching me, on the arm, on the thigh. She directed me up a few blocks to the 134 Freeway and then to the Glendale Freeway south toward downtown. "I'm thinking really close might be really far," I said.

"No, no. It's not far. Just stay on this freeway. You're really such a nice guy. They really should make more guys like you."

"Yeah, the world would be a better place." I didn't know where we were going, but I did know we were going on a drug run and I knew she was probably lying about everything. She reached over to massage my neck a little bit. I could feel it down to my dick, a feeling that wasn't as welcome as it once would have been.

"I'm from Beirut," she told me. "That's in Lebanon. I saw people get killed all the time when I was little. It's the most beautiful city in the world, but we came here. I didn't have a father anymore. I used to beat up my brothers. They weren't at all like you are. Sometimes it looks like the same as when there was war, here, right here in Los Angeles, except it's never as beautiful as Beirut was."

"The freeway dumps out up here going to Echo Park. We've gone a few miles, you know? I didn't pack a lunch."

"I know, I'm really sorry. I guess it's longer than I thought it was."

"I've heard that before."

"Huh? Echo Park, just a little bit more up here."

The Glendale Freeway made a long downhill curve onto Glendale Boulevard, funky but nice little bungalows in the green hills, metal industrial buildings and beauty salons, then down under the Sunset overpass, where homeless people were camped in pup tents and boxes.

Finally we arrived, an open lot off to the right of the road, two great slabs of concrete in a wedge holding up the side of a cliff, pavement, asphalt, and dirt at ground zero. Gang graffiti looked like Aztec and underground comix. A stairway through the wall and up the dirt to a funky white frame at the top. She touched me again and again, trying to give me promise of something I didn't really want and something she was probably already trying to figure a way out of. She begged me to wait, while she ran inside, please, *please* don't drive away leaving her there, and don't forget her poor, poor mother at home. Told me she'd be really quick, just get the keys from her brother. Up close her face was sexy, kind of skanky. I told her go get the key. I'll be here.

I turned the car around for a better view. Across the way was the Angelus Temple, a round, arena-like, modernist building with a

big white dome and a long row of double doors. Evangelist Aimee
Semple McPherson had built the massive house of worship in the
1920s. Sinclair Lewis had based *Elmer Gantry* on McPherson's
life. I thought about Burt Lancaster, who played Elmer Gantry
in the movie. I wanted to go inside, look around, and take some
pictures. I often saw places I wanted to photograph, but I never
followed through. I lacked motivation.

I lowered the windows and turned on the radio. It was my
habit to go home after my pastry and coffee, work or play in the
darkroom, sit at the computer writing. Andee came back down
the stairs, took a gun from her purse, and told me to drive to
Mexico, except she didn't really, and I wondered if I'd ever again
do anything worth writing about.

Andee was gone for fifteen minutes, but I didn't mind. She
was high on something speedy, didn't talk, but ground her teeth
until they squeaked like a loose floorboard. I drove us back to
Glendale, where she directed me to a little wood-framed, two-
toned fourplex, side by side by side, low to the ground, and very
Southern California. The sprinklers were on, but the lawn was
brown. I went inside with Andee and took outrageous pictures of
her with her elderly mother in the background watching televi-
sion, except I didn't carry a camera anymore and I didn't really
go inside.

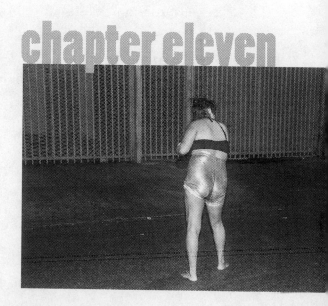

chapter eleven

dirty pictures

2013

Three-fifteen, Friday morning, I cruise through the intersection of Sixth and San Pedro Street in downtown Los Angeles. Looking both ways, I see encampments of disenfranchised souls: burning embers and black smoke, the horror of wartime America. I go south into a few square blocks of drug pushers, addicts, and whores. During the day, this is the flower district; they'll be hosing off the sidewalks in another hour or two. A few more hours after

that, people in other parts of Los Angeles will receive beautiful bouquets, cards that say "I love you."

Shadows are crooked and long black fences look like jailhouse bars. Everything is black, white, and grainy, like the photos I made twenty-five years ago. Everything is still all fucked-up, worse. At Stranford Avenue between Sixth and Seventh, drug dealers whistling from the shadows, tweet-tweet, vying for my attention as I cruise by at five miles an hour, windows half-mast, taking in the sights. Stopped at a corner, a guy in a hoody, his face a black hole, drifts toward me holding a dime bag with his forefinger and thumb, dangling it, like he has a mouse by the tail. None for me, thanks, I've got my medical marijuana, MS Contin, and Tylenol 3 at home. I'm as sober as I need to be, and I'm not looking for drugs. I'm making photographs again, and I'm looking for whores.

A woman emerges from the dark and I stop. She runs to the car and grabs the handle, but the door is locked. I unzip the passenger-side window. "Hey," I say. "You alright, you working?" Her face refuses to focus; it vibrates like a swarm of bees. She is wearing a black top with a single shoulder strap. She's wearing shiny silver short-shorts pulled up too high, tight yet a little baggy. She's frantically pulling the door handle, and I tell her hang on a minute. "I want to take your picture; I'll give you twenty bucks. Stop pulling on the handle for a second and I can unlock the door." She opens the door and gets in and I go back to driving.

"I want to take your picture," I tell her again but then realize communications are not working. She speaks painful nonwords that I can't understand. I take a twenty from my pants pocket and offer it to her, telling her, pictures, you know, say cheese? I'm wearing my camera, which I hold up to show her, but she doesn't notice. I keep my eyes on the road, old and industrial, but there

is madness in my periphery. I pass a narrow dead-end alley, about a half-block long with a yellow light and blue plastic tubs at the end, a loading dock. I back up and turn in.

Halfway down, a big dirty guy sitting in a doorway jumps up and watches us carefully as we drive by. I stop at the end, turn off the ignition, take a long breath, and turn to my passenger, who is in full spastic mode, a kinetic ball without definition. Again I offer her the twenty dollars, but I feel like an idiot offering money to a hallucination. I can't think of any hospitals in the area, but I'm thinking maybe I should look for one. She gibbers without pause and gobbles air like she's being strangled. I make out, "Harry has a tall hat," but I'm sure that's not what she said. She opens the door and jumps out. I get out of the car as well; I want to see what's going to happen next. I hit a stink that smells like rotten fish and makes me gag, and then I realize I've pulled into a loading bay next to a load of rotten fish.

The big dirty guy is walking toward us, not wearing a shirt but wearing grungy red pants and ugly tennis shoes. I get my cane from the car in case I need to clobber someone, or walk any-where. The woman is bouncing off walls that don't exist. The guy jumps suddenly, then takes off in a run. I'm glad to see him go. The woman looks at me, seemingly trying to tell me something, probably fuck you. Then she takes off as well, flailing herself out to the street. I get in the car, reverse out of the alley, and look around. The guy is nowhere and the woman is still running. I notice she's barefoot. I pull up closer and I see something I hadn't noticed before. I point my camera out the open window and push the button, but the autofocus is slow in the dim light. Finally, two seconds maybe, the camera's shutter opens and the flash fires. As she runs into the dark, her silvery shorts reflect my headlights like a street sign, a dark red blood stain in the seat of her pants.

Toward the end of 2011, I had little hope of ever doing anything with the streetwalker portraits. Then one sunny day, Carol and I went into an L.A. photography gallery we hadn't been to before. It was a nice exhibit, black-and-white and stark by an unknown photographer who deserved the exposure. What impressed me most was the guts and the eye of the curator, John Matkowsky. I introduced myself and told him I had a series of prostitute pictures, asked if he would take a look. The next day, I brought him a CD, and the day after that, he called to tell me he wanted to give me a solo show.

I felt I'd just been cured of a terminal disease.

A week later, I was contacted by a very cool online photography magazine. John had sent some of my pictures and a couple of the stories I'd written to accompany them. A week after that, my work was on the front page alongside that of Robert Frank, William Eggleston, Nan Golden, Pieter Hugo, and a host of other photographers who had long been at the top of the heap. I joined Facebook and did self-promotion. I started a blog. All my life, I'd been telling people about my photographs, and suddenly they were listening.

My images were passed around the Internet with a startling frequency. A budding young publisher in the U.K. wanted to launch its imprint with my pictures and words, *Lowlife*, the book. I started getting requests for interviews, and I had other gallery shows: London, Switzerland, and a second show in Los Angeles. *Lowlife* came out and got good press in the photo world. I got fan letters. My fame wasn't of great magnitude, nor did it give me any real solvency. But after so many years of struggle, I was finding just what I had always wanted, a small cult following and access to the minds of others. Now I have a legacy to leave to Dashiell, and I've got words and pictures that will live longer than I will.

Carol has worked to support us for twenty years, and now it is my hope that I can support us for the next however-many we have left. Sometimes, like a wave of drug-induced paranoia, I'm terrified I'm going to fuck it all up; I still think about all the missed opportunities in my sixty-three years, and much as I don't like it, I have to admit it's taken me all this time to become functional. I'm a late starter.

※

I'm on Santa Monica Boulevard going west. This used to be where all the boys were, dressed like Tom of Finland sketches, but then AIDS swept through like an evil storm and blew them all away. Now, thirty-some years later, they hopefully have a better awareness and I wonder where they are. It's not as though rent boys are shy. In the 1980s, working a gig in Times Square, I'd get off the train at Penn Station with a bladder full of morning coffee and head down to the lowest-floor men's room, where there was an array of hardworking dicks in the stalls and at the urinals, where guys would stand and jerk off while watching their neighbor take a leak. It was a fun place to pee.

I didn't photograph boys much in the past, which is a surprise considering my compulsive promiscuity at the time. A twenty-four-year-old molester named Dave popped my boy-cherry when I was a freshman in high school. He liked to drive boys around in his Lincoln Continental, buy them booze, and watch them drink it down. Dave was also known as The Bug, a nickname from his black horn-rimmed glasses and tall, skinny praying mantis body. He blew me and then I blew him and then he blew me again. It was a character-building experience.

Later, still in my teens, panhandling in City Park, Denver, Colorado, I sold it to a fortyish guy who called himself the Professor,

said he liked to teach young boys about life. I was a bumpkin, but I pegged him before he approached me. He told me how he understands the hippie boys; he knows they're good kids but doesn't understand why we don't get haircuts. He had a crappy third-floor hotel room a few blocks from the park. He fed me Dinty Moore Beef Stew, which he heated on a hotplate, with Hostess Twinkies for dessert. He had Coors beer in a Styrofoam cooler. He told me he wasn't really a homosexual and had a wife and a kid in Boulder.

I was sitting on the edge of the bed licking Twinkie from my fingers when he suggested we get physical. He went into the bathroom, stood in front of the sink, and looked across the room at me. "I'm going to make it really special for you," he said, then took out his teeth and put them in the sink. He grinned at me and lapped his tongue. Fortunately my erections were indiscriminate and I saw the opportunity to ask for twenty bucks, which he paid promptly enough that I wished I'd asked for fifty. After he swallowed my spunk, he jerked himself off into a hand towel, on his knees, looking at me like he wanted to kill himself. Before wishing him a nice day and taking a skedaddle, I stopped in the bathroom for a leak. I stood on my toes and pissed on his dentures in the sink. He didn't really deserve my bad attitude, but I guess I was still somehow connected to an outmoded respectability and chagrined by my own casual disregard to the rules of sex.

※

I turn right at La Brea. At Melrose, up on the left, a line of late-nighters at Pink's Hotdog stand. On my right, on the north side of Melrose, a funky little fifty-seat theater, where two nights ago, Carol and I went to see Dashiell, my thirty-year-old son, the stand-up comedian, as he hosted a comedy show and did a funny

seven-minute bit of his own. "I think it's kinda gross to pee in the shower," he deadpanned. "But it's hard to hold it in when you're taking a shit." That's my little boy, all grown up.

Up to Sunset going east, back the way I came, it's late and the clubs have let out, traffic is moderate. Smatterings of young people, the girls all gorgeous in short skirts and heels, and the guys the usual group of morons. At Sunset and Vine, the Cinerama Dome, a geodesic golf ball, where I saw *Apocalypse Now* in 1979, the first movie I went to with Sylvia. She was irritated because I had only brought enough money for my ticket, and I was irritated because she expected me to treat. A couple of blocks later, the Nickelodeon studio in the old Aquarius Theater, where I saw *Hair* with my first wife, Danielle, who was seventeen and even more untamed than I.

Eastward toward the Hollywood Freeway and a half block past Denny's Restaurant, I see a girl, but only for a second. I've got cars behind me, and my little 2005 Scion is a long ways from my long-gone Camaro, but I maneuver a turnaround and now I see her up ahead. She is young and black, short-shorts and way-high heels, a tight T-shirt, pink, like cotton candy. I go on ahead and then hook a right on Van Ness and drive to the Denny's back lot, which, I discover, doesn't go around to the street. I U-turn back to the street, and it occurs to me this is the same Denny's restaurant I'd been to when I picked up Pocahontas back in 1990.

I pull out of Denny's and cross Van Ness and into the parking lot of a Midas Muffler, and here comes my girl, skinny and sexy, tall and young; she wobbles on leopard-print heels and wiggles a little for my benefit. She walks into my headlight beams and stops to wave and smile at me. She's got pretty eyes and hoop earrings and a broad white smile. She has long, straight, black hair with chocolate brown streaks. Her tits are perky and I am a dirty old

man. Carol knows what I'm doing, where I am; she'll probably look at the photos in the morning before I get up. She worries about me because I'm doing things most would ill advise, but as long as I don't let my ante-meridiem friends stink up the car with cigarette smoke, Carol's okay.

I pull back onto Sunset next to the curb and zip down the window. She smiles at me and gives me a little wave. "Hi," she says. "How you doing?"

"I'm still alive," I tell her. "Hop in, let's go for a ride."

"Are you a cop?"

"No, I'm a Democrat."

"Can I touch you?"

"I don't have a problem with that."

"To make sure you're not a cop."

"Yeah, whatever."

She puts her head and upper body through the open window, up close to me, reaches down and gives my wiener a nice pull through the denim. "Okay," she says. "You're not a cop."

"You sure? You might want to check again."

She hops in and I ask her if she has a place to go and she tells me corner of Vine and Santa Monica she has a motel room. I tell her I want pictures. "How's forty bucks?"

"How's sixty?"

"Yeah, alright. I'm Scot. Nice to know you, what's your name?"

She giggles, actually says, "Tee-hee."

"That's your name, Tee Hee?"

"No, my name's Temptation." She's chewing gum and it sounds like lapping waves.

"Yeah, well, that makes sense."

All I want is photographs, but Temptation fills me with longing and my dick plumps up like a little body-builder. I wonder if

I should really be out here, doing what I'm doing, refusing to accept the limits of my sixty-three-year-old busted-up body. Am I competing with the past? Am I still trying to measure up to my background? Once my father accepted that he was going to live in Missouri and not Southern California with the glamour that some of his war buddies had found, he set out to be the best-known photographer in Springfield, and I think he succeeded. Over time, he won a slew of awards from the Professional Photographers of America. I dropped out of the PPA early on, but the awards and the recognition of his peers meant a lot to my pop. He also made a good living; I came of age in a home where we had everything anyone was asking for in those baby-boomer years. I look back and I'm proud of my pop.

My father sold Sothern's Studio along with the building in 1986, making a deal, which probably wasn't that great, with a young, ambitious woman photographer who kept his name on the sign, letterhead, and gold foil stamp that went on every photograph. He retired early and wintered for a few years in the Florida Keys, where he bought a boat that he used for a small sport-fishing business. In his spare time he pursued underwater photography, tennis, and golf. I never told him how upsetting it was for me when he sold the studio. It was supposed to be mine, and even if we all knew it never could have worked, this woman, a complete stranger, was taking away my inheritance, my connection to my father.

In my bedroom, I have a trophy that my father won for a hole-in-one when he was eighty-six. On a visit home that same year, he took me to lunch at Arby's and then to Sothern's Studio, which was still in business. The woman who owned the studio was about my age, maybe a little younger. The place looked like crap. Nobody had been in the darkroom in years and I wanted to

see it, but it was full of junk, unnavigable. She wasn't much of a photographer, but she'd been a good businessperson and had done very well with school pictures and weddings. First thing I saw as I walked in the front door was a large portrait in a gaudy gold frame: Attorney General John Ashcroft and family. A Springfield boy. There was nothing here I would ever want to measure up to.

Three years later, I came back for my father's funeral. His last wife had died the year before. I'd driven to 327 E. Walnut Street, Sothern's Studio's address since 1950, and it was gone, not a trace. The business still existed, though the owner had sold the building and worked from her home. My pop had been a photographer for nearly sixty years, and going through the things he left behind, there was not a single negative of his work. My brother has a black-and-white photograph of the London Bridge at night; Pop took it during World War II. That's it.

After the funeral, I talked to the woman who owned Sothern's Studio, a woman who loved and respected my father, who had been her mentor.

"Your daddy told me," she said, "you were too artistic for Springfield."

"Wow," I said. "That's really a nice thing to hear today, thank you."

Then she spoiled it. "I never understood," she said. "Why would he say that? What's that mean?"

"It means he thought my photography was art."

"You're an artist? I thought you were a photographer in California."

"I'm an editorial photographer, you know? Fine art."

"We have artists here, just like everywhere else."

"Yeah, I know, but he was talking more about temperament, you know?"

"What kind of pictures do you take?"

"I don't know, I guess I make dirty pictures."

<center>※</center>

There is a new breed of working girl in Hollywood; faces aglow from iPhones like footlights on a concrete stage, they wiggle their buns and wave like little girls playing grown-up. They are not desperate or drug addicted. They carry handbags, small and unobtrusive yet large enough for a can of pepper spray. They are only a handful of years beyond middle-class high schools where blow jobs and fucking mean nothing more than passing boredom. Now they find they can pretty-up all sexy and make easy money doing what they were doing already. I like them. They're a nice addition to the otherwise bleak world of street whores.

I turn down Vine with Temptation, my passenger, and pull to the curb four parked cars up from the Vagabond Inn, which is our destination. I don't drive into the motel lot, because a girl can get the boot if the manager is an asshole and sees her working out of the room. I pull up the brake; between it and the seat is my cane, clear Lucite, which I take by the hook handle, and Temptation puts her hand on top of mine. Her fingers are long and graceful and the nails are manicured but without polish. She gives me a radiant smile. "Is this your stick?" She takes a slow appraisal of the cane. "That's really gangsta."

"Yeah, well. I guess you got me pegged."

She laughs, tee-hee, and we get out of the car. It's a beautiful SoCal night, maybe sixty-eight degrees, stars in the sky, Venus and Mars. Between us and the motel are four guys hanging together. They're not pimps, they're not drug dealers, and they don't look homeless. "You're not connected to any of them, are you?"

She takes my hand as if she'll take care of them if they give

us any shit. "Ooh, no, no way do I know any of them. Don't pay them any attention." But they're paying attention to us; I guess we make a fine-looking couple. Guy says, "You got any money for a vet?" Now I notice they're passing a bottle. I like vets more than I like cops but not by much. "Not tonight, sorry."

"God bless you," he says, and then to Temptation, "You got something for me? Got some love for me like last time?"

She stops on her leopard heels. "I never had nothing for you, you don't talk to me that way, motherfucker."

He's chagrined.

"You want me to beat him up, for you?" I ask her.

"Tee-hee, maybe I might."

She walks ahead of me, slowly so as not to leave me behind. Going up the steps, I grab the metal banister, pulling myself up to the second floor. She must know I'm looking at her ass, because she's swinging it like it needs to be scratched. I feel good about myself and I'm having a good time. Not that I'm not all about the cause; all the women in my life have been feminists, most have been atheists, and all have been democrats. Men are evil fuckheads who don't deserve the brute strength they have over women; I'd like my photographs to punctuate that statement. But that doesn't negate the fact that I'm having fun taking pictures of a naked hot chick. Inside the Vagabond Inn, Room 216 on Vine just north of Santa Monica Boulevard, I give Temptation sixty dollars and she says, thanks, what do I want her to do? The room is nice, clean with the slight tinge of disinfectant. The walls are yellow and the double bed has a floral bedspread. The night table on the left has a plastic bag from CVS Pharmacy, a ring of keys, and the motel phone. The night table on the right has an iPhone plugged in, a couple of cartons of Chinese takeout, a box of ribbed condoms, and a bottle of baby oil. I need to pee; I always

need to pee, but it's never easy and right now I also have a boner, which means it's impossible so I have no choice but to wait.

I ready my camera. I'm shooting color these days.

I've got a Nikon D90 with an 18mm to 105mm lens, which isn't quite wide enough. Nikon calls it an entry-level camera and kit lens for advanced amateur photographers. It's what I could afford. I'd like a better camera, but I love digital photography. I shot plenty of film, starting with large-format nearly fifty years ago, and now I'm done with that. I'm making instant images, as fast and plentiful as I want. Smoking a joint, listening to tunes, and processing with Photoshop is life at its most enjoyable.

I rack back the zoom, which brings me closer to Temptation, who is on the bed, looking enticing; she's taken off her blouse and she's on her knees. She is still chewing gum and it still sounds like lapping waves.

"You're beautiful," I tell her. "You know that? You got my heart palpitating."

"That's what I like to do." She smiles at me. "Tell me what you want me to do."

"Take off your clothes."

"You want me to leave my shoes on?"

"Absolutely." I tell her she has beautiful skin, and I'd like to tell her she has a smile like Diana Ross circa 1965, but I don't think she's familiar with anything circa 1965. She asks me what am I going to do with the pictures, and I tell her I'm an artist; someday my pictures will be in museums all over the world. "Two hundred years from now," I tell her, "men will look at my pictures of you and they'll get boners."

"Tee-hee."

"Lie on your back with your head up top, and then look at me." I need to go to my knees, on the floor next to the bed, to get the

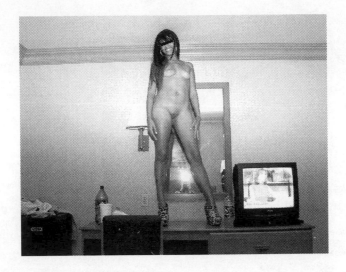

angle I want, but I've leaned my cane against the wall across the room and if I go to my knees I won't be able to get back up again. I try a squat, but it doesn't go well. I see a large silver patch of stretch marks on her hip and thigh like static light. I shoot the picture, then give her my hand and move her to the desk opposite the bed. The television is on with the sound turned down. I help her up to the desktop in front of a mirror and make a nice flash exposure where I can see the flash and myself reflected between her legs. Might make a nice Facebook profile picture.

I'm all done so I help her back to the floor, ask her if she wants to stay or wants me to drive her somewhere. She's going to stay and tells me I can stay for a little longer if I want to. I tell her no thanks and give her a hug and a couple of soft pats on the ass. In a touching good-bye gesture, she grabs me between the legs, checking for one last time to make sure I'm not a cop.

※

Once a month or so, around midnight, I pick Dashiell up at his place in Hollywood, and we go driving around Los Angeles,

sightseeing, until four or five. After Dashiell graduated from high school, he did a freshman year as a film major at UC Santa Cruz, but it didn't work out; it was too structured. I wanted him to finish with the education and get the connections I never had, but it just wasn't for him and I understood. His mother, Sylvia, is an attorney who works for a public defender's office specializing in children's rights. We're not really friends, but neither are we enemies. On the rare occasions we see each other, we have a pleasant discourse. After his one year of college, Dashiell moved to San Francisco and lived there for about ten years before he and his girlfriend moved down here last year to pursue show biz. They are wonderfully sweet and affectionate together. Makes my heart go pitty-pat.

On our forays into the night, I drive and drive and drive, and we see Los Angeles in the still dark and it is a beautiful thing. I talk about the history of the city, a favorite topic of mine. I talk about my history and Dash's history. I show him the building on Wilshire where I met his mother and I show him another building on Wilshire where I met Carol and yet another building on Wilshire, a wedding chapel where Carol and I were married, while he, at eight years old, jumped around making silly faces. We talk about his life and ambitions, and sometimes he tries out new comedy material on me. I always laugh because it's always funny. I worry that he will be like me, sixty-three, with a life of rejection before he gets noticed. But he's not as fucked-up as I was; he's a little fucked-up, but still I trust he will do what he wants to do and he'll never be just another guy. He wouldn't be happy any other way. Neither would I.

●

Good deeds or bad, I'm haunted by visions of my past. I watched a girl, seventeen or so, get beaten by a murderous fuckhead in a

whorehouse in Sedalia, Missouri. I stood in line at a bunch punch and saw a girl, about fifteen, abandoned late at night near a river bank to find her way home. I was still in my teens and I was drunk, but that's a lousy excuse. Last week, I saw a group of thugs on the sidewalk. A guy had a ho by the arm and he was flinging her against a car door, over and over. Whup, whup, whup. The other guys were watching with causal disregard. I stopped the car, but not for long. As soon as they noticed me, I was gone.

※

It's warm and windy and I sneeze and my lips are dry. Blistex now comes in about a dozen forms and flavors; I like the Medicated Lip Ointment that comes in a little plastic tube similar to the original. I lube up and look around. When I photographed prostitutes in the 1980s, even the most desperate of them had cheap motel rooms, crappy hotel rooms, funky apartments, places to call home. Now, downtown and around Los Angeles, home is the corner where you sit, hoping some degenerate fuck, looking for curb service, will offer you ten dollars to stick his dick where your teeth used to be.

I pull to the curb, lower the window, and ask a woman with a suitcase on wheels and an adjustable blue-aluminum cane would she like to go for a ride. She asks if she can put her suitcase in the backseat, and I tell her sure. She lugs the suitcase to the back, then gets in the front passenger seat and buckles her seatbelt. "Okeydokey," she says. "Let's go somewhere else."

"I want to take your picture. Do you have a good private spot?"

"This way, two or three blocks, and I'll tell you when to turn."

"How's twenty dollars sound?"

"Sounds like more than I have now."

"What's your name?"

"Whiskey. What's yours?"

"Scot. Really, your name is Whiskey?"

"It's what people call me."

"You have a whiskey voice." She sounds like an old man with lung cancer.

"I have a crystal meth voice; it's all ripped apart. Can't even sing the blues no more."

I'm paying more attention to her than the road when two guys in undershirts, baggy pants, and baseball caps dart in front of the car like freaked-out deer. I hit the brakes and squeak the tires without running anybody over. The two guys come to a stop under a street lamp at the corner where a small flock of pushers are congregated.

"Damn," Whiskey laughs. "Those boys are ready to die to get high."

Her face is hard, rough as pavement, and she has beautiful pale-blue eyes, long light-brown curly hair, clean and shiny, three teeth on the upper row and none that I can see on the lower.

I laugh along with her, ask her where she's from.

"Junction City, Kansas, but I said good-bye a long time ago."

"Yeah, I spent a couple of nights in Junction City about a hundred years ago."

"Funny, I don't remember seeing you there."

"Yeah, well, I look different than I did back then."

"Me too," she says. "See if you can guess how old I am."

She looks fifty-five. "Uh, I don't know, forty?"

"Twenty-two."

"Jesus, fuck. Seriously?"

She's laughing again. "Nah, man. I'm just yanking your chain. Crystal meth humor."

"That's pretty good, I'll remember that. By the way, that's the

Sixth Street viaduct, up ahead, goes over to Boyle Heights. Shouldn't we be making a turn around here?"

"Turn left at the street before the bridge. I know a good spot. What kind of pictures do you want anyway, dirty pictures?"

"Tastefully dirty, how's that sound?"

"Sounds a little crazy, but it's your money. I'm not much to look at, but I keep clean. My clothes are clean and I'm clean; I try and make sure of that every day. Some of the girls out here, they just don't care anymore. It's bad enough the way it is, but when you're all dirty, it's worse."

"Must be scary, out here. By yourself."

"Scary, nah, it's not scary. It's sad and it's stupid, but it's not scary. Nobody's gonna bother nobody who's already killing themselves. Nothing scary out here."

I take the left at Mateo Street and then a right, and I see a spot of street that goes down under the bridge and it's filled with graffiti and pillars and atmosphere, so I go that way. "Let's go over here," I say. "This is great."

"Yeah, it's great if you want to go to jail."

"Oh, really. Too many cops?"

"Any cops is too many cops."

"We're just taking pictures, no law against that."

"Dirty pictures."

"Yeah, well sort of."

"You can tell the cops all about how you're not breaking the law, some other time, with some other ho."

"Yeah, okay, damn, that's too bad. You're in charge."

"I'm in charge? If I was in charge I'd be asleep right now, in my Beverly Hills mansion, and you'd be a big handsome stud."

"What are you doing out here anyway? Shouldn't you be writing sitcoms in Burbank?"

"I'm a drug addict, Scot. I used to be a real person, and now I'm an addict. All the promise I ever had is gone baby gone. Pull up over there."

Seemed like we'd been driving in circles. The last street I'd recognized was Santa Fe, and I had no idea how to get back to it.

"Do we need to get out of the car to take pictures?"

"Yeah, we do."

"Then just stop and don't get out yet. There's some people in that car."

We're off the street in an open area surrounded by old brick industrial factories and processing plants, mangled gray fences and gates, back doors behind black bars. Decades-old faded signs slapped across building fronts with curly razor-wire trim. I put the car in park, turn it off, and douse the lights. There are three people in the other car, and two of them are getting out. Music and chatter coming my way by way of echo. An after-hours club. Now all three are out of the car, good-looking young people, two girls and a guy. The girls are dressed like whores. Whiskey is wearing slip-on tennis shoes, heavy dark-blue tights, a clean black T-shirt, and a sleeveless blue-jean jacket. "Wait until they go," she says. "Then we can get out."

"Why don't we just go ahead and get out now? They don't care about us."

"I'm shy. What are you going to do with these dirty pictures anyway? Make Halloween masks?"

"No, not at all. I'm an artist. I'm making a statement."

"Con artist."

"Yeah, maybe, a little bit. Everybody has a job skill, you know. Mine is photographing prostitutes."

Whiskey laughs. The young people have walked around the corner. "Okay," she says. "Let's do this now."

Out of the car looking around, it's a nice night, in the low seventies and clear. The moon is full and opens the dark spaces away from the streetlights. To the northwest a dome of clear yellow in the sky from the downtown lights. I love Los Angeles.

"It's a nice night."

"Yeah," she says. "Romantic. You can go ahead and give me that twenty dollars if you want to."

"I do. Here, here's thirty. Let's go over there."

Over there is a loading dock, shut tight with a metal pull-down door, concrete and exposed-brick wall scarred by a thousand truck bumpers. She pulls down her tights and undies and I take a picture, but I don't think it works. "Wait," she says. "Before you take another picture. I don't want this to show." It looks like a brand-new medical supply store cane. She sets it out of the picture.

"We are both walking with a cane," I say and realize it's a stupid thing to say.

"Yours is a cane," she says. "Mine's a fashion accessory."

"Yeah, you want to see which one of us can run around the block the fastest?"

"You go first," she says. "I'll wait here."

Next to the loading dock a porch and a door, five steps up. I take the steps up and then have Whiskey get on her knees on the bottom step. I shoot down on her while she exposes her tits. I make three exposures. She's a little irritated because she got dirt on her knees and I tell her I'm really sorry, I didn't mean to disrespect her.

Back in the car, I tell her I'll take her wherever she wants to go and she says in that case, she wants to go to the Hard Rock Cafe.

"What? The Hard Rock Cafe?"

"Just yanking your chain again, Scot. Just go back the way we came."

We go silent for a minute or so.

"I'm going to rehab," Whiskey says.

"Really? Good, cool. When?"

"Six weeks. It's a California thing. Department of Rehabilitation. I got in and I got a new cane and clothes. Just six weeks is all I gotta wait."

"Jesus, six weeks. That's a long time."

"Not really."

"You got a place to stay?"

"I was thinking maybe I could come and stay with you."

"You enjoy yanking my chain, don't you?"

I find my way to Palmetto Street, past long tall buildings from a time when movies were silent, L.A. was sleek, and business was thriving. I turn on Alameda and take Whiskey back into the madness of skid row. She takes her suitcase from the backseat and shows me how it's rigged to morph into a chair for when she can't stay on her feet anymore. I tell her that's great and I give her the remaining eighteen dollars in my wallet.

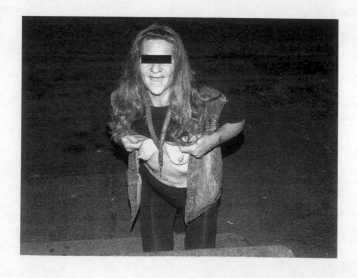

acknowledgments

I owe a great debt of gratitude to Matt Golden who gave me friendship and a place to crash for three harrowing years at the end of the 1980s. He paid for the pot, the beer and most of the food, and without his generosity this story might not exist. I don't know if that's something he'd want credit for or not.

Thank you to the wonderfully talented Bill Fitzhugh, whose's efforts on my behalf and unwavering support of my literary quest have been much more than I could ever ask for. I'm lucky to have you on my side.

An eternal thank you to John Matkowsky who found me hidden away in a lifetime of darkrooms and brought me and my photography out into the light. I don't think there is another gallerist anywhere who is more courageous and principled than he.

I want to thank Amy Tipton at Signature Literary Agency for her extraordinary perseverance and smarts. You're the best.

Thank you to Dan Smetanka for his editorial magic and thank you to everyone at Soft Skull Press for making *Curb Service* a better book, what a delight it has been.

Thank you to Stephen Parker for a whole lot of stuff.

Thank you to my mother for the gifts of empathy and humor and everyday goodness.

I'd like to thank Linda Sturges for the long list of contributions in the making of this book. Thank you also for the best years of my life.

Printed in the United States
by Baker & Taylor Publisher Services